THE ART OF PAPER CRAFT

Helen Hiebert

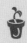
Storey Publishing

The mission of Storey Publishing is to serve our customers by publishing practical information that encourages personal independence in harmony with the environment.

Edited by Liz Bevilacqua and Mia Lumsden
Art direction by Michaela Jebb and Ian O'Neill
Book design by Michaela Jebb
Text production by Liseann Karandisecky and Ian O'Neill
Indexed by Samantha Miller
Technical edit for illustrations by Michael G. LaFosse

Front and inside back cover artwork by © Owen Gildersleeve
Back cover and interior photography by Mars Vilaubi © Storey Publishing, LLC, except for author photo (back cover) by Lata Gedala
Additional interior photography by Courtesy of Ann Martin, 222 l.; Courtesy of Arnold Grummer's, LLC, 144; © Bhavna Mehta, 194; © Béatrice Coron, 22 t.; © Béatrice Coron & photo by Etienne Frossard, 130; © Box Studio, 77 r.; © Cathryn Miller/Byopia Press, 52; © Courtney Frisse, 191; © 2021 Crane & Co., Inc., 16; © Dan Kvitka, 7 r., 106, 118, 136, 168, 250 l., 252 r.; © Diane Jacobs, 9; Courtesy of Dieu Donné, 15; Courtesy of Doug Beube, 2, 7 c.; © Eric Gjerde, 126; Sculpture and photo by © Erik Demaine and Martin Demaine, 21; © Genevieve Naylor/Getty Images, 20; Courtesy of the Getty Museum, Los Angeles, 11; © Gina Pisello, 231; © Green Banana Paper, 247 b.; © Helen Hiebert Studio, 1, 7 l., 102 t., 209, 238; © Ioana Stoian, 70 l.; © Janna Willoughby-Lohr, 198; Artwork by © Jane Ingram Allen, © Timothy Allen Photographer, 251 r.; © Jill Powers, 6 b.; katrin_timoff/stock.adobe.com, 13; © Ken Adams, 46; © Laura Russell, 176; © Leah Buechley, 184; © Lynn Sures, 247 t.; © Madeleine Durham, 258 b. ; © Marianne R. Petit, 60; © Michael G. LaFosse, 77 l.; Courtesy of Nancy Cohen, 248 b.l.; Courtesy of Nicole Donnelly, 14; © Olga Niekrasova/Alamy Stock Photo, 22 b.; © PaperPaul, 202 t.; © Paula Beardell Krieg, 110; © Paul Jackson, 57; © Paul Johnson, 122; © Paul Warchol, 165; © Peace Paper Project, LLC, 249; Photo and design © Peter Dahmen, designed for the MoMA Design Store, 172; Courtesy of Peter and Donna Thomas, 93; © Peter Gentenaar, Eternal Flame, 2011. Linen pulp, pigment, and bamboo; 75" × 59", 253; © Robert J. Lang, 85; © Scott Beitz, 247 m.; © Scott R. Skinner, 99; © Shawn Sheehy, 180; © Steph Rue, 217; Courtesy of Susan Byrd, 239; Artwork by Susan Joy Share, Photo © Clark James Mishler, 150; © Susan Kristoferson, artist, 255; Susan Mackin Dolan, 252 l.; © Tyler Olson/stock.adobe.com, 6 t.
Interior illustrations and diagrams by Missy Shepler, except Brigita Fuhrmann, 272 r.; Gayle Isabelle Ford, 273 l. & c.; Ilona Sherratt © Storey Publishing, 194, 212, 261–266, 269, 271, 272 l., 273 r.

Text © 2022 by Helen Hiebert

Storey Publishing
210 MASS MoCA Way
North Adams, MA 01247
storey.com

Printed in the United States by Versa Press
10 9 8 7 6 5 4 3 2 1

Library of Congress Cataloging-in-Publication Data on file

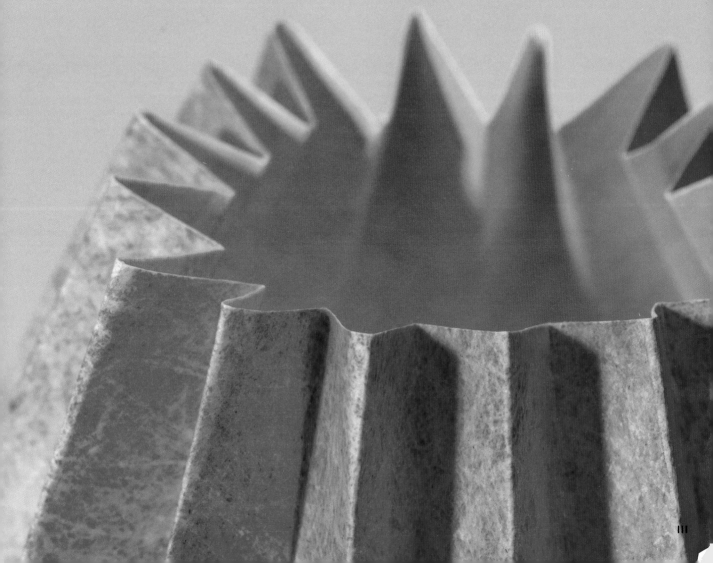

Many years ago, I acquired a pair of papermaking moulds from England that were already a century old. Every time I use them, I feel a connection to the papermakers who used them before me. Making paper was their job, and it is backbreaking work to produce hundreds of sheets each and every day. I have the luxury of using paper in a very different way than they did: to create artistic surfaces and sculptural artwork. As I repetitively dip my hands into the vat and scoop up the pulp, I envision the hands of those papermakers, holding that same tool in another vat and another era. I am transported to a place where I can only imagine the similarities and differences between our lives.

This book is dedicated to all hand papermakers, from prior generations and those who will continue to make and create with paper into the future—and to those who use paper as an art form and continue to push the medium in new directions.

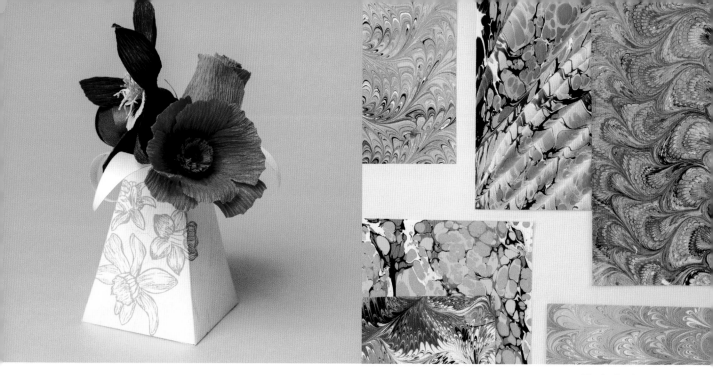

Contents

Foreword

PEOPLE OF ALL AGES TURN TO PAPER, AGAIN AND AGAIN, to make real the wonderful, yet unrealized, products of their imagination. We often begin exploring these pleasures in childhood, and for many, the charm seems never to fade. For some, much of the fun is in learning about papers and searching for and finding (or making) the perfect sheet for a project. Then comes the engineering—figuring out how best to accomplish the transformation. But before anyone can make anything from paper, the paper itself has to be *made*.

Helen Hiebert has dedicated this book to all hand papermakers, a nod that touches my heart. Long before Richard Alexander and I opened the Origamido Studio in 1996, I had been making custom handmade papers for my original origami designs. I loved the challenge to innovate and meet my origami designs' needs through my papermaking efforts, and the two paths merged in Origamido. In addition to providing our once-thriving manufacturing city with a public art gallery, we offered origami lessons and hand papermaking workshops. We promoted arts and crafts for all ages and helped launch a healthy art community in our downtown neighborhood.

Always hungry to explore even more areas of working with paper, our customers helped us expand our horizons. And so it was that while writing my book *Paper Art: The Art of Sculpting with Paper—A Step-by-Step Guide and Showcase*, I became acquainted with Helen. I was delighted to be able to include her works among those of a couple dozen other talented artists in the book. Like mine, Helen's work explored the whole process of creating—from pulp to paper to art—and often was born of freshly made sheets of paper.

Helen is a seasoned author, artist, papermaker, and teacher who has created a comprehensive exploration of paper arts in *The Art of Papercraft*. This book will prove to be an excellent resource for teachers and students alike. And families with budding paper crafters will be delighted with this collection. All of the projects are fun one-sheet wonders that introduce essential cutting, folding, and assembly techniques. Each project is simple enough for beginners while being sufficiently sophisticated for the seasoned crafter. The projects are organized into different papercrafting categories, which may help you find a starting point for your creativity.

In addition, Helen weaves her inspiring personal journey into the pages, along with accounts of papermaking's history and lore. She has included the works and stories of other notable paper artists, experts, and innovators, many of whom I have met and worked with through my own artistic journey.

Every paper artist has their own strategies for planning, coloring, texturizing, cutting, folding, assembling, and whatever else they need to do to create a finished piece. In my youth, I learned a lot of these strategies from books, and for that reason, I have a particular fondness for books that teach the "hows" and the "whys" of making beautiful things. Books that do this well become treasured references I visit again and again, and I fully expect that *The Art of Papercraft* will become such a book for me and for you.

—MICHAEL G. LaFOSSE
Origamido, Inc.
Haverhill, Massachusetts

My Introduction to Paper

I studied art at a small liberal arts college in Tennessee and had the opportunity to spend my junior year in Germany, where I took a class that changed my life. The class focused on paper as a material: making recycled paper in a blender, constructing furniture out of cardboard, and creating pop-up cards, among other things. Around that time, I discovered a book called *Pop-Up Origamic Architecture* by Masahiro Chatani, a Japanese architect and professor who explored how paper could be transformed through cutting and folding, without removing any part of the sheet. After that year abroad, I returned to college in Tennessee and created a body of work inspired by Chatani for my senior thesis. My life with paper had begun.

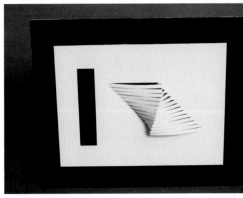

Helen Hiebert, *Untitled #2*, 1987.
Kromekote papers; 8" × 12" × 2".

Helen Hiebert, *Untitled #4*, 1987.
Kromekote papers; 12" × 12" × 6".

Opposite page, clockwise from top left: cyanotype by Beatrix Mapalagama; stamped paper by Beatrix Mapalagama; screen printing by Hedi Kyle; Van Dyke print by Alyssa Salomon; stenciled paper by Michele Roberts; rubber-stamped paper by Michele Roberts; and cyanotype by H. Lisa Solon

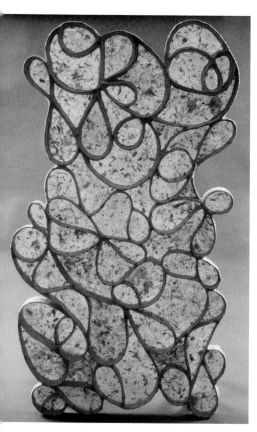

Helen Hiebert, *Japanese-Influenced Screen*, 1993. Artist-made abaca/onion skin paper, wire mesh, plaster bandage; 48" × 20" × 3".

A trip to Japan a few years after college sparked my interest in making paper by hand, which led in a roundabout way to a 6-year stint as the program director at Dieu Donné, a nonprofit papermaking studio in New York City. I learned all about making paper by hand and was exposed to the work of artists and technicians who were pushing the boundaries of what could be done in, on, and with paper.

Since then, I've gotten married, moved around the country, and raised a family. I have set up my own studios (first in Portland, Oregon, and now in Red Cliff, Colorado) where I create artist's books and installations; write a weekly blog called *The Sunday Paper*; teach online and in-person classes; run an online membership program called The Paper Year; produce a podcast called *Paper Talk*; and host the annual Red Cliff Paper Retreat and papermaking master classes.

That class in Germany opened my eyes to the variety of ways that a single sheet of paper can be transformed, and the idea for this book came to me more than a decade ago. I'm delighted that Storey Publishing (the publisher of my books *Papermaking with Garden Plants & Common Weeds*, *The Papermaker's Companion*, and *Paper Illuminated*) agreed to publish another book about paper.

In addition to being a substrate for information, imagery, and art, paper is a medium used in fine art, fashion, graphic design, architecture, jewelry making, model making, and crafts. This book will show you how cutting, folding, twisting, tearing, weaving, crumpling, and more can transform a single sheet of paper into fantastic and sometimes unbelievable forms. I hope that you will be inspired to invent your own creations and explore paper beyond the single sheet. The possibilities are endless.

WHAT CAN YOU MAKE WITH A SINGLE SHEET OF PAPER?

We are most familiar with paper that holds content (newspapers, letters, books, and magazines) and of course with the many papers that simply serve a purpose (toilet paper, stationery, paper cups, shopping lists, and sticky notes), but I am guessing that you have paper memories. I fondly remember covering my schoolbooks with brown paper bags that I decorated, and crumpling notebook paper until it looked and felt like cloth. I folded origami frogs and water bombs and made gum wrapper chains.

ONE SHEET OF PAPER OPENS A CREATIVE WORLD OF POSSIBILITIES

Kite

Paper doll

Airplane

Boat

Hat

Lantern

Lampshade

Star

Mask

Mobius strip

Hat

Crown

Chain

Box

Basket

Flower

Fan

Snowflake

Envelope

Valentine

Bookmark

Pinwheel

Map

Fortune-teller

Frog

Balloon

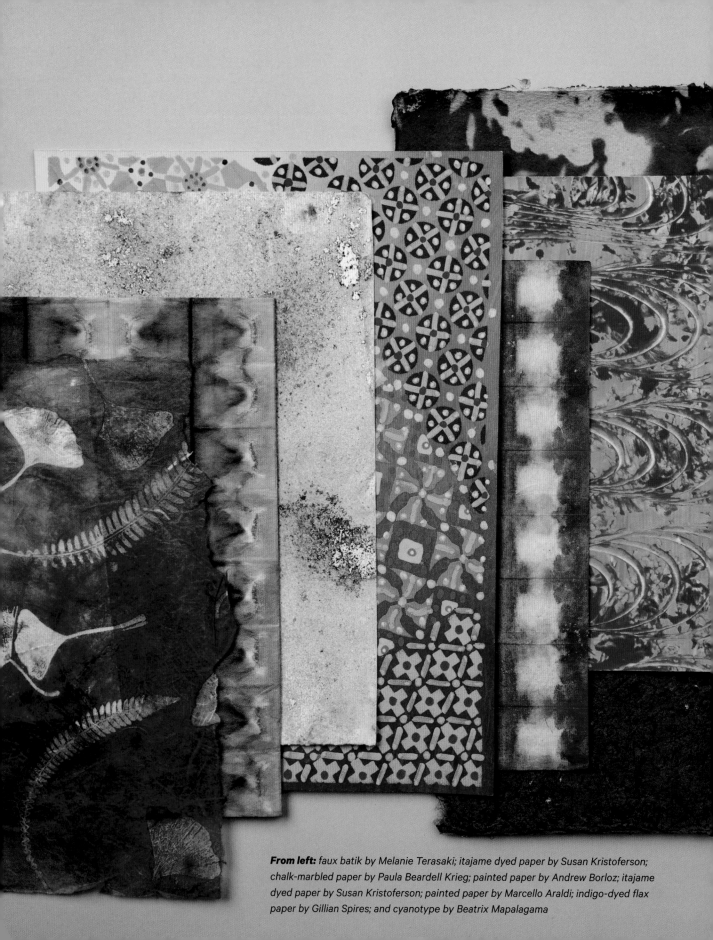

From left: *faux batik by Melanie Terasaki; itajame dyed paper by Susan Kristoferson; chalk-marbled paper by Paula Beardell Krieg; painted paper by Andrew Borloz; itajame dyed paper by Susan Kristoferson; painted paper by Marcello Araldi; indigo-dyed flax paper by Gillian Spires; and cyanotype by Beatrix Mapalagama*

All About Paper

PAPER IS A MAGICAL AND DIVERSE MATERIAL, and it is no wonder that German journalist Lothar Müller describes how it has "coursed its way through the veins of civilization" in his book *White Magic*. Paper can be both a surface (used in practical and artistic ways) and a work of art in and of itself. This book is printed on paper, and paper can also be folded, twisted, torn, and transformed into new shapes and creations. You can even make your own paper from plant leaves, stalks, and seeds or by recycling sheets of paper.

What Is Paper?

I n its simplest form, paper is a substance made from plant fibers that contain cellulose. These fibers are often cooked and beaten to a pulp, diluted in water, and scooped onto a mesh surface called a mould. As the water drains through the mesh, the fibers collect on the surface and interlock. This wet layer of paper is usually pressed and dried to form a sheet of paper, but there are many alternative ways to use wet sheets of paper or pulp as an art medium, interrupting the traditional sheet-forming process, to create dimensional surfaces and sculptural forms.

Sometimes, instead of cooking and beating the fibers to a pulp, plant fibers are either sliced into very thin sheets or overlapped and then pounded together to form sheets. Central American amate and Polynesian tapa, for example, come from the inner bark of a branch, while papyrus and pith "paper" come from the pith of a plant stem or tree branch. Sometimes these materials are referred to as proto papers because the process to make them is different from the process used to create more conventional papers today. Before humans had developed any of these materials, we wrote on other substrates, including clay, wood, slate, and parchment.

A sheet of handmade paper being formed on a mould

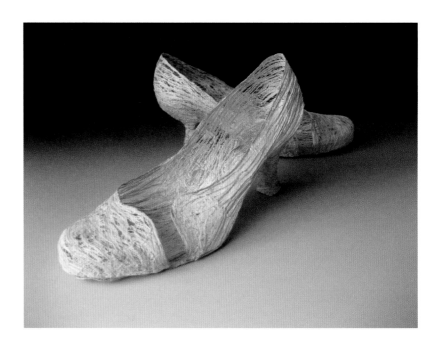

Jill Powers, *Kozo High Heels*, 2008. Kozo bark fiber; 9" × 4" × 5". Powers works with cooked and softened inner bark fibers before they are made into sheets of paper.

The first papers were made by hand using a variety of methods developed in different parts of the world. All of these methods, however, followed the same basic principle of using a sievelike screen. Whether commercial or handmade, the basic papermaking process hasn't changed much throughout history. You still can make a simple sheet of paper with almost no equipment (see Plantable Paper on page 142) or you can recycle paper in a blender, hand-beat plant fibers, or break rags down in a Hollander beater, a professional papermaking machine that beats fiber to a pulp.

Of course, making paper with a machine is much more efficient than creating sheets by hand, but handmade sheets are unique with their deckled (feathered) edges and variations of content, thickness, and color. In addition, when you make paper by hand and work on a small scale, you can add subtle changes to a sheet during each step in the process.

ABACA: THE INCREDIBLE SHRINKING SCULPTURAL MATERIAL

When I make paper by hand, my favorite fiber to work with is abaca, a plant from the banana family that is also known as Manila hemp. I process abaca in a beater and turn it into sheets of paper that are smooth enough to draw on, supple enough to fold into book pages, and strong enough to construct into sculptures and installations.

Helen Hiebert, artist-made abaca sheets.

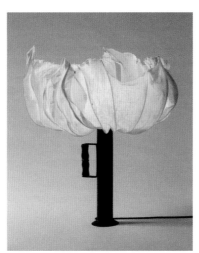

Helen Hiebert, *Naval Bloomer Lamp*, 1995. Artist-made abaca with embedded wire, found object base; 18" × 14" × 14".

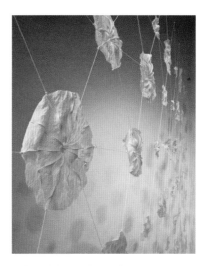

Helen Hiebert, *The Hydrogen Bond* (detail), 2008. Artist-made abaca paper, hemp thread; 96" × 288" × 2".

IN BETWEEN: MOULD-MADE PAPER

Mould-made papers fall in between hand- and machine-made paper. Made on a machine from high-quality pulp, these papers often have deckled edges on one or two sides of the sheet and more texture than commercial papers. They combine the consistent quality of machine-made paper with the individual character of handmade sheets—at a lower cost than true handmade paper. Many commercial mills produce a line of mould-made sheets for artists working in watercolor, drawing, and printmaking.

Paper Properties

One of the first things you probably notice about any kind of paper is how it looks. But when you are crafting with paper, there are other factors you might wish to consider, including what the paper is made of; its surface finish and texture; its weight, size, and shape; whether it has sizing (a liquid coating that keeps ink and other media on the surface); and whether it is pH neutral, which prevents the fibers from breaking down over time.

Many commercial paper companies will send you samples for free or for a small fee. Just as with clothing, papers go in and out of style. Some are always available, while others have a short shelf life—and new papers are being developed all the time.

Each project in this book lists the name of the paper used to make the photographed example, but feel free to experiment. Most of the projects can be made with a variety of papers, and I have explained what properties to look for to make your project a success. Before making a finished work of art that you'd like to last a long time, though, I suggest testing the paper you would like to use. In addition, I recommend making a model of the project with scrap paper before you make it with an expensive sheet.

Fiber Content

Commercial papers are made from a range of fibers. Wood pulp is used to make most of the papers we encounter on a daily basis, including newspapers, magazines, and inexpensive office and stationery products. These products are often recycled and given a new life. Many fine stationery and art papers are made from 100 percent cotton rag. In addition, decorative art papers are produced around the world using fibers that are abundant and available. Traditional handmade papers in both Japan and Korea, for example, are made from the inner bark of shrubs, the most common of which is paper mulberry (*Broussonetia papyrifera*), called kozo in Japan and dak in Korea. (For more about traditional Japanese and Korean papers, respectively, see Paper Thread on page 232 and Bojagi Curtain on page 210.)

THE HAIRY TIMES

If you make paper by hand, you have a wide range of fibers at your fingertips. *The Hairy Times* is a handmade newspaper that artist Diane Jacobs created out of shredded newspapers. For Jacobs, it represents the media's failure to hold the government accountable and ask hard questions.

Diane Jacobs, *The Hairy Times*, 2005. Handmade paper from shredded *Los Angeles Times* and *New York Times*, human hair, letterpress text; 14" × 15" × 2½".

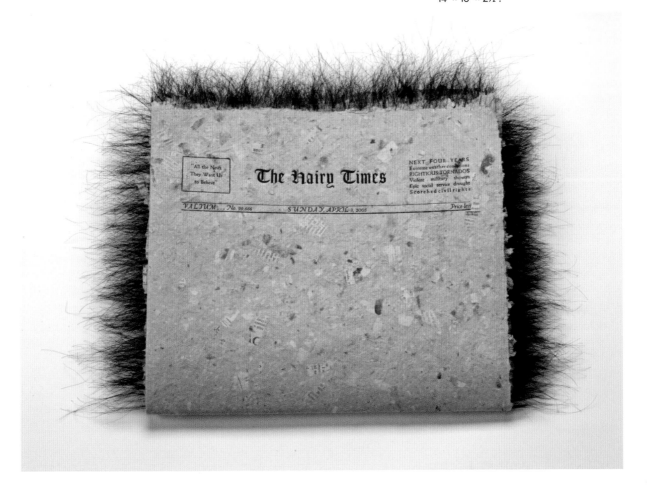

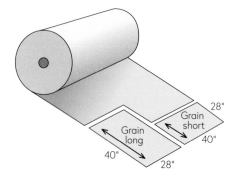

Grain Direction

Commercial paper has a grain, like wood does, and it is important to pay attention to the grain direction when you are folding paper. When paper is manufactured commercially, the fibers align in the direction of flow on the machine that produces large paper rolls. These rolls are cut down into sheets, and generally the longer dimension indicates the grain direction. For example, on a 28 × 40-inch sheet, the grain runs in the 40-inch direction. In some cases, the paper grain runs parallel to the shorter dimension, in which case it is referred to as grain short.

If you fold "against the grain," your book or card might not close properly, or the paper might crack along the fold. In general, you want the grain running in the direction of the most folds in each project (parallel to the spine of a book, for example). Some projects require you to fold in multiple directions, so it is important to choose a paper that will accommodate all of these folds, even the ones that go against the grain. Handmade papers do not have much of a grain, and origami papers are thin enough to handle folds in many directions.

TESTING PAPER GRAIN

Here are a few different ways you can determine a paper's grain direction.

BEND TEST. Bend the paper and see which direction has less resistance. The grain runs in the direction with least resistance. The bend test works well on thicker papers.

FOLD TEST. Fold a sheet of paper in half in both directions. The paper will fold more easily and smoothly going with the grain. Going against the grain, the paper may crack or be more resistant to folding.

TEAR TEST. Tear the sheet in both the longitudinal and latitudinal directions. The pattern of the tear will be straight when parallel to the grain and jagged across the grain.

Surface/Edge

Machine-made paper often has a subtle woven texture that is noticeable on the finished sheet. This pattern is created by the machine's wire mesh cylinders that carry the wet paper fibers. Other textured finishes such as embossed patterns are created using rollers on the papermaking machine late in the papermaking process.

Traditional Western handmade paper is formed on a mould and deckle, resulting in either a laid or wove surface. (In papermaking terminology, the wire patterns are referred to as laid or wove.) Early moulds were made with strips of wire that spanned the wooden frame of the mould in one direction; paper made on this type of surface is called laid paper. Ultimately, it became much quicker to produce woven wire screens, which give the paper a woven surface. Eastern papers are often dried on boards and, as a result, pick up a subtle wood grain surface. And because handmade paper is created one sheet at a time, it has deckled edges, which are rough and feathery borders.

Didactic paper mould and deckle by Tim Moore, showing laid and wove surfaces

EAST VS. WEST

Paper was first made in the East, in the areas that are now China, Korea, and Japan, then migrated west, reaching Europe and finally the Americas. The methods, tools, and materials used in Eastern and Western papermaking traditions varied, depending on the types of plants (for papermaking fiber) that grew in each region and the technologies of the times.

Eastern traditions tended to use a flexible screen surface held taut when forming sheets with multiple dips into the vat. Western traditions usually employed a permanent taut screen surface and one dip into the vat to form a sheet of paper.

Many of these traditions have diminished or become extinct, but there are still papermakers around the world using age-old ways of making paper by hand. And, as is the case with most crafts, a multitude of contemporary adaptations exist.

Paper Thickness and Weight

Commercial paper is identified by weight, with separate metric (grams per square meter, or gsm) and US (pounds, lb., or #) standards for measuring paper thickness (see Paper Weight Explained, at right).

In addition, papers are commonly categorized by *text weight* or *cover weight*: Text weights are relatively light and are used for book pages and office papers, while cover weights (also commonly referred to as card stock) are stiffer papers used for paperback book covers, brochures, and greeting cards. Papers that are thicker and heavier than card stock are used in printmaking and for watercolor and drawing.

For most of the projects in this book, I include the weight(s) of the papers used in the photographed samples, but you don't need to worry about using the exact same paper for your version. The best way to choose paper for a particular project is to handle it and test it. Over time, you will develop a feel for the weights of paper you like to work with.

Archival Paper

Most commercial papers are made from wood fibers that are treated with acidic or alkaline chemicals to get rid of the non-cellulose material in the wood. Over time, these chemicals (no matter what their pH) cause the cellulose in paper to break down, and it becomes discolored and brittle. This kind of decay isn't a concern if you don't need paper to last, but it is a primary concern for artists and conservators who want their work to be preserved for hundreds of years. Archival paper has a neutral pH and will not deteriorate over time. Most of the papers used for the projects in this book are not archival, but the projects could certainly be made with pH-neutral papers if you so desired.

PAPER WEIGHT EXPLAINED

The commercial paper industry uses standard weights used to identify paper thickness. In the United States, this is called the basis weight and is calculated by measuring the weight (in pounds) of a ream (500 sheets) of paper cut to the "basic size" for that particular grade of paper. Each grade of paper—such as text and cover—has its own basic size. For example, the basic size of book paper (used in the printing of text and trade books) is 25" × 38". If 500 sheets of book paper at the basic size weighs 80 pounds, then the basis weight is 80 pounds.

When that same exact paper is cut down to letter size and packaged, it still is referred to as 80 lb. paper. It is important to note that an 80 lb. text paper is completely different in weight from an 80 lb. cover paper. In this system, higher numbers don't always equate to heavier paper. For example, a sheet of 100 lb. text paper is thinner than a sheet of 80 lb. cover stock.

In the metric world, grams per square meter, or gsm, is determined by weighing one sheet of a particular paper that is cut to one square meter in size. The higher the gsm number, the heavier the paper. You can find conversion charts online if you need to make a comparison between pounds and gsm.

Point sizes, as measured by a tool called a micrometer, are another way to indicate the actual thickness of a sheet of paper. Micrometers measure the caliper, or thickness, of a sheet of paper in thousandths of an inch, which is expressed in points. One point equals 0.001". For example, a 10-point card stock is 0.010" thick. In general, the greater the caliper, the thicker the paper.

PAGING THROUGH PAPER'S HISTORY

The first papers were made in China about 2,000 years ago. News of how paper could be made traveled along the Silk Road through Asia and into Europe and eventually made its way to North America. The industrial revolution came shortly after colonization, so hand paper-making didn't have a very long life in the New World before it was replaced by machines. In contrast, paper was made by hand for centuries in other parts of the world before papermaking was mechanized, and today it is still made by hand in many countries, although on a much smaller scale than previously.

Historically, paper has had many functions: In Japan, handmade washi (*wa* means "Japanese" and *shi* means "paper") was used to make paper thread that was spun into cloth, then woven into clothing (see Paper Thread on page 232). Paper was made into functional objects for the home, such as screens and lanterns. And during World War II, Japan produced hot-air balloons with handmade sheets to carry bombs to America (and some arrived; see *Japan's World War II Balloon Bomb Attacks on North America*, by Robert C. Mikesh, and Ilana Sol's documentary movie, *On Paper Wings*). Korean hanji (literally translated as "paper made in Korea") was used to create many items, ranging from floor and wall coverings to fans. As paper made its way to the West, it was increasingly used as a medium to carry messages, in letters, official documents, newspapers, and books.

Traditionally, European printmaking was based on a studio system with artists working in ateliers under master printers. Several similarly fashioned papermaking studios began in the United States in the 1970s. Many, including Twinrocker Handmade Paper in Indiana, Dieu Donné in Brooklyn, and Magnolia Editions in California, are still in operation.

In the 1960s and 1970s, as printmakers in the United States became interested in the substrate they were printing on and discovered they could make paper themselves—varying the shape, color, texture, size, and more—classes on hand papermaking began to creep onto college campuses. When he was still a young artist, Laurence Barker spent a couple of weeks with legendary papermaker Douglass Howell in the late 1960s and then taught the first college-level papermaking class at the Cranbrook Academy of Art in Michigan. Barker attributes Howell with "letting the cat out of the bag" when it came to popularizing

Douglass Howell, *Synchronic Drawing*, 1966. Linen rag paper with embedded thread, watercolor; 12" × 9".

papermaking as both an art form and an educational pursuit. Today, there are papermaking programs in many higher education institutions, usually housed in fiber arts, book arts, or printmaking departments. Paper is so versatile.

Dieu Donné is a nonprofit organization in New York City dedicated to developing hand papermaking as an artistic medium. Since 1976, Dieu Donné has shared this unique process with artists, from aspiring students to contemporary career professionals. Here, Amy Jacobs (co-director of artistic projects and master collaborator, at left), Caledonia Curry (artist, professionally known as Swoon, second from left), and Mai Ohana (studio assistant, center) view four just-completed 40" × 60" abaca sheets with various pigmented pulp layers on top, which form the basis for a large wall piece.

Swoon, *Paulie*, 2019. Pigmented linen, abaca, and cotton paper; 120" × 96".

This rotary boiler disgorges a load of cotton or flax after it has been cooked to remove impurities.

The "dry end" of the paper machine at one of the Crane currency paper mills in Dalton, Massachusetts, producing paper for United States currency

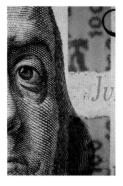

A close-up of the engraved portrait of Benjamin Franklin and the 3D embedded security thread on the $100 bill

CRANE & CO.

There aren't too many paper companies around today that started out making paper by hand, transitioned to machine production, and remain a viable business more than 200 years later.

In 1770, craftsman and entrepreneur Stephen Crane founded the Liberty Paper Mill with two partners near Boston. One of Crane's first customers was Paul Revere, who used Crane paper for his engraved banknotes, which helped finance the American Revolution. Stephen Crane's son Zenas moved the company in 1799 to the small Berkshire town of Dalton, Massachusetts, where U.S. paper currency is still made.

Crane & Co. was at the forefront in the fight against counterfeiting currency and developed a method to embed parallel silk threads in banknote paper. The company became the only one in the United States to not only make sophisticated banknote paper but also develop and manufacture the currency's security features in-house.

Crane currency paper has long been made from a mixture of cotton and linen. In the early days, these raw materials came from used household rags. Today, the company sources fibers from around the world, buying waste fibers from textile companies. In addition to banknotes, Crane used to produce men's collar paper and tracing paper. Government proclamations, stocks, and bonds have also been printed on Crane paper. And since the United States Postal Service began delivering mail, Crane & Co. has been a leader in the letter-writing business, producing specialty stationery such as gold-leaf cards and envelopes lined by hand, as well as personalized notecards and sheets.

Operations for both the currency and stationery businesses remain in the northeastern United States, but they have been under different ownership since 2018.

Where to Find Paper

Paper is a material that we come into contact with multiple times every day—so often, in fact, that most of us don't even think about where it comes from. I didn't until I took an art class in college where we threw a mixture of recycled papers into a blender and created our own hand-made sheets. After that, I couldn't stop thinking about paper.

Specialty papers are sold for graphic design, printing, stationery, and more (see page 275 for a list of where you can purchase fine papers). But there are many papers right at your fingertips, and some you don't even have to purchase. Here are some creative places to find paper.

From back to front: die-cut vintage paper with gel prints by Gina Pisello; persimmon-dyed vintage paper from Japan (courtesy of Gina Pisello); recycled security envelope paper; map paper; and joss paper (courtesy of Jade Quek)

Recycle It

In addition to your own recycling bin, you might find interesting papers at library sales, garage sales, used bookstores, and secondhand shops (not to mention your attic or basement). Look for:

- Magazines
- Brown paper bags
- Printed ephemera, such as postcards and calendars
- Maps
- Pages from old or used books, including dictionaries and encyclopedias
- Wrapping paper
- Packing materials
- Envelopes
- Office papers, including copier paper, graph paper, notebook paper, and file folders
- Wallpaper
- Historic papers

Buy It

You can purchase all sorts of amazing papers at art supply stores, scrapbooking stores, and specialty paper shops. You can often find unique papers when you travel, and even when you're not traveling, you can likely find paper from all around the world thanks to large and small distributors that import them. There is also a growing number of online outlets for all kinds of unique papers, although you may be reluctant to make a purchase online without touching and feeling a paper first.

From back to front: decorative Indian cotton rag papers from Shizen Design (sheets 1–4); and origami paper

Do It Yourself

Turn to page 246 for a visual guide to decorative papers that you can try making yourself. In addition, several books in the reading list on page 277 will help you delve deeper into a variety of papermaking techniques.

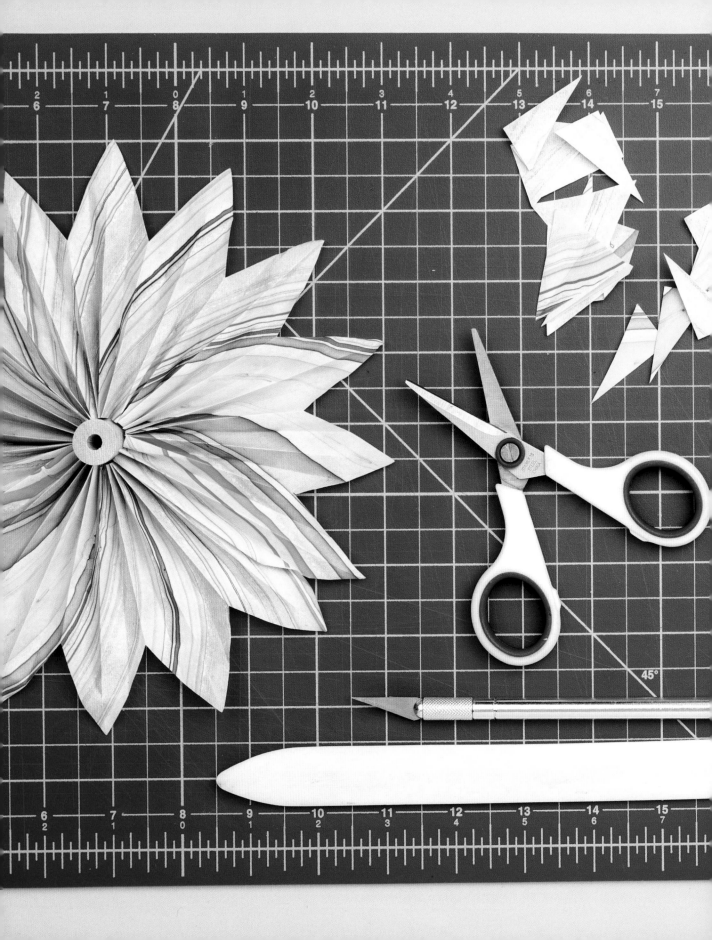

Paper-craft Skills

ONCE MACHINE-MADE PAPER was widely available starting in the early 1800s, it became the perfect material for many kinds of arts and crafts. The following pages offer an overview of the ways paper has been and continues to be explored as a material. Then you'll learn some folds and tips for working with paper.

The Versatility of Paper

Josef Albers with his class at Black Mountain College in North Carolina

PAPER FOLDING traditions developed around the world over the centuries. Friedrich Froebel, who started the German kindergarten movement in 1837, developed a set of 20 "gifts" designed to educate young children. Several of the gifts involved paper, and these could be the first educational uses of paper. We may have Froebel to thank, then, for helping to spark movements in papercraft and paper art that continue today.

Some of the instructors at the Bauhaus, a progressive German art college founded in 1919, most likely went to kindergartens that incorporated Froebel's teachings. For example, Bauhaus instructor Josef Albers had his students explore paper as a material. Eric Gjerde is a contemporary paper artist who re-created a series of models based on the Bauhaus explorations (see page 124).

Long before either kindergarten or the Bauhaus existed, early forms of origami (the Japanese word for paper folding) were used in Japan for religious or ceremonial purposes, as handmade papers were a luxury item. Akira Yoshizawa was a Japanese origami artist who popularized the craft in the twentieth century by inventing thousands of unique designs and is credited with bringing origami from a craft to an art form. Paper folding has steadily evolved over the past several decades, and artists are continually inventing new ways of folding.

RESPECTING PAPER AS A MATERIAL

On the hundredth anniversary of the Bauhaus founding, the Berlinische Galerie (Berlin's modern art museum) held an exhibition called *Original Bauhaus* and published a book by the same name. The book included a description of an exercise Josef Albers gave his students: After distributing a stack of newspaper among the students, Albers encouraged them to make the most out of every material they encountered.

To do so, Albers said, you have to really understand what a material can do. He then instructed his students to experiment with the newspapers without aiming to make anything specific. "At the moment we prefer cleverness to beauty," Albers said. By trying to do more with less, he encouraged his students to think constructively and creatively. "I want you to respect the material and use it in a way that makes sense—preserve its inherent characteristics," he said. "If you can do without tools like knives and scissors, and without glue, the better. Good luck."

In addition, scientists are using origami combined with technology to solve real-world problems. In the 1990s, based in part on models of curved creases that Bauhaus students created, a field emerged called computational origami, which uses computer programming to model ways that various materials—including paper—can be folded. At the Massachusetts Institute of Technology, father-and-son team Martin and Erik Demaine are exploring what shapes are possible in the genre of self-folding origami, with applications to deployable structures (for example, space satellites), manufacturing (as an alternative approach to 3D printing), and self-assembly (for example, medical devices for drug delivery within the body). This transformation of flat paper into swirling surfaces also creates sculpture that feels alive.

Robert J. Lang (page 78) is a pioneer of the newest kind of origami, using math and engineering principles to fold incredibly intricate designs that are beautiful and, sometimes, very useful. He has consulted on applications of origami to engineering problems ranging from airbag design to expandable space telescopes.

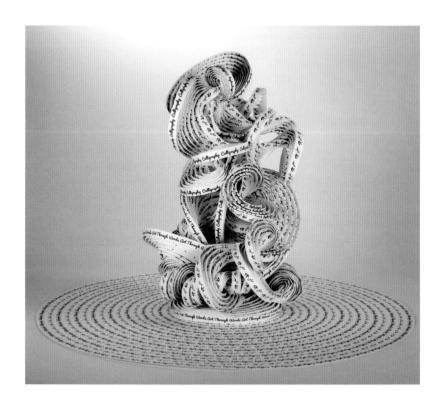

Erik Demaine and Martin Demaine,
***Art through Words*, 2015.** Canson
Mi-Teintes watercolor paper; 8" × 8" × 12"
sculpture resting on 18" × 18" print.

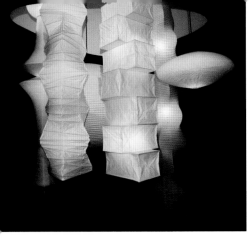

A selection of **Isamu Noguchi's Akari** lights, the collapsible paper structures he designed in the 1950s for the city of Mino, Japan

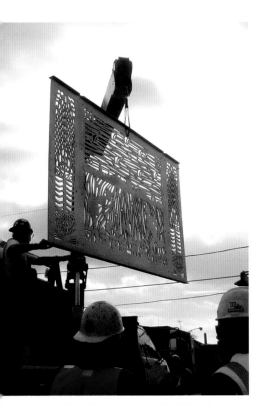

Béatrice Coron, *Seeds of the Future Are Planted Today*, 2004. Stainless steel decorative fences; 72" × 120", Kostner subway station, Chicago.

PACKAGING AND GRAPHIC DESIGN also began with the mechanization of paper production in the nineteenth century. Unfold an envelope, a cereal box, or just about any kind of package, and you will often discover that it is created from a single sheet. Creating an object from a single sheet is economical, and because machines can cut, score, and fold, many parts of the process can be mechanized.

Self-proclaimed folding fanatic Trish Witkowski shows off a clever printed design every week on her popular YouTube channel, *Fold Factory*. And Paul Jackson (page 54) has written numerous books that diagram various ways to cut, fold, pleat, and otherwise manipulate paper. In addition, paper often shows up in other areas of design such as architecture and lighting. Architect Shigeru Ban constructs parts of buildings, including Colorado's Aspen Art Museum, from cardboard, and in the 1950s, artist Isamu Noguchi revived the ancient lantern-making tradition in Mino, Japan, by creating a series of collapsible paper sculptures called Akari lights, which are still produced today.

PAPER CUTTING made its way from east to west starting in the sixth century, with strong traditions developing in what are now China, Japan, India, Israel, Poland, Switzerland, Germany, and Mexico. Henri Matisse created large-scale paper cuts later in his life, and today paper cutting is a popular art form, due in part to the advancements in cutting machines. Many artists still do amazing cuts by hand, including Béatrice Coron (page 128), who cuts designs in paper, then has them fabricated in glass, metal, and other permanent materials.

PAPER ENGINEERING, the creation of pop-up paper art and movable books, has a long history. Some of the earliest paper movables were designed in the form of volvelles, or rotating paper disks, that served as simple calendars. Another early use of paper engineering came in the form of flaps that adhered to a page and could be lifted to reveal something underneath. Flaps were commonly used in anatomical illustrations. Pop-up books became popular in the nineteenth century, and companies in England and Europe set up specialized departments for hand assembly. Today pop-up books are still hand-assembled in factories.

In the early twentieth century, paper engineering branched out to include greeting cards and advertising, and advancements in this field continue. My Pop-Up Alphabet (page 116), Shawn Sheehy's Pop-Up Dragonfly (page 178), and Jean-Paul Leconte's Curved Flip Mechanism (page 200) each illustrate different paper engineering styles.

BOOK ARTS emerged as a new field in the 1970s as artists began exploring and altering the traditional book structures that had been in use since paper was first invented. Several projects in this book feature innovative folds and structures designed by contemporary book artists, including Hedi Kyle, Cathryn Miller, Laura Russell, Susan Joy Share, and Peter Thomas.

QUILLING, also known as paper filigree, involves strips of paper that are rolled, shaped, and glued together to create decorative designs. During the Renaissance, French and Italian nuns used rolled paper strips to decorate books and religious items. Paper quilling remains popular today, and Ann Martin shares a stunning snowflake ornament (page 218) that can be crafted from a quarter sheet of printer paper.

The creative approaches to crafting with paper that you'll find in this book don't stop there, though. On page 94, Scott Skinner's Capucheta (Paper Kite) is an example of paper that can fly; on page 232, Susan Byrd documents the tradition of making paper thread, which can be spun into cloth; and Steph Rue takes a patchworking tradition from her native Korea and applies it to paper (page 210).

For many years now, I have self-published a different paper project each month. These projects appeared first on my blog and then in a series of yearly planners called *The Twelve Months of Paper* and *The Paper Year*. Several of my projects in this book come from those publications. In addition, I picked a diverse group of guest artists—designers, tinkerers, inventors, and a physicist—to share their unique one-sheet wonders.

Each project in this book transforms a single sheet of paper in a different way. Not only will you cut and fold, you will also use paper to weave, construct, sandwich wire and house electronic components, collage, quill, and spin thread. Some of these papercrafting techniques have been around for centuries, while others are new adaptations. Our ability to perform complex calculations and 3D modeling on computers, coupled with the advancement of computer-driven tools and machines, enables us to transform paper in ways that were not possible in previous decades.

USING THIS COLLECTION

My hope is that you will use the projects in this book:

TO LEARN. Wind your way through this diverse set of projects as you explore innovative ways of working with paper.

FOR INSPIRATION. Peruse the techniques throughout the pages.

AS A POINT OF DEPARTURE. Try the projects and then push the medium further.

Fold, Set, Stitch

In several of the projects in this book you will use a few common folds and stitches and/or attach items to the paper. Try out these techniques now or refer to them when you need to when making the projects.

How to Set an Eyelet

We are familiar with eyelets as those little round metal rings that we thread shoelaces through. They can be attached to paper in fun and functional ways. Use them to reinforce holes for lacing or to add a decorative element (see Wrist Cuff on page 156). Eyelets come in a variety of shapes and sizes, and there is a special eyelet-setting tool.

1 Use a Japanese screw punch (see page 35) to make a hole in your paper that is slightly smaller than the size of the eyelet shank.

2 Place an eyelet facedown on a cutting mat. With the paper facedown, set the hole in the paper over the shank, and put the eyelet setter on top of the shank.

3 Hammer the flat top of the eyelet setter with a few forceful taps to set the eyelet.

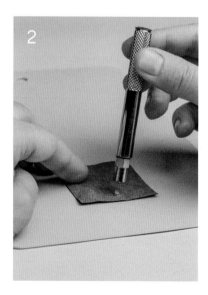

Illustration Key

Note that mountain and valley folds are relative to the way your paper is oriented. Blue indicates the display (front) side of the project paper and white indicates the back side of the project paper.

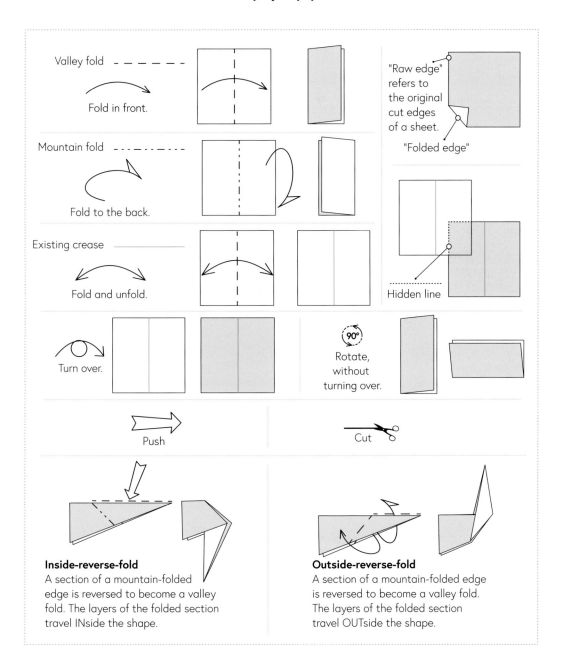

Valley fold

Fold in front.

Mountain fold

Fold to the back.

Existing crease

Fold and unfold.

Turn over.

Rotate, without turning over.

Push

Cut

"Raw edge" refers to the original cut edges of a sheet.

"Folded edge"

Hidden line

Inside-reverse-fold
A section of a mountain-folded edge is reversed to become a valley fold. The layers of the folded section travel INside the shape.

Outside-reverse-fold
A section of a mountain-folded edge is reversed to become a valley fold. The layers of the folded section travel OUTside the shape.

Valley fold

2

Mountain crease

3

4

5

6

7

How to Fold an Accordion

It is a good idea to practice a fold before you try it on your masterpiece and potentially make a mistake. I learned this technique for folding an accordion from Hedi Kyle (page 160), and there is no measuring involved. It works like a charm and creates such accurate folds.

I recommend trying this with standard printer paper to get a feel for the process. You can accordion-fold many types of paper—it really depends on how many folds you will be making. In general, the heavier the paper, the harder it will be to fold, especially multiple times. I often use a bone folder to pre-score folds and help crease the paper once it is folded, resulting in clean, crisp folds. Make sure the grain of your paper runs in the direction of the folds.

1 Fold the paper in half and crease it well.

2 Open the paper and place the peak of the mountain fold faceup, then align it with one cut edge. Crease the new folded edge.

3 Fold over the remaining cut edge so it lines up with the other edges you aligned in step 2. Crease the new fold. This makes a four-section accordion.

4 Open up the paper so the original faceup side is facing up again, and turn the center valley fold into a mountain fold. You now have three mountain folds.

5 Align the peak of the leftmost mountain fold with the nearest cut edge. Crease the new folded edge.

6 Repeat with the remaining mountain folds.

7 Fold over the final cut edge, lining it up with the folds you made in steps 5 and 6. Crease well. This makes an eight-section accordion.

8 Continue dividing each section in this manner if you wish to divide your accordion further, into 16 or 32 sections.

Three-Hole Pamphlet Stitch

This is a simple way to hand-sew one signature (a gathered section of folded pages) to make a book or to add a shoelace into a sheet of paper to create a fastener (see Shoelace Wrap-Around with Bone Attachment on page 264).

1 Fold a stack of three to five sheets of paper in half and then open and flatten the pages. Punch three evenly spaced holes through the spine of your paper signature, with the top and bottom holes positioned evenly, approximately 1" from the edges. The holes should be large enough to accommodate the string you will thread through them.

2 Cut a piece of string three times the height of the signature or sheet of paper. Thread the string through a needle.

3 Starting on the inside of the folded signature, draw the needle through the center hole. Bring the needle back to the inside through the top hole. Skip the center hole and bring the needle back out through the bottom hole. Finish by coming back to the inside through the center hole of the booklet.

4 Position the thread ends on either side of the vertical middle thread and tie a square knot (page 273). Trim the ends of the thread to approximately ½".

Working with Templates

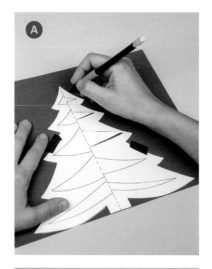

Many of the projects in this book require templates, which are available to photocopy (see pages 280–302) or to download online at www.storey.com/papercraft-projects. The templates are designed to be printed at 100 percent on standard 8½" × 11" printer paper, unless otherwise noted. To transfer a template to your project paper, you have three options:

PHOTOCOPY THE TEMPLATE IN THE BOOK onto card stock, cut out the template, and tape and trace it onto your project paper (A). Or photocopy the template onto printer paper, tape the printed template onto your project paper, and cut through both layers of paper at the same time.

LOCATE THE ONLINE FILE, download it, and print it out on card stock. Proceed as described above.

SCAN OR DOWNLOAD THE TEMPLATE, then print it onto the project paper by running it through a printer, with or without a carrier sheet.

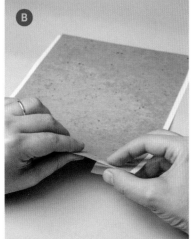

How to Print with a Carrier Sheet

1 Place your project paper on top of the carrier sheet, which can be just a standard sheet of printer paper.

2 Attach half of two pieces of transparent tape to one of the shorter (8½") edges of the project paper, about 1" in from each end. Wrap each piece of tape around, affixing it to the back of the carrier sheet (B).

3 Before printing on your project paper, I recommend printing a test copy of the template at 100 percent on regular printer paper to determine which way to feed the paper into your printer. Note whether you need to have the project paper facing up or facing down; you may also need to determine which end will become the top of your paper.

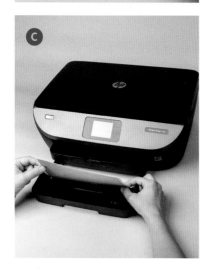

4 Orient your project paper (and carrier sheet) properly in your printer's paper tray, feeding the taped end of the two sheets into the printer first (C); so that the project paper and the carrier sheet are pulled in together), and send the template file to print.

PRINTER-FRIENDLY TIPS

I often run my project paper through a desktop printer so that I have the template right on the sheet. This is much quicker than printing the template, cutting it out, and tracing it onto the project paper.

When printing directly onto the project paper, there are a few things to consider:

WILL THE PAPER FEED INTO THE PRINTER? Thick, fibrous papers are not likely to work and could damage your printer. In addition, my printer usually doesn't recognize very thin sheets of paper. If the project paper is very thin, I have had success attaching it to a standard sheet of printer paper (a carrier sheet) with tape (see the instructions at left).

WHAT SIZE PAPER SHOULD YOU USE? I always cut my project paper to the standard 8½" × 11" sheet size for my printer. All of the templates in this book are formatted for this size, unless otherwise noted.

WILL THE PRINTED TEMPLATE LINES APPEAR ON YOUR FINISHED PROJECT? In some cases, you can print on the back of the project paper. If lines are printed on the display side of the paper, you can cut slightly inside of the printed lines so that they will be removed.

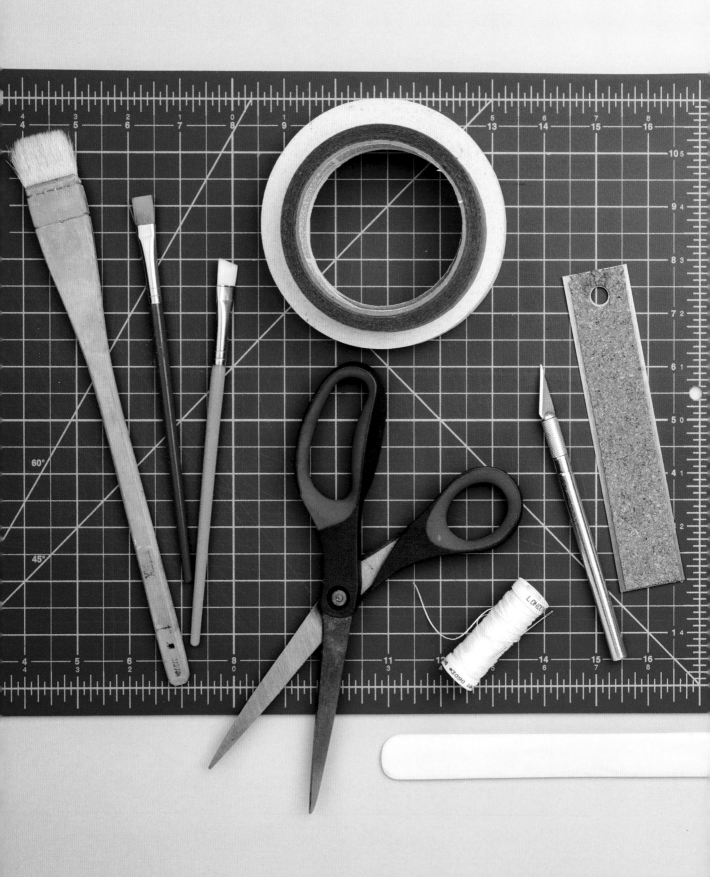

Tools & Materials

A SHEET OF PAPER AND YOUR HANDS are all you need for some of the projects in this book, like the origami projects. Most of the other projects require tools you probably own, and a few require specialized items. As with any art practice, you can start simply and build up your tool collection over time. You can also get creative and find substitutions for certain tools.

Folding and Scoring Tools

Before you fold a heavier-weight piece of paper, it's wise to score it. A **bone folder** is a common bookbinding tool used for this purpose. Position a ruler on the paper where you want the fold to be and run the pointed end of a bone folder along its edge to create a straight crease.

Bone folders are often made from cow or deer bone, though some are made out of wood, plastic, or Teflon (which are great because, unlike bone folders made from bone, they don't leave a mark on your paper when you reinforce a fold after creasing). You can also purchase a scoring board to help you score lines cleanly and accurately. In a pinch, you can use the back of a knife or a paper clip to score paper.

No matter what tool you use, it is often helpful to place the paper on a cutting mat or a piece of cardboard to cushion the paper when scoring. Using too much pressure could tear the paper, so it may take a bit of practice to get the hang of it. I sometimes use a micro spatula or a paper piercer to score lines on very thin papers, such as those used for the Bojagi Curtain (page 210). Micro spatulas also come in handy for lifting or tearing paper and applying adhesives, among other tasks.

Many tools exist that can help you make straight folds and cuts. For each project you work on, use the type and size of straightedge that will give you the best results. For instance, I have **rulers** ranging in length from 6 to 36 inches. For measuring, I like to use a transparent graph ruler because it has a printed-on grid, which makes plotting and drawing parallel lines very easy. I prefer to use a metal ruler for cutting because a plastic ruler can fray when you run a craft knife along the edge. I recommend using a metal ruler that has cork on the back to help prevent the ruler from slipping as you cut. In addition, you will find that a plastic or metal **triangle** can come in handy when plotting, cutting, and scoring angles. Use a spring divider (which looks like a double-pointed compass) when you need to mark a certain dimension several times.

TIP

Make sure you always have a pencil and eraser on hand for marking accurate folds and cuts on your project paper. I like to use mechanical pencils and have both a kneaded eraser and a white eraser for working with various papers.

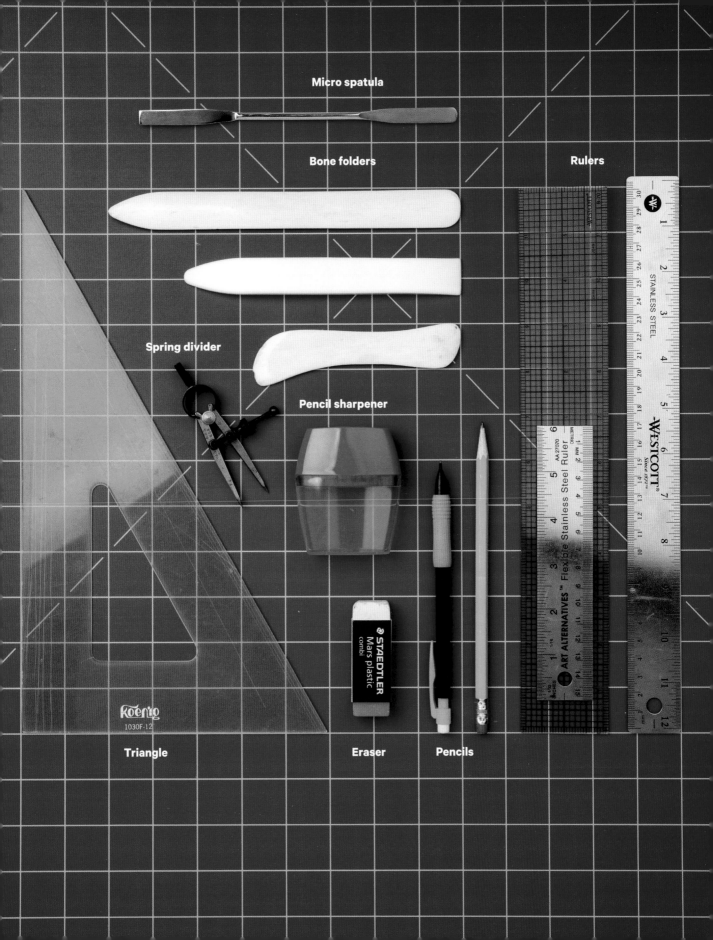

Micro spatula

Bone folders

Rulers

Spring divider

Pencil sharpener

Triangle

Eraser

Pencils

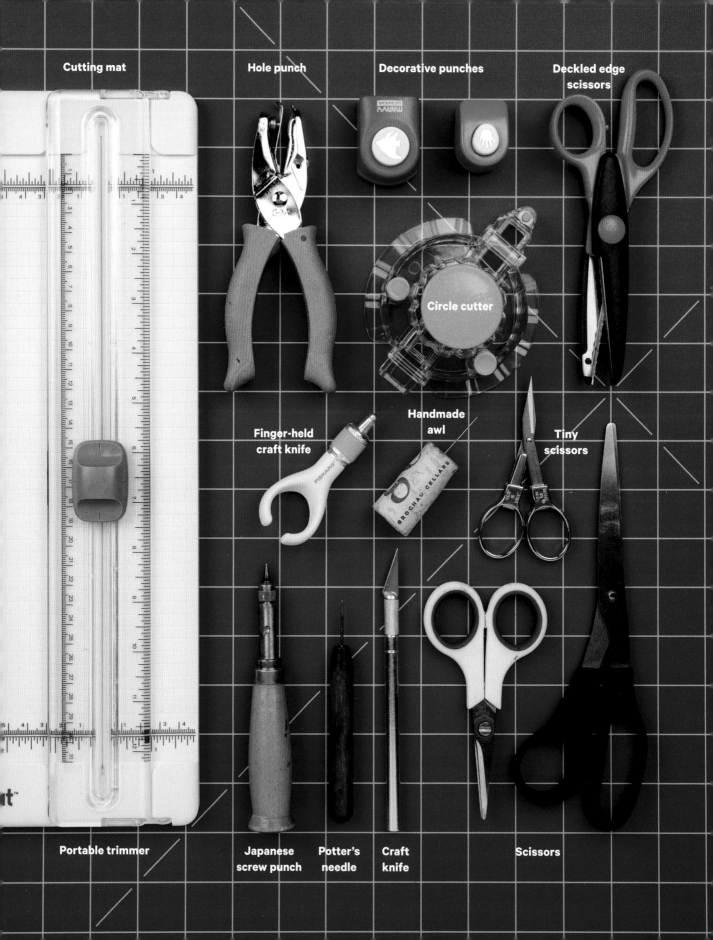

Cutting mat

Hole punch

Decorative punches

Deckled edge scissors

Circle cutter

Finger-held craft knife

Handmade awl

Tiny scissors

Portable trimmer

Japanese screw punch

Potter's needle

Craft knife

Scissors

Cutting Tools

The most basic cutting tool, of course, is a pair of **scissors**. I have an assortment of scissors: a standard 8-inch pair (sewing or multimedia scissors), a child-size pair, and a tiny pair for making intricate cuts. There are also scissors that cut deckled edges in paper (similar to pinking shears) and rotary tools (used for fabric).

You also will need a **craft knife** for many of the projects in this book. I prefer to use craft knives with a replaceable #11 blade, which are inexpensive and easy to find, but there are many kinds of knives you can use in papercrafting, including scalpels, swivel tips, and one that has an index fingertip handle. No matter what kind of knife you use, replace the blade often—a sharp knife cuts best—or better yet, get a whetstone and sharpen your blade each time you use it. There are good videos online that show you how to do this.

When you are using a craft knife, use a **cutting mat** to protect your work surface and keep your blade from getting dull too quickly. Cutting mats come in many shapes and sizes: I've seen them as small as 4 × 4 inches and up to 4 × 8 feet!

Portable trimmers, commonly used for scrapbooking, work really well for cutting small sheets one at a time. In my studio, I have a small paper cutter with a swinging blade for cutting small sheets to size. You can also use a pasta machine to cut multiple strips of paper!

On the other end of the technology spectrum, digital equipment has revolutionized what can be done with paper. Desktop laser cutters and smart cutting machines can cut out and score papers with precision. And if you use these tools in tandem with certain computer programs, you can design and create intricate cutouts that could not be cut by hand.

Use a thin **awl** or a **potter's needle**—or make your own by poking a needle into a cork—to punch tiny holes. Alternatively, try an unthreaded sewing machine to make a row of holes in a flash. Handheld hole punches—including leather punch sets—are great for making shapes and holes close to the edge of a sheet, but my favorite is the **Japanese screw punch**, which has interchangeable punches in various sizes and allows for punching holes anywhere on a sheet. **Decorative punches** come in a variety of shapes and are easy to use. When you need to cut perfect circles, use a **circle cutter**. This tool requires a steady hand and frequent blade changes and must be used on a cutting mat.

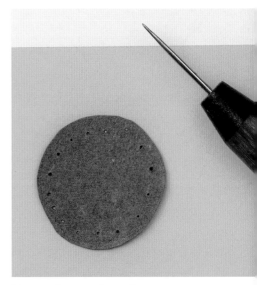

Use an awl or potter's needle to pre-punch small holes for any hand-sewing and crocheting on paper, being careful to make the smallest hole possible in any given situation.

To mark points where craft knife cuts begin and end, use a bookbinding awl or Japanese screw punch with the smallest bit.

Adhesives and Glues

There are so many adhesives on the market, but these are the ones I used to create the projects in this book.

PVA (polyvinyl acetate) is white glue that dries clear and is archival. I love using a miniature glue applicator because it allows me to apply a thin bead along the edge of a sheet or in small spaces. I sometimes apply PVA glue with the applicator and then spread the glue with a brush.

Pastes have a thinner consistency than PVA, making them a good option for spreading over large surfaces, such as when you laminate two sheets together. For the Bendable Paper Sculpture on page 166, I mixed PVA (for strength) with methyl cellulose (for spreadability; see the glue mix recipe on page 38). Methyl cellulose, wheat paste, and rice paste all come in powder form, are available from bookbinding suppliers, and have to be mixed prior to use. Konnyaku is another paste that has a light adhesive quality, but it is mainly used to coat paper and stiffen it, specifically when making momigami, a type of Japanese paper traditionally softened by coating and crumpling.

Brushes come in all shapes and sizes, from inexpensive children's paintbrushes to high-end brushes made with animal hair. At art stores and hardware stores, you can find bristle brushes and foam brushes for all types of applications, including applying glue or paint or dampening paper with water.

Glue sticks are useful for temporary gluing and when adhering thin papers. Some glue sticks dry up quickly and become useless, and there are archival glue sticks as well.

Double-sided tape is thin and works well for laminating sheets of paper together. I always use archival tape, which has a removable strip on the back. You can also use adhesive-backed film, which comes in sheets or rolls, if you need to adhere a large area and want to avoid adding moisture from glue to your work.

Artist's tape and blue painter's tape are usually repositionable and don't leave a residue, making them perfect options for temporary connections. If the tape is stickier than I want and doesn't come off easily, I touch the tape once or twice to my clothing (which makes it a bit less sticky) before applying it to the paper.

NEAT AND TIDY

No matter what kind of glue or paste you use, it is a good idea to put **scrap paper** underneath your work. I use newsprint, old phone book pages, and freezer paper. In addition, have a damp towel or a wet paper towel nearby to wipe glue off your fingers.

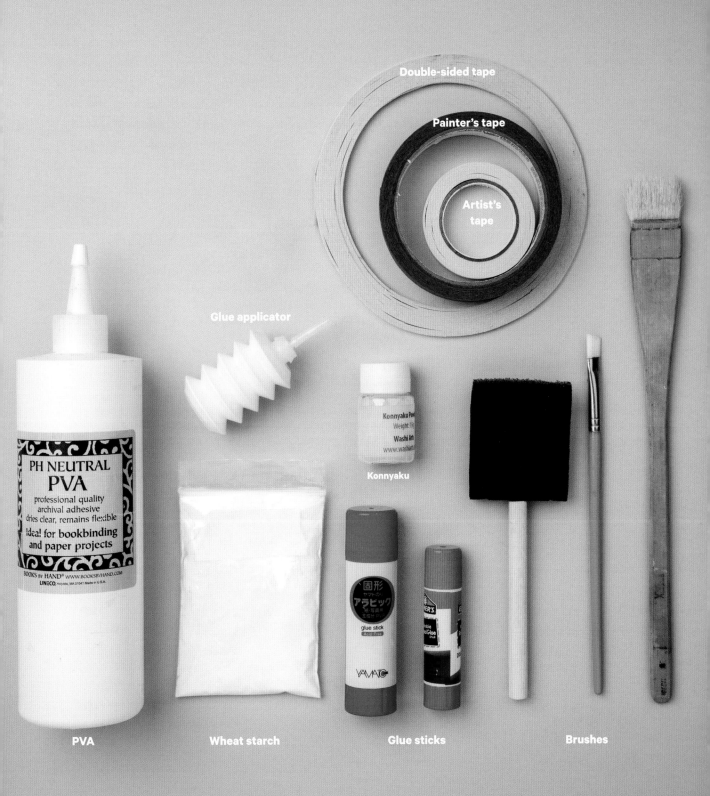

Double-sided tape

Painter's tape

Artist's tape

Glue applicator

Konnyaku

PH NEUTRAL
PVA
professional quality
archival adhesive
dries clear, remains flexible
Ideal for bookbinding
and paper projects

PVA

Wheat starch

Glue sticks

Brushes

Glue Recipes

The following recipes are referenced in projects in this book. I know they work, but there are many adhesives out there, so feel free to make substitutions if you have favorite adhesives that you use on a regular basis. I usually try to mix just the amount I need for a particular project, because most of these glues do not keep for long once mixed with water.

Methyl Cellulose

There are generally directions on the packaging, but this is the recipe I use for the Bendable Paper Sculpture on page 166.

- **4 teaspoons methyl cellulose powder**
- **1 cup water**

Sprinkle the methyl cellulose powder into ½ cup of boiling water. Stir vigorously to dissolve the powder. Add ½ cup of cold water, stir again, and refrigerate overnight. Keep refrigerated.

Glue Mix

This is a general recipe and the exact quantities will vary depending on the consistency of your glues. You'll need about ½ cup of this mix for the Bendable Paper Sculpture.

- **2 parts liquid methyl cellulose (from above recipe)**
- **1 part PVA**

Start with ¼ cup of liquid methyl cellulose mixed with ⅛ cup PVA. This yields ⅜ cup of the mixture.

Apply the mixture to one side of a small test swatch of paper. Sandwich one or two wires between the swatch and another sheet the same size to make sure they stick together. If the glue spreads well and adheres, you're good to go. If it is too thick, add more methyl cellulose; if it isn't sticky enough, add more PVA.

Wheat Paste

You can find wheat starch (for cooking) in Asian grocery stores, and bookbinding-grade wheat starch is available from bookbinding suppliers. If you purchase wheat starch, follow the cooking directions on the package. The Bojagi Curtain on page 210 requires so little wheat paste, though, that Steph Rue offers this microwave alternative.

½ cup distilled water
2 tablespoons wheat starch

Put the water in a glass measuring cup and sift in the wheat starch while whisking to combine. Set the microwave for 2 minutes. After about 90 seconds, the paste mixture will start bubbling up. (Keep an eye on it through the microwave window. Every microwave is different, and your paste might start to bubble up sooner.) Right before it looks like it will bubble over, open the microwave door and let the bubbles settle. Close the door and resume cooking until it bubbles up again. Open the microwave door and let the bubbles settle. Close the door one last time and cook the mixture until it bubbles up again. Remove the paste from the microwave and stir. Let cool on the counter for several hours.

If your paste has lumps, strain it once or twice through a fine metal sieve to remove any lumps, and thin it down with distilled water if necessary. The paste is now ready to use. Mix it well with your brush before applying.

Specialty Tools and Materials

You will need a **needle and thread** for a few of the projects that require sewing. Sometimes I use a **sewing machine** to stitch and pierce paper. You'll also need a **hammer** to set eyelets, grommets, and snaps (each of these usually come with their own setting tools) and a **drafting compass** for drawing circles and partial circles.

Perhaps you have a box filled with notions—get creative and turn them into unique embellishments and fasteners. Many of the items shown at right are used in the fasteners section that starts on page 260. These specialty items can be found at bookbinding suppliers, hardware stores, sewing shops, stationery stores, or online.

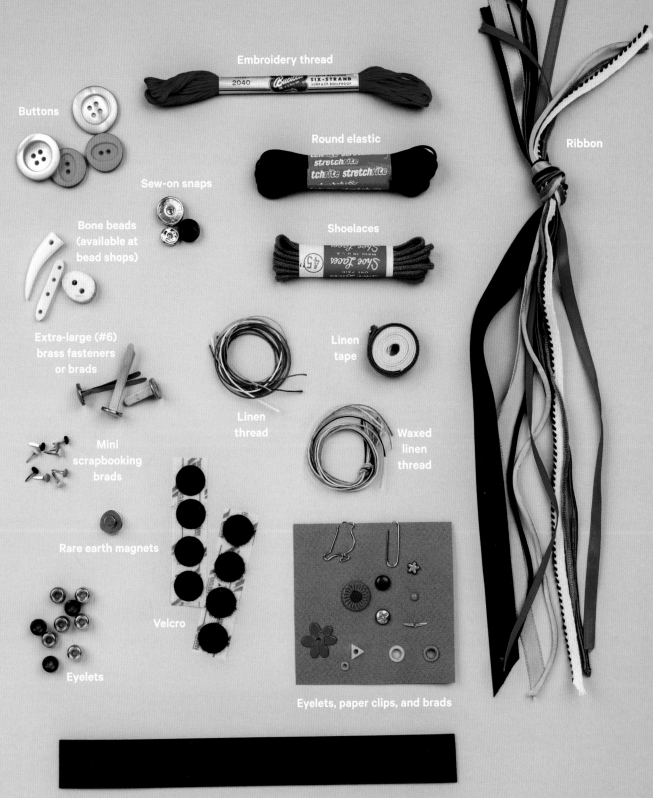

Embroidery thread

Buttons

Round elastic

Ribbon

Sew-on snaps

Bone beads
(available at
bead shops)

Shoelaces

Extra-large (#6)
brass fasteners
or brads

Linen
tape

Linen
thread

Waxed
linen
thread

Mini
scrapbooking
brads

Rare earth magnets

Velcro

Eyelets

Eyelets, paper clips, and brads

Rubber magnet strips

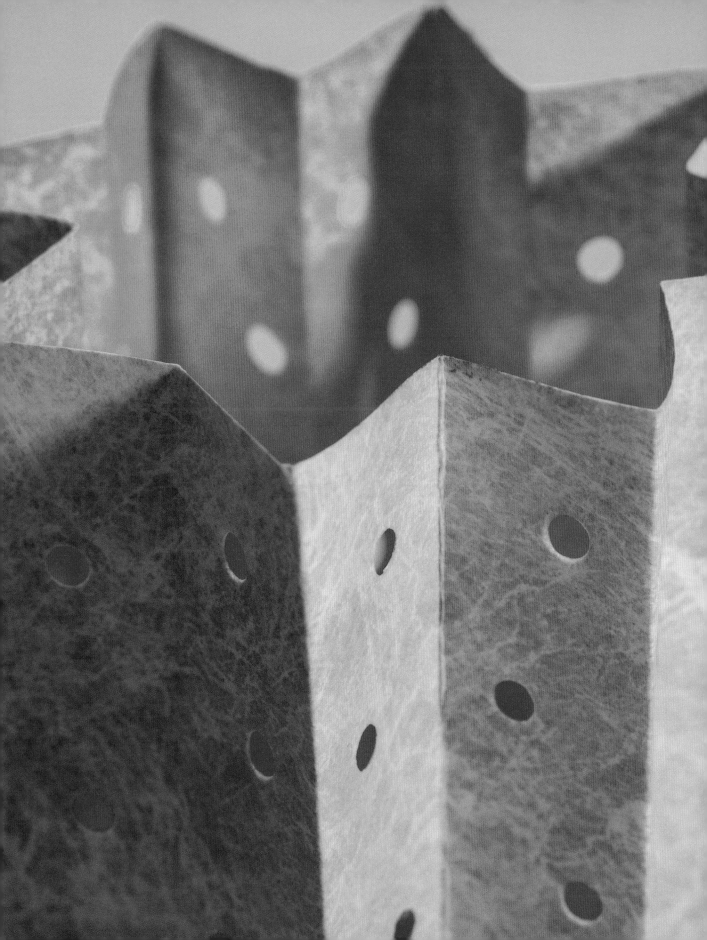

Folding
Origami, Accordions &
Simple Folded Structures

FOLD ANY SHEET OF PAPER IN HALF and what happens? It diminishes in size, it becomes a folding card or a four-page book, and it gains structure, allowing it to stand up (provided there isn't a gust of wind). The following projects explore a variety of ways to fold sheets of paper, transforming them from ordinary sheets into extraordinary objects.

Origami Candy Dish

DESIGNED BY Trinity Adams
PAPER USED Chiyogami Prints double-sided origami paper
LOOK FOR Any origami paper or text-weight paper. Double-sided papers are fun, and you can even fold these candy dishes from the pages of old magazines.

This cleverly folded candy dish is delightful to fold. Trinity Adams, the 11-year-old director of marketing for the nonprofit Paper for Water, came up with this design by accident when she was just 7. She was trying to fold a fortune-teller. Remember learning to fold those with friends at school? Well, Adams made a mistake and ended up with this design instead. If you try folding a fortune-teller, you'll see where she went wrong. Sometimes mistakes lead to new inventions.

Material

- 6¾" square of origami paper

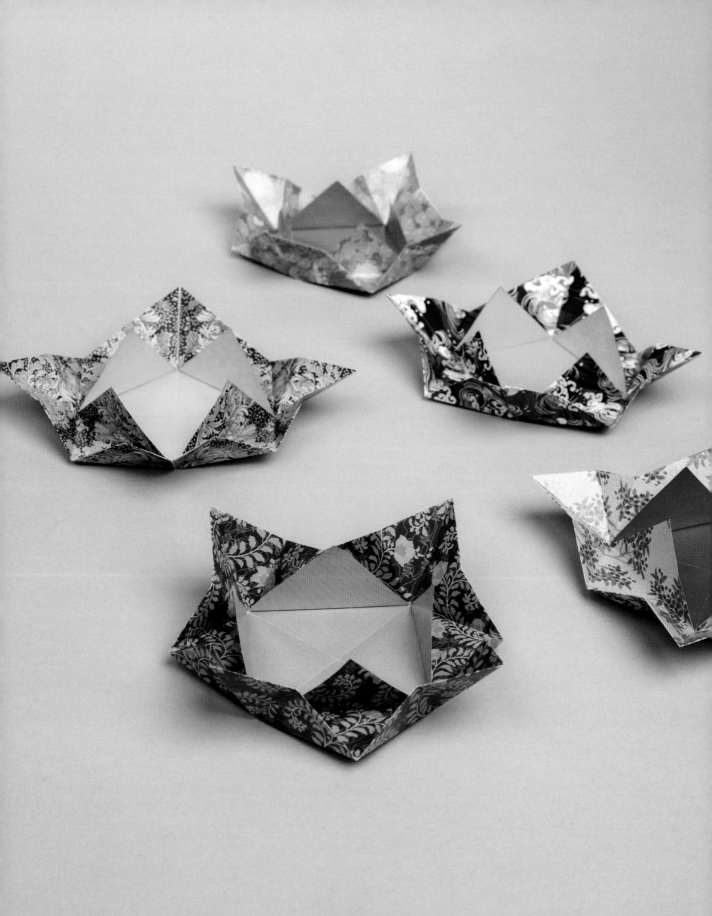

Instructions

1 Place the square of paper on your work surface. The side facing down will become the display side of the finished candy dish. Fold the square of paper in half to create a rectangle. Unfold. Fold in half again to create a rectangle in the other direction. Unfold.

2 Fold all four corners into the center, forming four triangles.

3 Without turning the piece over, repeat step 2 twice: Fold all four corners into the center again (A). Fold all four corners in one more time to create a third layer of folded triangles (B).

4 Carefully unfold two layers, pinching the points between your thumbs and forefingers, as shown, to shape the edges of the dish. Gently lift up the bottommost layer to reveal the second paper color, then place a treat inside.

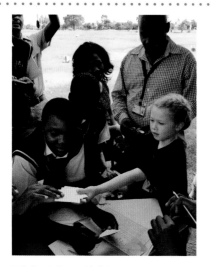

Trinity Adams (right), at age 7, teaching origami to schoolchildren in a village near Kisumu, Kenya

ARTIST

TRINITY ADAMS is an 11-year-old from Dallas, Texas. She and her sisters Isabelle and Katherine run the nonprofit organization Paper for Water. Trinity loves lizards, jumping on the trampoline, and riding horses.

PAPER FOR WATER

Sisters Isabelle, Katherine, and Trinity Adams run Paper for Water, a nonprofit Christian mission. They fold and sell origami products to raise money to bring water to the thirsty. When the sisters learned about girls worldwide who can't go to school because they spend their days hauling water, and that a child dies every 20 seconds from unclean water, they wanted to make a change. Paper for Water works to educate kids from developed countries about the global water crisis with the goal of making them more compassionate and understanding world citizens.

1

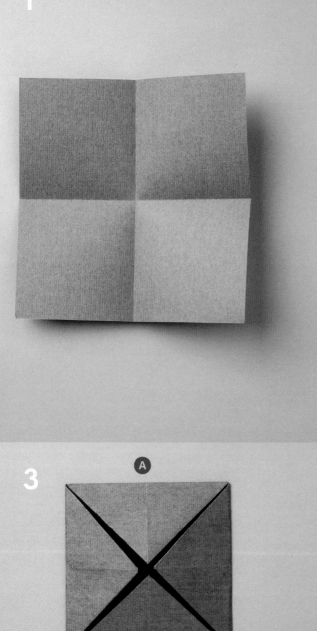

2

3

4

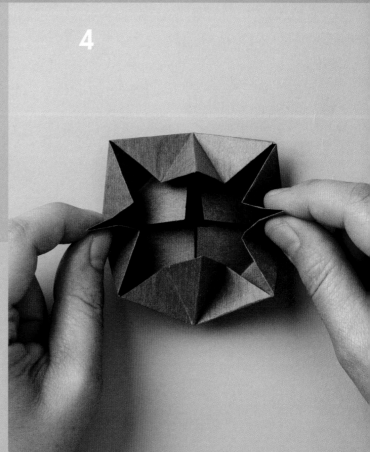

Valentine Love Note

DESIGNED BY Cathryn Miller
PAPER USED 90 gsm pearlized sakura
LOOK FOR Any lightweight paper will do.

TIP

If you are using a paper that is 20 lb. (75 gsm) or lighter, you can turn your triangle into a little square (as seen at right) by folding the bottom two corners up to the top point and then tucking them under the heart.

Most origami projects begin with a square sheet of paper, but this one starts with a rectangle and has a printed element that magically transforms into a heart as you fold it. Create this fun little triangular love note to give to a special someone for Valentine's Day—or any day.

Materials

- Template (page 285)
- 3½" × 7" sheet of paper

Tools

- Scissors or craft knife and cutting mat

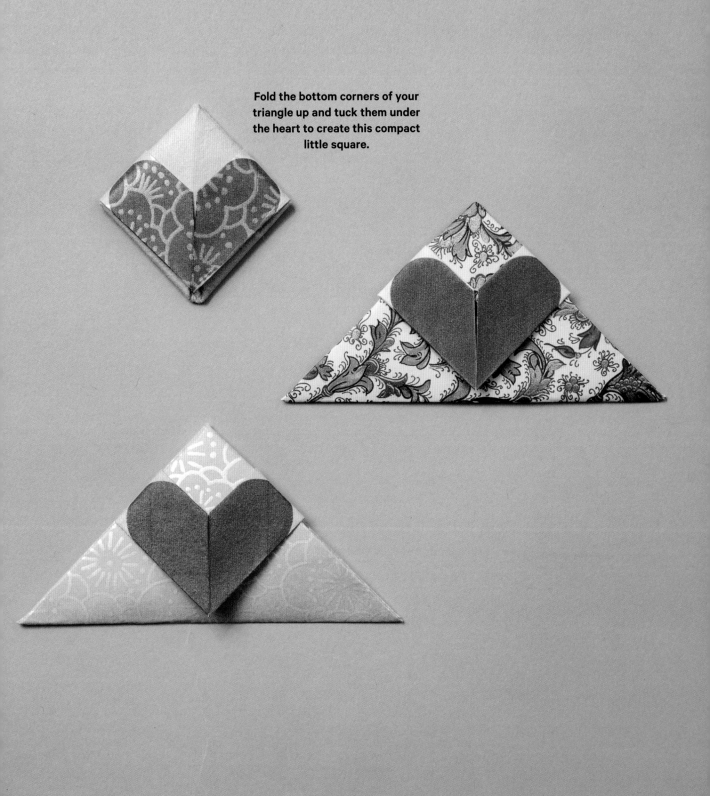

Fold the bottom corners of your triangle up and tuck them under the heart to create this compact little square.

Instructions

1 Photocopy or print the template onto the plain side of the project paper (see Working with Templates on page 28 and the Template Key on page 280), then cut it out with scissors or a craft knife. With the decorative side of the project paper facing down (printed heart facing up), fold the top right corner down to the left.

2 Unfold, and then fold the top left corner down to the right.

3 Unfold the left corner and turn the sheet over, so the plain side (with the printed heart) faces down. Fold the top edge down and make a horizontal crease across the point where the folds you made in steps 1 and 2 intersect. Make sure the bottom corners of the top flap touch the points where the folds from steps 1 and 2 end.

4 Unfold, and then fold the top corners in to meet in the middle.

5 Unfold, and then fold in the top corners at a diagonal to meet the fold lines you made in step 4.

6 Roll the top edges over and fold, as shown.

Continued on page 52

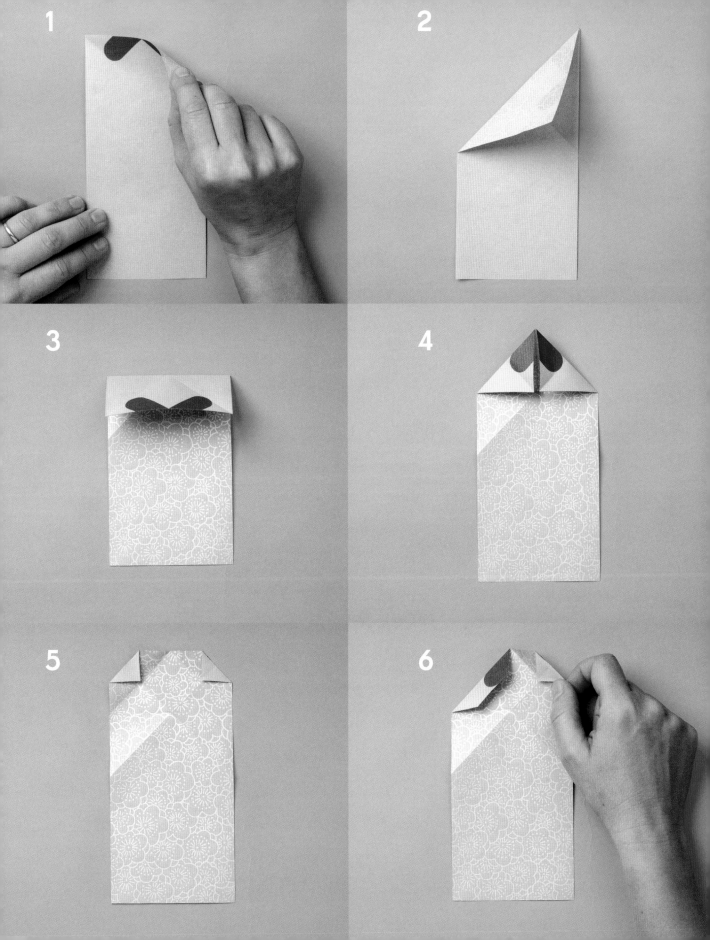

7 Turn the paper over so the plain side faces up. Using the previous fold lines as your guides, bring the two side points together, as shown (A), while simultaneously pushing the top point forward and down (B). Firmly crease all the folds.

8 Fold the bottom right corner up and to the left, as shown.

9 Fold the bottom left tip up and to the right.

10 Insert the bottom central point into the pocket under the heart.

TIP: To reduce the gap between the two parts of the heart, place your love note under a heavy weight, or use a small bit of adhesive under the flaps that make up the heart.

ARTIST

CATHRYN MILLER has been playing with paper since she was 3 years old. Her current creations include artist's books and artworks made from manipulated papers, both new and recycled. Miller writes a weekly blog post about her work, occasionally featuring DIY artist's books, paper toys, and other paper projects for her readers to make.

Cathryn Miller, *You Can't See the Forest . . . (or Memories of Uncle Vanya)*, 2013.
765 leaves made from a discarded copy of *Webster's New Students Dictionary*, florist's wire, and starch paste/PVA mix; dimensions variable.

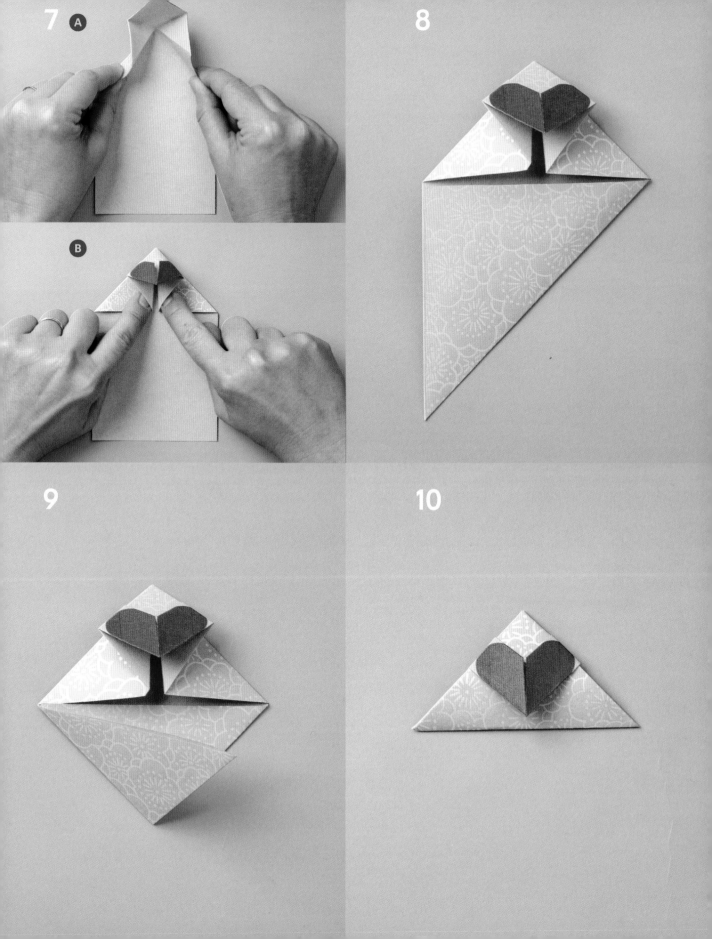

7 **A**

B

8

9

10

Two-Fold Name Card

DESIGNED BY Paul Jackson
CALLIGRAPHY BY
DavidAshleyStudio.com
PAPER USED Scrapbooking
paper
LOOK FOR Almost any paper
will work.

TIP

This name card will stand very stably under tension. Try making these cards in other sizes. The only rule is that the proportions between the two folds in steps 1 and 2 must be kept.

You have to make this project to believe it. I literally laughed out loud the first time I created this simple name card. I thought I was going to have to glue the paper to make it hold its shape, but no! The beauty of this project is that it holds its shape under tension.

As the designer, Paul Jackson, told me, "This project is simple and versatile. You can make it from any paper of any size or weight, bending it with or against the grain, decorate or print it in any way you choose. Playing with the proportions of the paper gives very different-looking results. It's one of those apparently simple ideas that keeps on giving as you explore it."

Material

- 11" × 5½" sheet of paper

Tools

- Ruler (optional)
- Bone folder (optional, but especially helpful if using a heavier-weight paper)

Instructions

1 Fold the sheet in half, short end to short end. If using a heavier-weight paper, you might want to use a ruler and bone folder to measure and score before folding, here and throughout the project. Unfold.

2 Fold one half of the paper in half again. Unfold this last fold so that it stands up at a right angle.

3 Bend the top edge down and slip it inside the right-angled piece. Crease both folds, if necessary, to reinforce them. Flip the name card over so that it stands up on the flat panel.

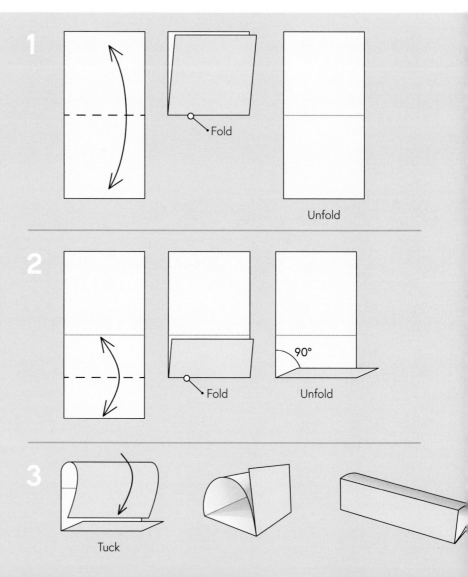

Fold

Unfold

Fold

90°

Unfold

Tuck

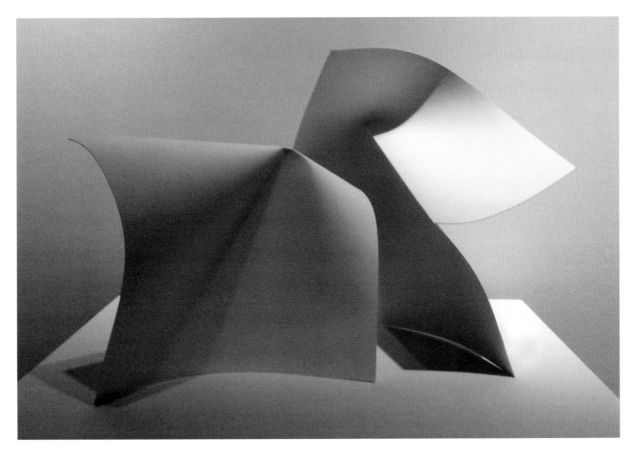

ARTIST

British artist **PAUL JACKSON** lives in Israel, creates unique paper designs, and has written numerous popular books on the many innovative ways that paper can be transformed. He has inspired graphic and packaging designers, structural engineers, and architects. As a child, Jackson spent hours in the bathroom watching the colored shadows that a stained-glass window cast on the wall. It was then that he started playing with toilet paper squares and created a paper yacht.

"I taught the circular fan to my first-year interior design students at Shenkar College, and they loved it! What appeals to me as a teacher of design students is how many variations can be made using color, texture, material, changing the number of pleats, the proportion of the paper, cutting the fan to shapes, etc. As simple as it is, it's a portal to a lot of creative work ... providing you're not an origami purist!" —Paul Jackson

Paul Jackson, *He Said . . . She Said*, 2017.
450 gsm watercolor paper (2 sheets), folded wet; 13¾" × 13¾".

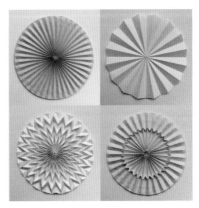

Paul Jackson, *Circular Fans*, 2019.
80 gsm copy paper, glue; 7¾"–12" diameter.

Inflatable
Paper
Votive

DESIGNED BY Marianne R. Petit
PAPER USED 55 gsm Dai Chiri.
In Japanese, *chiri* means "left-over," and in relation to this paper it refers to the small, dark pieces of bark from the kozo plant that spot the paper.
LOOK FOR A paper that folds well and can be run through a printer.

TIP

I recommend trying this project with regular printer paper first to make sure the imagery ends up in the right place. You can also create your own illustrations on the flat panels prior to folding.

This is one of seven inflatables in artist Marianne Petit's *Portable Reusable Inflatable Paper Votive Kit for Meditation on the Seven Virtues*. The inflatables were inspired by Petit's love of votives (part of her Catholic upbringing) and an appreciation for the simple origami water balloon form, which you may have folded as a kid. I love how Petit combined her expertise in paper engineering and graphic design, placing the imagery in just the right place between the folds in the balloon—something to consider when designing your next origami project. In addition to illumination, the tea light provides a lovely base for the paper votive.

Materials

- Template (page 289)
- 8½" × 11" sheet of paper
- Battery-operated tea light (pictured here with 1¼" × 1⅜" LED votive)

Tool

- Scissors

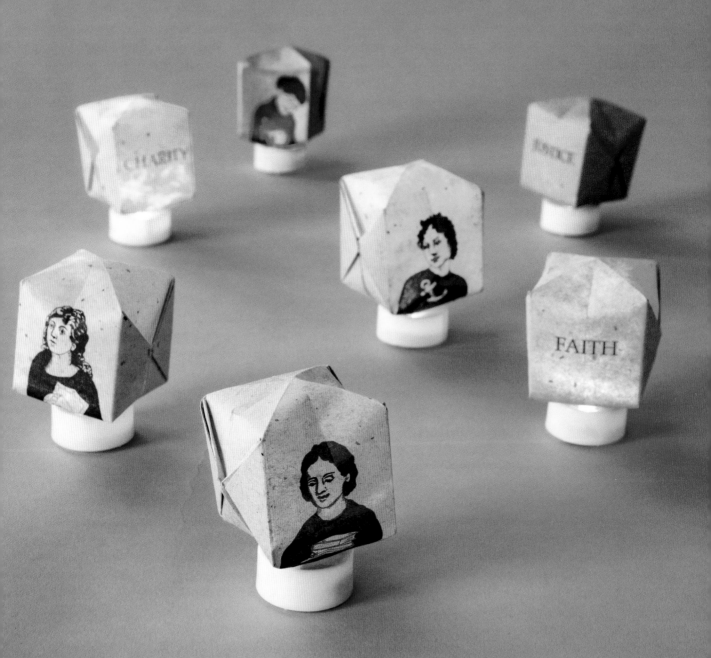

MARIANNE R. PETIT creates mechanical books that combine animation and papercraft. In her art, she explores fairy tales, anatomy, and collective storytelling. She teaches in the Interactive Media Arts Program at New York University. I met Petit a few years ago at a Movable Book Society conference, a fantastic gathering of paper engineers who create and collect pop-up books (see Resources on page 275).

Marianne R. Petit, *Anatomical Flap Book*, 2015. Moab Bright White Rag; 18" × 19".

Instructions

1 Photocopy or print the template onto the project paper (see Working with Templates on page 28 and the Template Key on page 280). Then cut the paper down to 8" × 8" along the template outline. Alternatively, you can start with a blank square and create your own design.

2 Fold the square of paper in half, point to point, in both directions, creating mountain folds on the side with the printed imagery.

3 Fold the square in half side to side in both directions, creating valley folds on the side with the printed imagery.

4 Flip the sheet over so that the printed image is facedown on the right and the word *hope* is facedown on the left. Let the mountain and valley folds guide you in forming a triangle that has the image and words tucked inside on the right and left.

5 Bring each bottom corner up to the top point, as shown. Flip the triangle over and repeat on the other side.

6 Fold in each tip on both the right and the left to meet the centerline. Turn the paper over (facedown) and repeat on the other side.

7 Take the top points and bring them down over the angles created by the last fold and crease (A), then fold the point back on itself, as shown (B).

8 Tuck the double-folded piece you just folded into the pocket in the triangle beneath it. Repeat on the other side; flip over, and repeat two more times. Locate the open end in the balloon and blow into it to inflate it and reveal the imagery. Set it on top of a battery-operated votive and watch it glow.

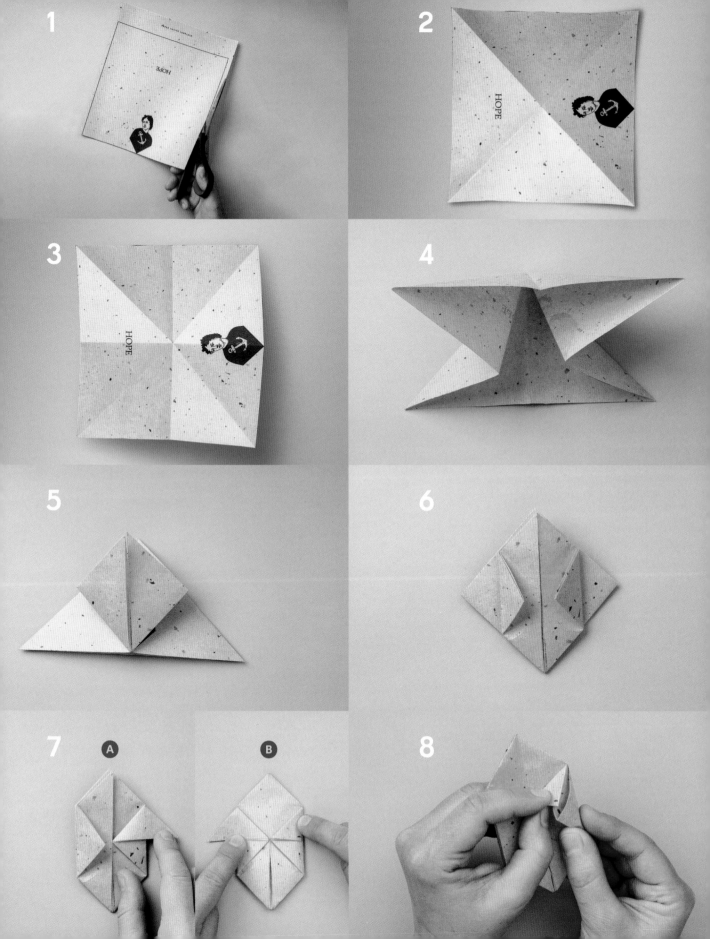

Tyvek Lantern

DESIGNED BY Helen Hiebert
PAPER USED Tyvek
LOOK FOR If you don't have Tyvek, use a thin strong paper that will stand up to multiple folds.

Explore Tyvek, a strong and fibrous paperlike material. Bring out its texture by staining it and discover the wonder of paper tessellations. With a Velcro hinge, this little lantern is reversible, too. I highly recommend making a model with scrap paper first, or if you want some up-front practice, see How to Fold an Accordion on page 26.

Materials

- Template (page 282)
- Card stock
- Acrylic or watercolor paint or liquid matte medium (2 colors)
- 14" × 4" piece of Tyvek
- Paper towel
- Velcro dots (or double-sided tape or PVA glue)
- Battery-operated tea light

Tools

- Pencil (optional)
- Paint mixing tray
- Foam brushes (2 or more)
- Bone folder
- Craft knife
- Straightedge
- Cutting mat
- Scissors

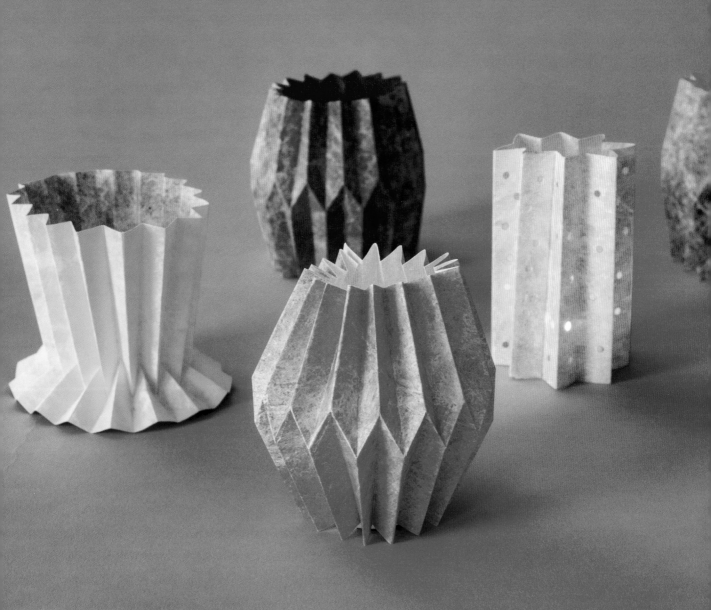

Instructions

1 Photocopy, print, or trace the template onto your card stock (see Working with Templates on page 28 and the Template Key on page 280). Set it aside for now.

2 Mix your favorite paint color on a paint mixing tray and use a foam brush to apply one color to one side of the Tyvek. Rub the paint into the Tyvek with a paper towel or a dry sponge brush. Let the paint dry on the first side, then stain the other side of the Tyvek with the second color.

3 Fold a ½" seam on one short side, then fold the sheet in half up to the seam edge, and then into quarters. Unfold. Reverse the middle fold so that there are three mountain folds. Fold each of those three mountain folds up to the folded seam edge. You now have eight sections plus the seam. Use a bone folder to reinforce the creases, if desired.

4 Reverse all of the valley folds to form eight mountain folds (including the seam fold). Fold each of the eight mountain folds up to the folded seam edge, dividing each section in half. Fold the last section up to meet the edge where the folds meet. You will end up with 16 sections plus the seam. Repeat this step to yield 32 sections plus the seam. I recommend reversing all mountain and valley folds at this point to make them more flexible for the next step.

5 Using a craft knife, straightedge, and cutting mat, trim the template to the width of a double accordion (if necessary). Center the template on a pleat, as shown, and use a bone folder to score along the rooftop edges. Score every doubled section of Tyvek. You should end up scoring a half rooftop on the final seam.

TIP: Make the template longer or shorter to change placement of the folds and the resulting look of your lantern.

Continued on page 67

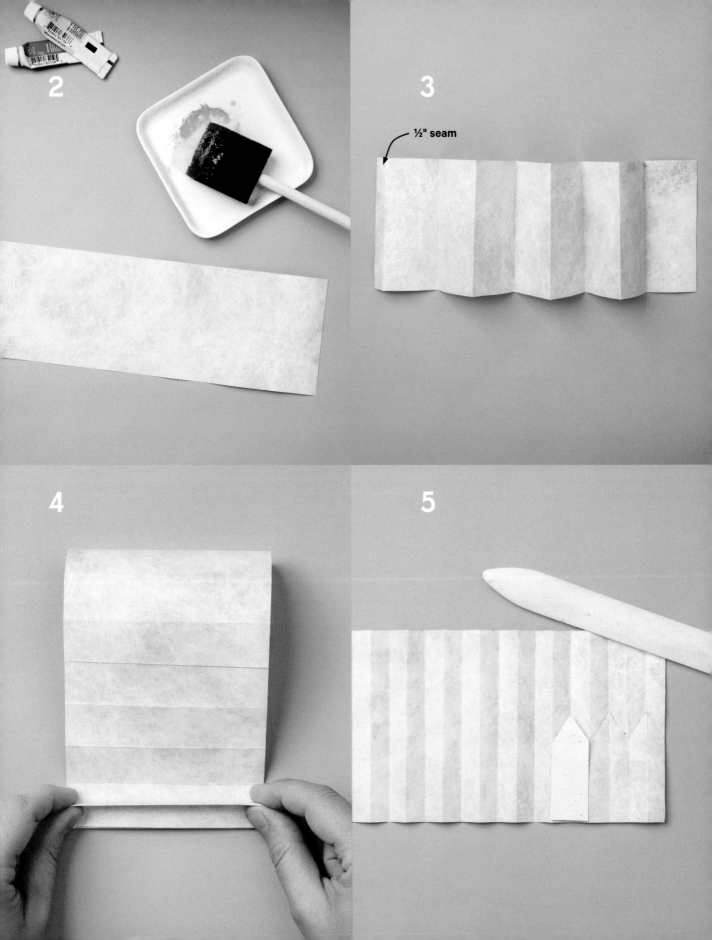

2

3

½" seam

4

5

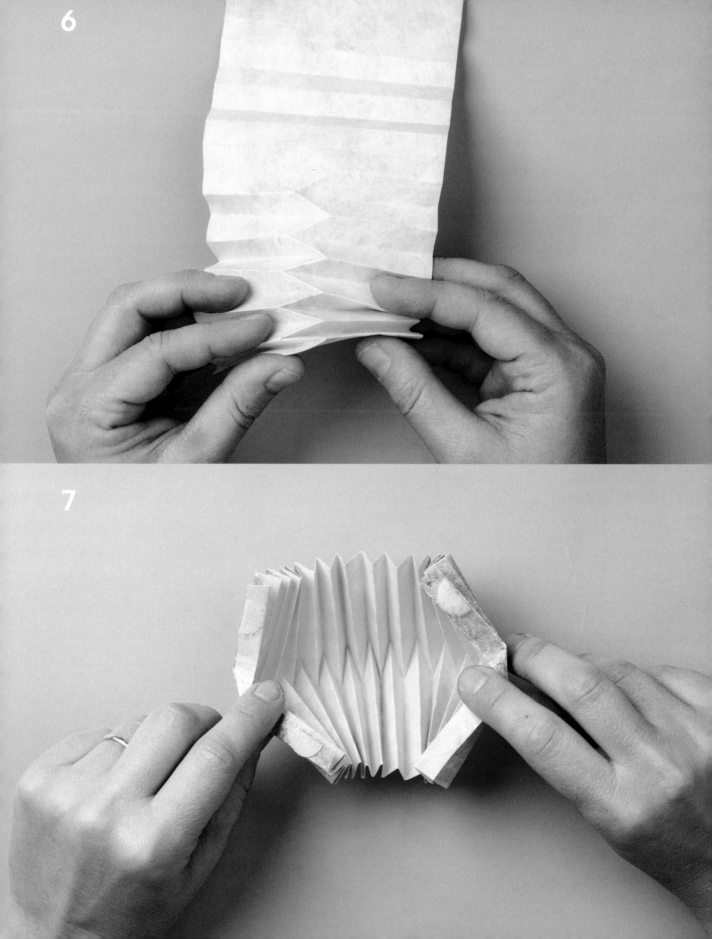

6

7

6 Fold the entire structure lengthwise in the middle—along the rooftop folds—while keeping one half of the accordions intact (as folded) and reversing all of the accordion folds on the other side of the rooftop folds. Once you get the hang of doing one or two pleats, the rest will fall into place.

TIP: This step is a bit tricky; be patient! It is difficult to describe how to do this, so I recommend studying the photo below and making a four-pleat model on scrap paper to test out this fold before tackling the entire accordion.

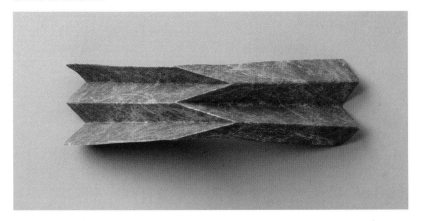

7 Cut the Velcro dots in half (if your pleats are large enough, you can use full dots). Attach two or three half circles to one seam edge. Rather than trying to guess where to put the Velcro on the opposite seam, you may find it easier to connect Velcro to Velcro and then bring the other seam edge around and fasten the two edges. Place a battery-operated tea light inside your lantern and watch it glow.

TIP: This lantern is reversible. Carefully pull the Velcro seams apart, leaving one side of Velcro on each seam edge. Turn it inside out and connect the Velcro seams to create another look, both in color and in shape.

Origami
Bat

DESIGNED BY Ioana Stoian
PAPER USED 110 gsm black
Zanders elephant hide paper
LOOK FOR Any lightweight
cover paper or sturdy text-weight
paper will do, but you need to use
a paper that can withstand lots of
folding.

TIP

**You can make a larger bat with
any size sheet of paper; just use
the same 2:1 proportion.**

Discover a unique way of expanding an accordion fold
by incorporating a few strategically placed cuts. You will
be amazed by how this flat rectangular sheet of paper is
transformed. This model came about from simply playing
around with corrugations. I encourage you to do the same
and, most importantly, to have fun.

Material

- 5½" × 11" sheet of sturdy
 text-weight paper

Tool

- Scissors

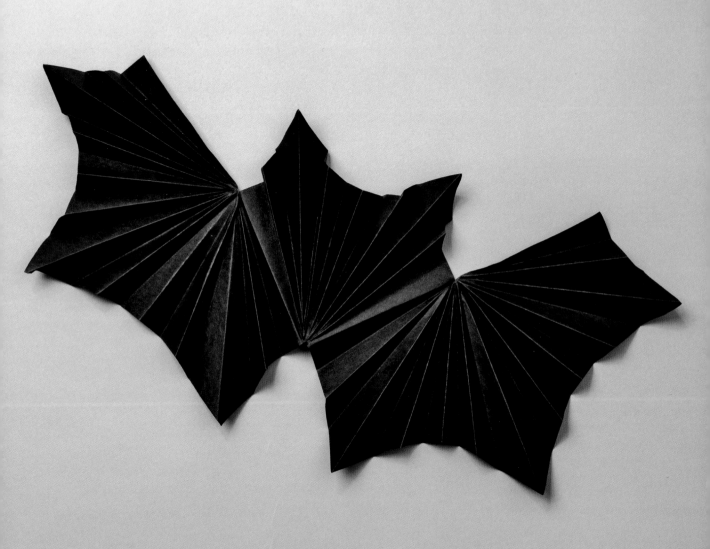

ARTIST

IOANA STOIAN is a British-born paper artist who enjoys the challenge of creating origami designs. In addition to making handmade paper artworks and artist's books, she is the author of *Origami for All: Elegant Designs from Simple Folds* and *The Origami Garden*.

Ioana Stoian, *Draga*, 2010. Pigment and gold leaf on one sheet of hand-folded handmade flax and abaca paper; 51" × 23½".

Instructions

1 Divide the sheet of paper into eight equal squares, making every fold a valley fold.

2 Valley-fold and unfold the diagonals as shown, paying close attention to the arrows, which will guide you in using the edges of the paper and previous folds to make your new folds accurate.

3 Cut three slits as shown.

4 Turn the model over so that all of the folds appear as mountains. Fold each section in half again, making new valley folds between each of the existing mountain folds. This will result in one long accordion fold.

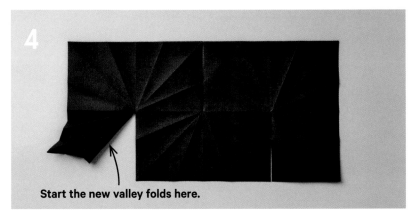

Start the new valley folds here.

5 Make your bat three-dimensional by bringing the wings together behind the head.

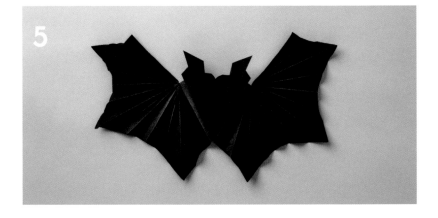

1

2

Ⓐ Ⓑ Ⓒ

Ⓓ Ⓔ Ⓕ

Ⓖ

3

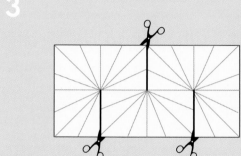

4

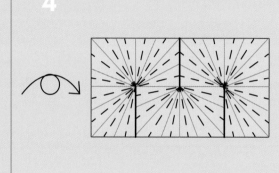

Origami
Sailboat
Envelope

DESIGNED BY Michael G. LaFosse

PAPER USED Stencil-printed Japanese washi

LOOK FOR Any double-sided origami paper or text-weight paper will work. Vary the square size to make envelopes in different sizes.

These sailboat envelopes are simple and fun to make, and I could envision folding an entire fleet and then sending (or sailing) them off to friends in far places.

This Michael G. LaFosse envelope design was unveiled at the OrigamiUSA 1999 convention to commemorate the fortieth anniversary of the founding of the Origami Center of America. It was used as a challenge piece for the annual convention games, so the design had to be brand new to prevent anyone from having an advantage. Each participant was given an envelope that contained the diagrams for this new model. The catch: Each diagram sheet had been torn into pieces, requiring the contestants to first put the diagram sheet back together and then fold the model successfully.

Material

- 12" × 12" sheet of double-sided paper

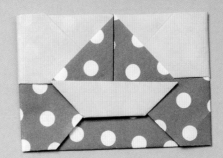

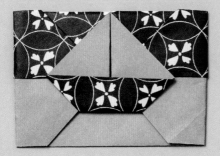

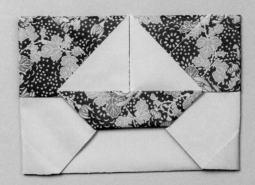

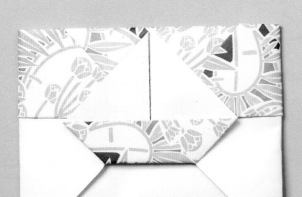

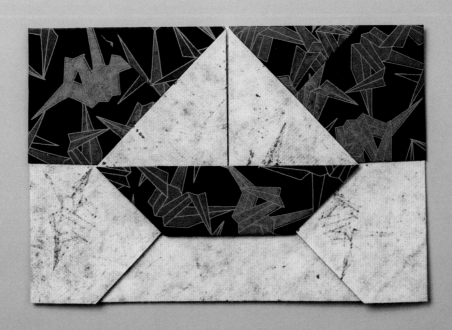

Instructions

1 Begin with the display side of the paper facing down. Fold it in half, bringing the bottom edge up to the top edge. Unfold. Fold the bottom edge up to align with the horizontal center crease. Unfold.

2 Rotate the paper 90 degrees so that the creases are vertical, and repeat step 1. Turn the sheet over (display side facing up) and rotate it 45 degrees, so that the corner with the crossing creases is at the bottom.

3 Look closely at the orientation of your paper, making sure the crease pattern matches the step 3 illustration.

4 Fold the top and bottom corners to meet at the center of the paper. Unfold the bottom corner. Turn the sheet over again (display side facing down).

5 Fold the left and right corners to form triangle shapes that align with their nearby crease. Fold the bottom corner to the point where the three creases intersect near the bottom.

6 Use the creases indicated by dashed lines to fold the bottom left and right sides in at the same time, while allowing the bottom to fold at the crease indicated by the dashed and dotted line into the shape of the two sails of the boat. The second image for this step shows the collapsed shape.

Continued on page 76

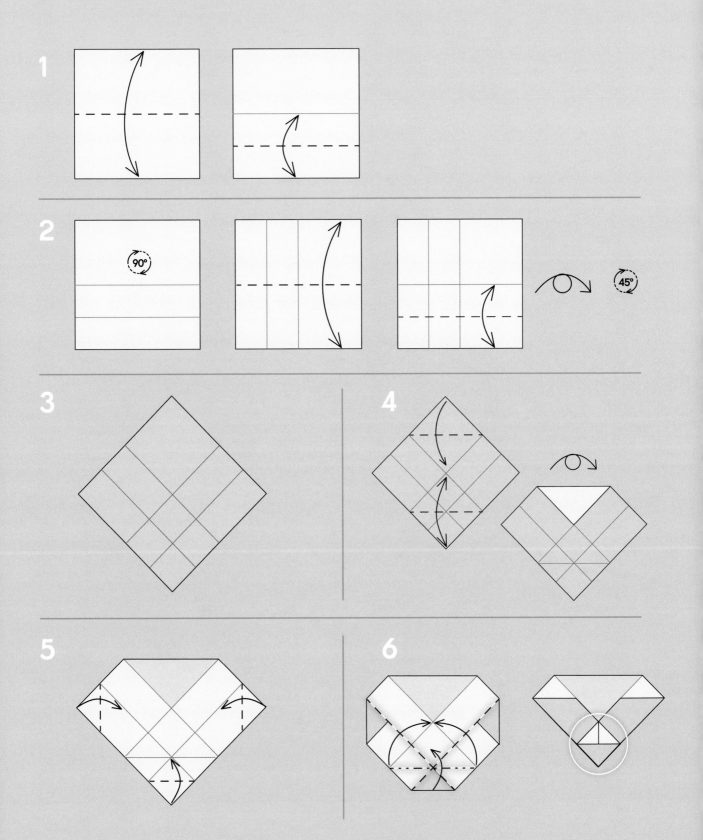

7 Fold the bottom corner up as shown, forming the base of the boat. Unfold, then refold that same triangular flap to the back side of the boat. Now you have created the completed sailboat shape.

8 Turn the paper over, bottom to top. Fold down a portion of the new top edge, creating a fold line at the top tip of the large triangular flap and parallel to the bottom edge. When this step is completed, the tip of the sail will be at the top edge of the fold.

9 Fold the left and right corners to meet at the center. Return the corners to the left and right. Tuck the left and right corners behind the corners of the sailboat.

 TIP: This envelope is not meant to be mailed, but it can be stuffed with a little gift and tucked into a mailing envelope (or delivered by hand). To insert contents, pull out the left and right flaps, lift up the sailboat flap, unfold the bottom flap, and insert an item. Refold in the opposite sequence.

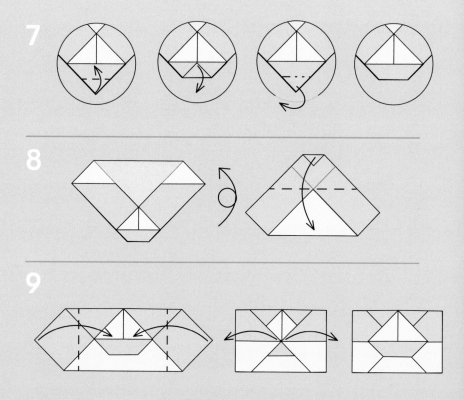

Kevin Box and Michael G. LaFosse, *Seed Sower*, 2017. Patinated and painted cast bronze; 75" × 27" × 16". LaFosse's origami design was made into a permanent sculpture by Box Studio as part of a traveling exhibition called *OrigamiintheGarden*. (This photo was taken at the Morton Arboretum in 2018. There is an origami acorn in the photo as well: *Seed* by Kevin Box and Beth Johnson Brown. Ferric patina on cast bronze; 13" × 16" × 13".)

ARTIST

MICHAEL G. LaFOSSE has been working as an origami artist, paper-maker, and author for more than 40 years. Trained as a biologist, he finds his strongest inspiration in the natural world and prefers to study his subjects in their natural habitats. He credits Akira Yoshizawa, the late Japanese origami grand master, for popularizing origami by exploring nature and achieving creative expression in origami art. LaFosse and Richard Alexander cofounded the Origamido Studio, a teaching center, gallery, and origami design studio where they also make custom hand-made paper for each new creation.

Michael G. LaFosse, *Origami Gray Squirrel*, 1995. Folded from a 23" square of handmade Japanese kozo paper, colored white on one side and gray on the other (made by pasting two sheets together); 8" × 7" × 2½".

Origami
Parrot

DESIGNED BY Robert J. Lang
PAPER USED Tant origami paper
LOOK FOR Any origami paper will work.

A parrot is a wonderful paper pet, and this clever design allows it to balance on your finger. This is a challenging fold. I had to try a few times to get the final folds correct. Remember that practice makes perfect!

Material

- 6" square of origami paper

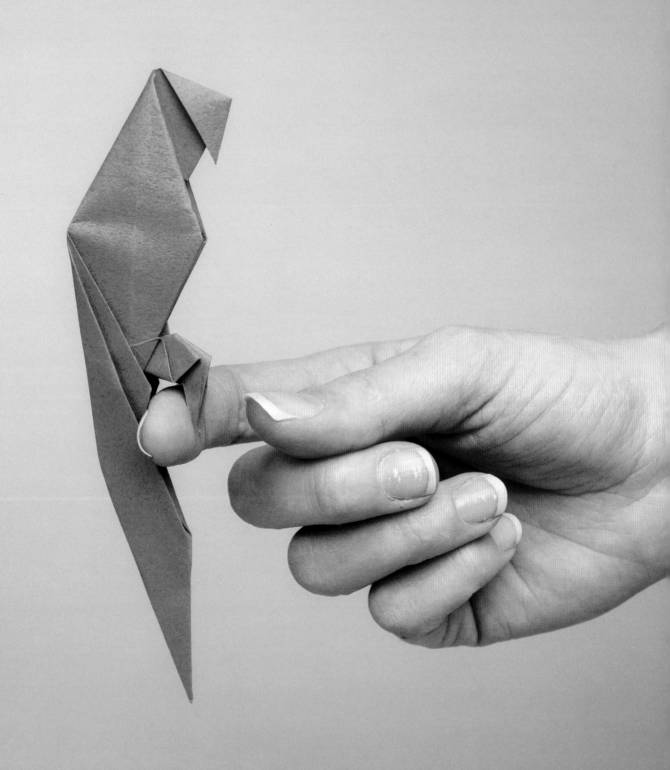

Instructions

1 Fold the sheet of paper in half, point to point. Unfold. Then fold the two edges into the centerline. Unfold.

TIP: If you are using colored origami paper, start with the white side up.

2 Fold the bottom right corner up to the dot and crease as shown. Unfold. Fold the top left corner over to the dot and crease. Unfold.

3 Fold the top right corner down, using the dots as a guide and aligning the corner to the centerline.

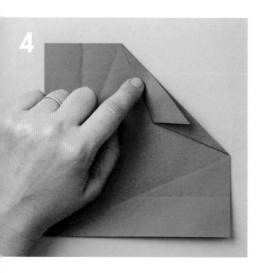

4 Fold back each side of the piece you folded in step 3 to meet the upper right angled edge, creasing just to the center point, one at a time.

5 Push what will become the parrot's beak over to the right, then flatten and crease. Rotate the model one-eighth turn (45 degrees) counterclockwise.

6 Fold the right side behind.

7 Outside-reverse-fold (see the Illustration Key on page 25) about one-third of the small angle to form a beak.

8 Fold the top layer down, aligning the top edge with the vertical right side. Unfold. Turn over and repeat on the other side.

Continued on page 82

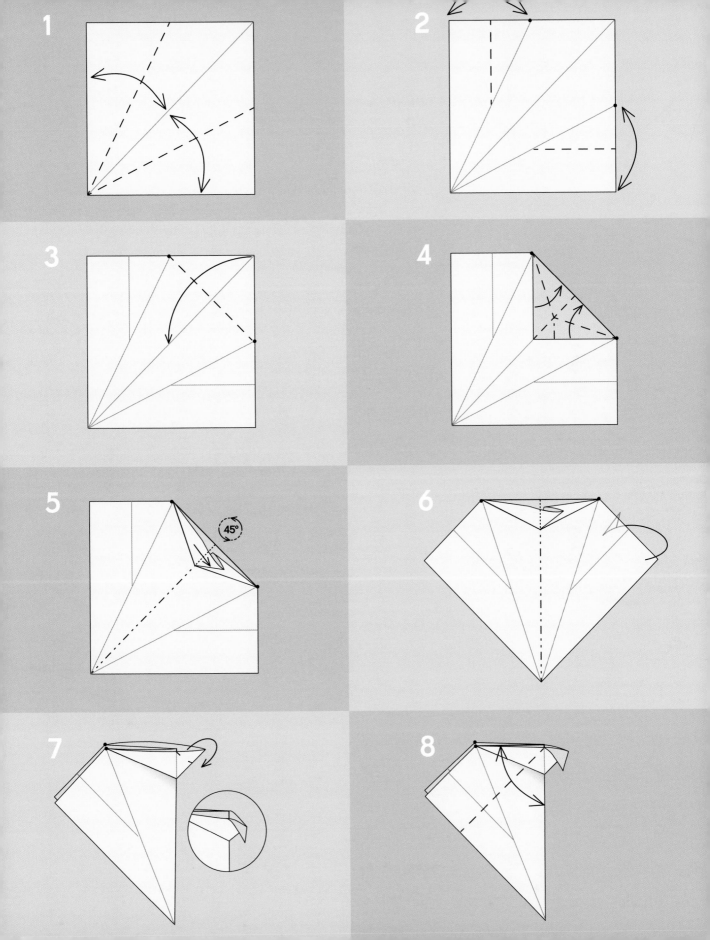

9 Fold the top layer down again on a diagonal to meet the crease you just made. Turn over and repeat.

10 Fold the top layer over to the right and align the dot on the diagram with the right edge of the parrot. Turn over and repeat.

11 Lift the bottom right corner of the large triangle on the existing horizontal crease, and swing the bottom left corner of that triangle over to the right and flatten. Turn over and repeat.

12 Fold the top edge of the leg in half diagonally. Turn over and repeat.

13 Fold the leg back along the short vertical crease, so that the bottom of the leg lies horizontally, as shown, closing and collapsing the foot back on itself. Turn over and repeat.

14 Fold the tip of the foot toward the back, bringing it up to the centerline, as shown. Turn over and repeat.

15 Make a crease through the dots, as shown (A), then reverse and tuck the fold into the belly of the parrot. The leg will flip forward to point toward the right (B). Turn over and repeat.

Continued on page 84

9

10

11

3 Swing corner to align with highlighted edge, creating new fold.

2 Fold along this existing crease.

1 Lift.

11

12

13

14

15 Ⓐ Ⓑ

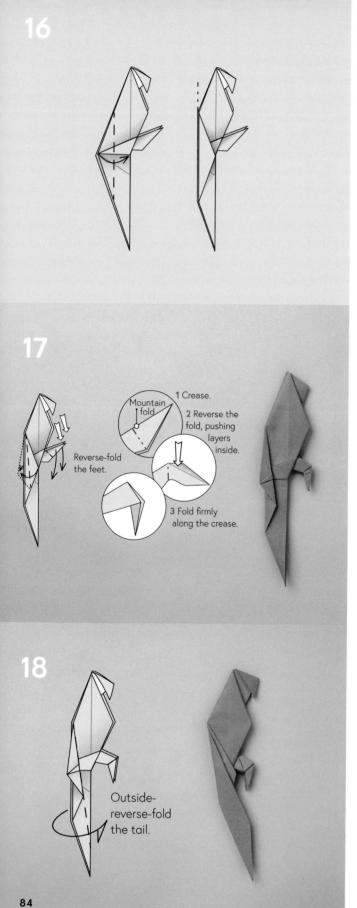

16 Fold the point of the tail to the centerline. Repeat on the other side.

17 Fold the the tip of the foot back to the left. Turn over and repeat. Then crease and inside-reverse-fold both feet. Crease the tail, as shown; turn over and repeat.

18 Crease as indicated and outside-reverse-fold the tail toward the feet. Put your finger in the front of the parrot's body and spread the layers at the back. Perch the parrot on your finger!

Reverse-fold the feet.

Mountain fold

1 Crease.

2 Reverse the fold, pushing layers inside.

3 Fold firmly along the crease.

Outside-reverse-fold the tail.

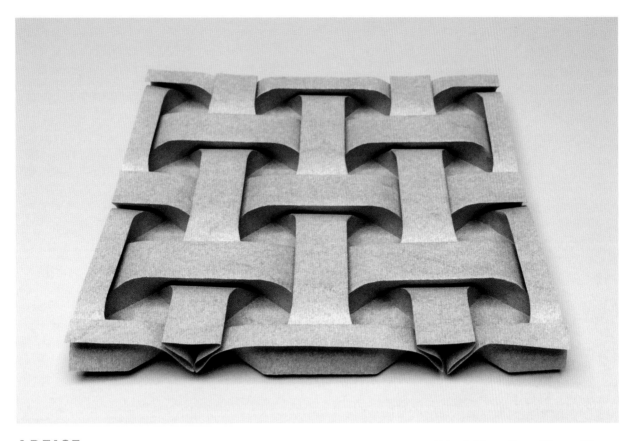

ARTIST

ROBERT J. LANG has been folding origami for more than 50 years and, with more than 800 original designs, is recognized as one of the world's leading masters of the art. His pioneering cross-disciplinary work combines aspects of the Western school of mathematical origami design with the Eastern emphasis on line and form, resulting in designs that are both elegant and challenging to fold. Lang also uses mathematics to advance origami techniques for applications in technology, including folding a giant telescope into a compact form so that it can travel to space.

"The world of mathematics might seem far removed from the world of art, but mathematics both describes and enables the creation of beautiful forms. Furthermore, the same mathematical description that lets us create folded art also allows us to solve real-world practical problems in the fields of science, engineering, technology, medicine, and more." —Robert J. Lang

Robert J. Lang, *Curved Square Weave, Opus 665*, **2014.** One uncut square of elephant hide paper; 8" × 8" × ½".

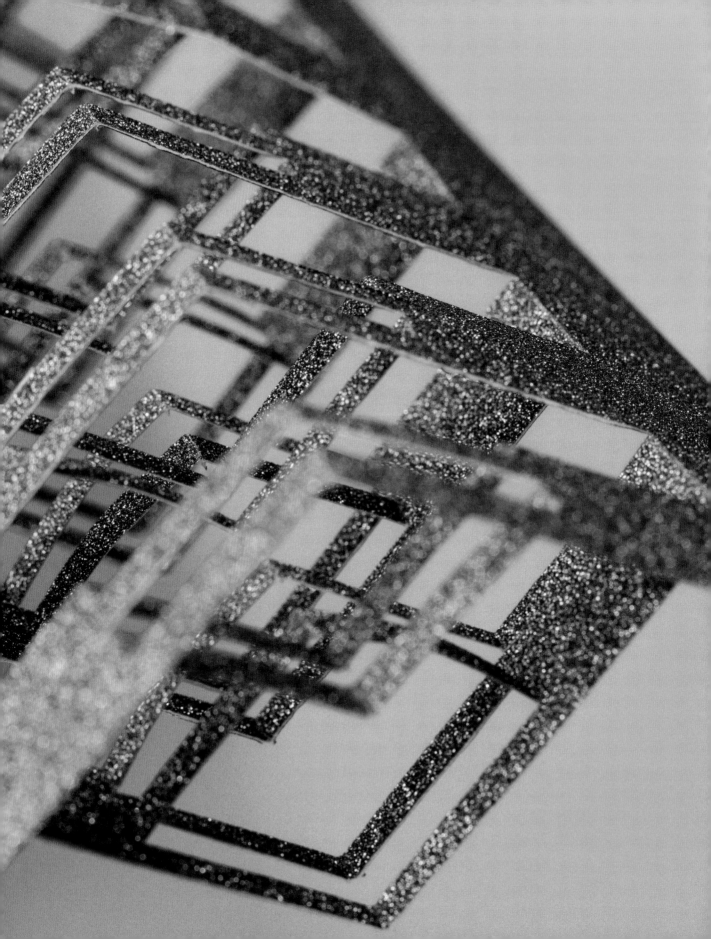

Cutting

Pop-Ups, Slice Forms & Other Multidimensional Structures

TRANSFORM A PIECE OF PAPER by adding cuts before or after folding. From books and kites to masks and cards, these projects both amaze and inspire.

One-Sheet
Books

DESIGNED BY Helen Hiebert and Peter Thomas
PAPER USED Double-sided origami paper
LOOK FOR Most papers, in almost any size, can be folded into one-sheet books.

Graphic designers and book artists have been exploring economical ways to cut and fold a single sheet of paper since paper and printing were invented. Here are a handful of popular models that are folded from 6" square double-sided origami papers. The beauty of a model at this scale is that you can explore the structure, then experiment with various sheet sizes and numbers of panels to invent your own books.

These one-sheet book structures have been given various names in the past, but there doesn't seem to be a standard. Book artist Peter Thomas came up with the idea to name each structure based on the letter of the alphabet it most closely resembles in a diagram showing the cut and fold lines.

Materials

- Several 6" (or larger) squares of origami paper

Tools

- Scissors
- Ruler
- Straightedge (optional)
- Bone folder (optional)
- Craft knife (optional)
- Cutting mat (optional)

Folio

Quarto

O-Cut

U-Cut

J-Cut

C-Cut

M-Cut

N-Cut

Instructions

You can fold these one-sheet books without any tools, but if you're using thicker papers, you might need to use a straightedge and a bone folder to pre-score the fold lines. Cut with scissors or, where instructed, use a craft knife and cutting mat to ensure your cuts are precise.

FOLIO

Fold your project paper in half. Voilà, a simple four-page book. In book-making terminology, this is called a *folio*.

QUARTO

Fold your project paper in half, top to bottom, then in half again, left to right. This type of four-page book is called a *quarto*, or French fold. Unfold to reveal four more pages inside.

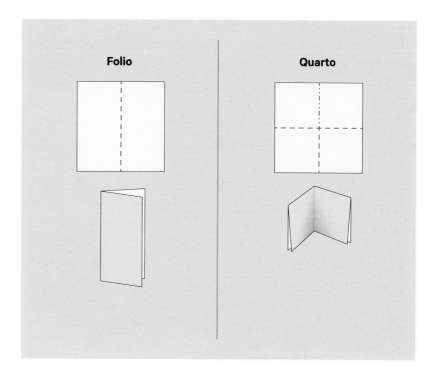

Folio

Quarto

O-CUT

This structure allows you to print on one side of a sheet of paper to create multiple pages. Valley-fold the nonprint side in half both ways, unfolding after each. Mountain-fold two opposite vertical edges to meet at the center. Unfold. Use a craft knife to cut along the horizontal center crease between the two vertical mountain creases. Valley-fold along the horizontal valley crease, display side out.

Below are two options for how you can fold and display this model. Alternatively, you can arrange the model in a doubled accordion fold.

- Push ends A and C inward, making the center cut open along edges B and D to create a box-shaped tube.
- Push to the center, forming a four-page cross-shaped structure, then arrange the pages into a book form.

U-CUT

Mountain-fold the display side of your project paper in half lengthwise and then widthwise, unfolding after each. Then valley-fold the horizontal top and bottom edges to the horizontal center mountain crease. Unfold. Cut three-quarters of the length of the vertical center crease. Mountain-fold the short crease at A. Use the remaining creases to arrange the book's pages.

C-CUT

Valley-fold the back side of your project paper in half lengthwise and then widthwise, unfolding after each. Then mountain-fold the top and bottom edges to the horizontal center crease. Unfold. Cut the right half of the horizontal center crease and then cut the two center segments of the vertical center crease. Valley-fold in half horizontally, then use the remaining creases to arrange the book's pages.

Continued on next page

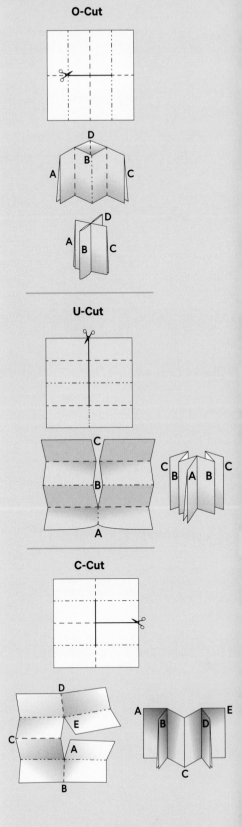

J-Cut

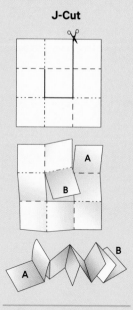

N-Cut

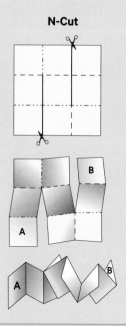

M-Cut

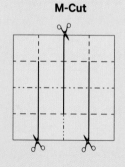
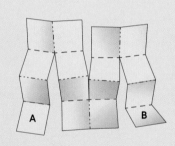
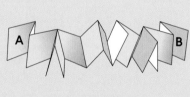

J-CUT

Begin by creating a nine-square grid, using a ruler to measure equal thirds on two adjacent edges of your project paper. Fold the sections you just marked out horizontally, then vertically, unfolding after each. Make a J-shaped cut following creases in the center column. Complete the book by collapsing the panels using alternating valley and mountain folds.

N-CUT

With the back side of your project paper faceup, begin with a nine-square grid using the same method as for the J-Cut book. Make an N-shaped cut following the indicated creases. Complete the book by collapsing the panels using alternating valley and mountain folds.

M-CUT

Begin by creating a 16-square grid by mountain-folding the display side of your project paper in half lengthwise and then widthwise, unfolding after each. Then, in turn, valley-fold each of the outside edges to the center, unfolding after each. Cut three-quarters of the length of a center crease. Then, from the opposite edge of the paper, cut three-quarters of the length of the left and right creases, parallel to the first cut. Use alternating valley and mountain folds to arrange the book's pages.

Peter and Donna Thomas, *Ukulele Series Book #2: The Ukulele Accordion,* **1996.** Handmade paper, made from cotton rag; 18" × 6" × 3".

Peter and Donna Thomas, The Wandering Book Artists

ARTIST

PETER THOMAS has been making books since 1974 and works collaboratively with his wife, Donna. He didn't consider himself a book artist until he made a series of books out of ukuleles. For Thomas, printing, bookbinding, and papermaking are more than just "craft" work; they are all pieces of his aesthetic vocabulary for book arts. When he edited *1000 Artists' Books*, he developed a system for classifying the books by their structures, dividing all artists' books into four structural genres:

- codex books (books with pages joined to make a spine)
- folded books (books with multiple-fold pages)
- single-sheet books (books made from one sheet of paper that is folded, cut, and folded again or rolled)
- sculptural books (books made from objects and objects made into books)

Between 2009 and 2019, the Thomases made four cross-country road trips, teaching classes and giving talks about the book arts as they traveled in their tiny home on wheels. They kept a blog documenting their travels (see Contributing and Referenced Artists on page 276).

Capucheta
(Paper Kite)

DESIGNED BY Scott Skinner
PAPER USED 96 gsm marbled jute paper. Jute fibers are hand-cut from recycled rope, then formed into sheets of paper. Artisans in Bangladesh marble this paper by hand.
LOOK FOR This kite flies best when made from a sturdy text-weight paper.

In Brazil, a kite is known as a pipa. The children there competitively fly kites with glass-coated lines, which, when maneuvered correctly, can cut the lines of their opponents' kites. The losers' kites drift down onto the housetops, trees, or power lines. Children who can't afford kites of their own aggressively pursue these fallen kites, then give them a second life by repairing and flying them.

This capucheta, or simple paper kite, is a great flying alternative. It is easy and inexpensive to make, doesn't require sticks for a frame, and mimics the flying characteristics of a real pipa. It is said that when flown by a skilled youngster, a capucheta can even defeat a real pipa.

Materials

- 12" square of decorative light-weight art paper for the kite
- Transparent tape
- Kite-flying line and winder
- Enough 1" strips of the same paper used for the kite to create a 5'-long tail

Tools

- Ruler
- Pencil
- Scissors
- Sewing needle with an eye large enough for the kite line

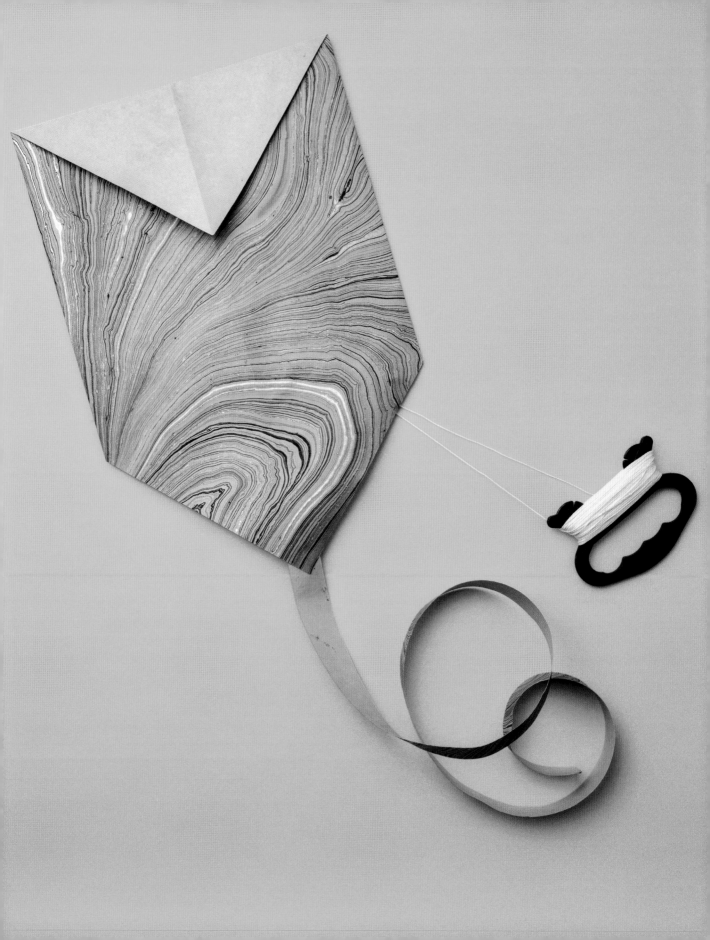

Instructions

1 Place the square of your project paper with the display side face-down on your work surface in a diamond orientation. With a ruler and pencil, measure and lightly mark the center. Fold in three corners to meet at the center.

2 Turn the paper over (display side faceup) and reverse the top fold, folding it down, corner to center.

3 Turn the kite over again (display side facedown) and fold it in half longitudinally. Unfold.

4 Fold the two points that meet at the center back about 1" on each side. Reinforce each of these folds with a rectangle of tape that wraps from the front around to the back.

Continued on page 99

1

2

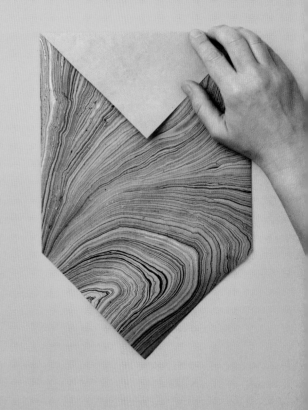

3

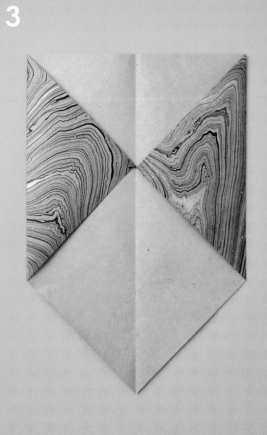

4

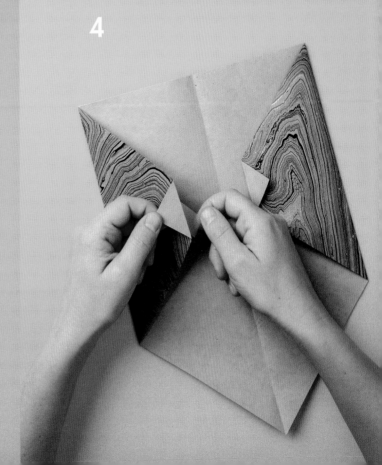

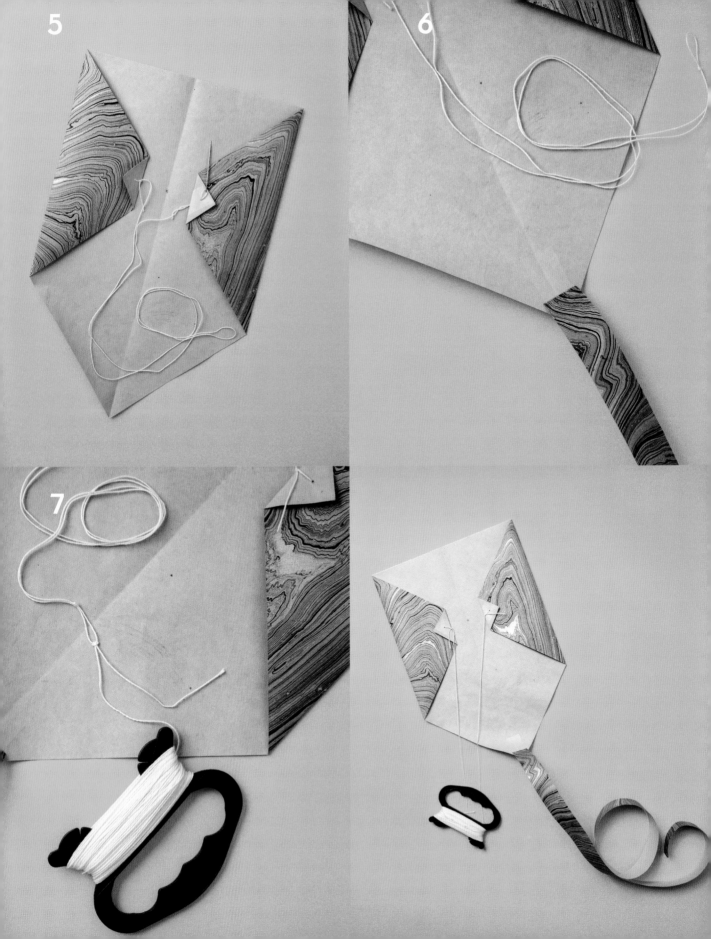

5 With scissors, cut a 4' length of kite-flying line from the winder. Thread the flying line into a needle and, in the center of one of the taped corners, pierce a hole through both layers and bring the needle through from underneath. Pull the line through and tie a square knot (see page 273) around the flat edge of the corner. Thread the needle onto the other end of the line and repeat to attach the line to the other corner. This is the bridle line. Find the center of the bridle line by holding the two kite corners together and drawing both sides of the bridle line together. Tie an overhand knot (see page 273), leaving a loop.

6 Tape a few of the 1"-wide strips together to create a 5'-long tail. On the back of the lower triangle flap, place one end of the tail faceup near the point of the triangle, so that the two tips almost touch the diagonal ends; tape it in place.

7 Make a loop in the end of your flying line, and secure it around the center loop of the bridle with a lark's head knot (see page 272). Fly in an open field away from trees or power lines.

ARTIST

SCOTT SKINNER is a professional kite maker, kite flyer, kite collector, and author. For 25 years, he led the Drachen Foundation, which works to educate people around the world about kites. Skinner likes that through kite flying he meets people from many other flying disciplines, such as balloonists, boomerang flyers, paper airplane builders, glider pilots, and fixed-wing pilots. At one such meeting, he found himself among a group of paragliding pilots, and one of them described his childhood experience of flying kites in Brazil, which led to this project.

Scott Skinner, *Paper and Bamboo Kite,* **2019.** Antique kite photos printed on Japanese washi pieced in a Sode kite design; 40" × 45".

Peace
Tree Card

DESIGNED BY Helen Hiebert
PAPER USED 78 lb. corrugated paper
LOOK FOR Corrugated papers are available in a variety of colors at some art supply stores and online. They are a bit tricky to cut, but they are sturdy. You can use any card stock for this project, and feel free to decorate the tree.

Tuck this card into an envelope and mail it to a friend. When they unfold the card, the message will be deciphered.

Materials

- Template (page 284)
- 5" × 12" sheet of card stock
- Printer paper (optional)
- Removable tape (optional)

Tools

- Scissors (optional)
- Craft knife
- Cutting mat
- Straightedge
- Bone folder

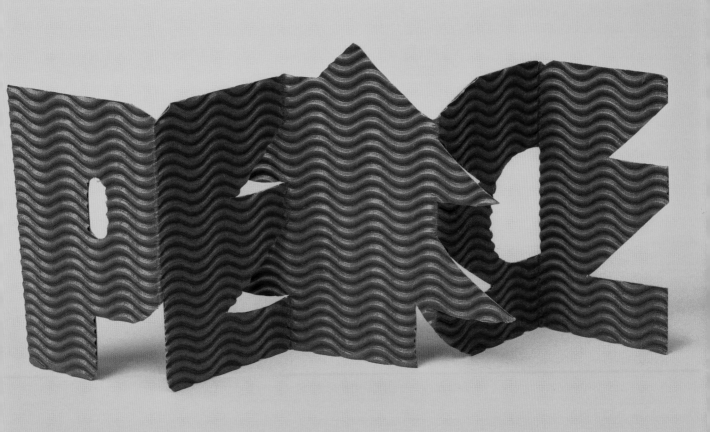

This card has had many lives: I designed it in a graphic design class at the School of Visual Arts in New York City in the late 1980s. Here's how it looked then.

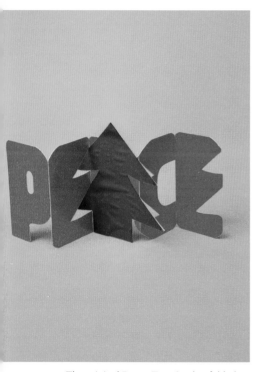

The original Peace Tree Card unfolded

Instructions

1 Photocopy or print the template onto the project paper (see Working with Templates on page 28 and the Template Key on page 280), then cut it out with scissors or a craft knife. Or photocopy or print the template onto printer paper and tape it to the project paper, then tape both sheets to your cutting mat. Carefully cut around the edges, cutting through both the template and the project paper, to create the outer shape of the card.

TIP: Reposition the tape to hold the template and corrugated paper together as necessary while you cut.

2 Use a craft knife and cutting mat to cut along the rest of the solid lines, removing the hole in the *P* and the center of the *C*. Be sure to cut along the inner tree branches in the *E* and the *C*.

3 Use a straightedge and bone folder to score along all of the dotted lines.

4 If the template is taped to your project paper, remove it now. Accordion-fold the card, starting with a mountain fold so that the *P* ends up on top.

1

Peace Card

2

Peace

3

Spring
Shamrock

DESIGNED BY Helen Hiebert
PAPER USED 100 gsm marbled jade paper. This is a handmade 100 percent cotton sheet featuring a rich batik-style pattern that's unique to each sheet.
LOOK FOR You'll need a thin paper that holds up to lots of folding and cutting through several layers.

Have you ever hunted for a four-leaf clover? It's practically impossible to find one. Statistically speaking, there are 10,000 three-leaf clovers to every four-leaf clover. Traditionally, each leaf is believed to represent something different: The first is for faith, the second is for hope, the third is for love, and the fourth is for luck. Here's to luck in creating your very own four-leaf clover.

Materials

- Template (page 282)
- Card stock
- 7" square of paper

Tools

- Pencil (optional)
- Bone folder (optional)
- Scissors
- Paper clip or small binder clip (optional)

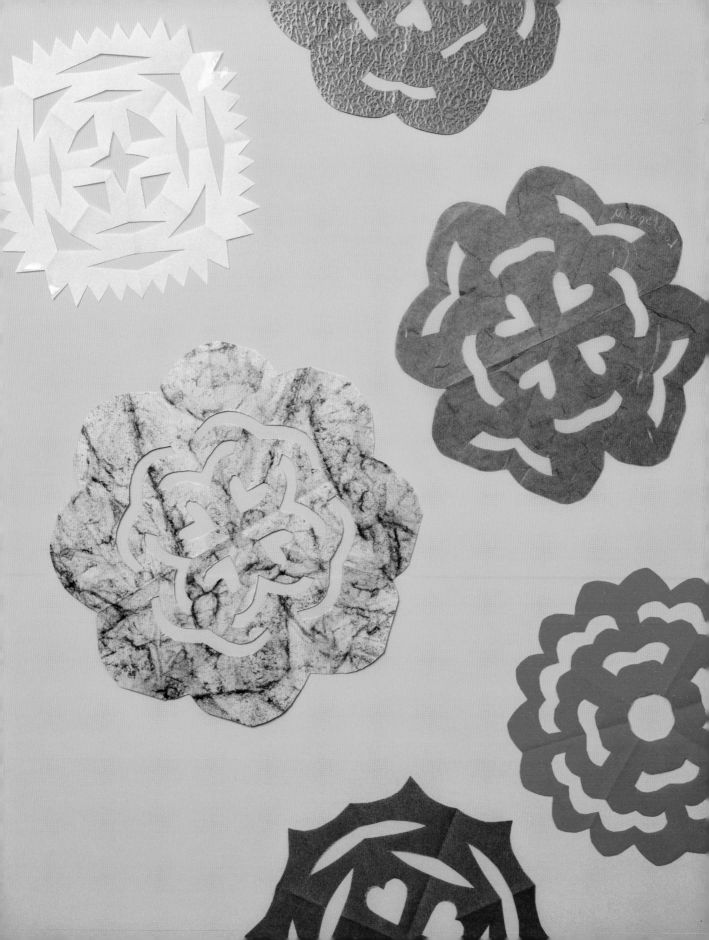

Instructions

1 Photocopy, print, or trace the template onto a piece of card stock and set aside for now (see Working with Templates on page 28 and the Template Key on page 280). Fold the square of project paper in half diagonally to create a two-layer triangle (A), in half again to create four layers (B), and then in half once more so that you have an eight-layer triangle (C).

TIP: I like to use a bone folder to reinforce creases when folding multiple layers.

2 Cut out the template and place it on the folded project paper (use a paper clip to hold it in place, if desired), orienting it so that the side with two cutouts is aligned with the single folded edge. The side with just one cutout will lie upon the edge with multiple folds.

3 Cut out all of the markings on the template, making sure to cut through all of the layers of paper at once.

4 Unfold to find your four-leaf clover. Good luck!

A PAPER-CUT LIFE CYCLE

Paper cutting is a tradition in many parts of the world, and contemporary paper artists are taking it to new heights. My limited-edition artist's book *Interluceo* features Béatrice Coron's exquisite paper-cut designs that illustrate the various stages in life, from birth to death. Here you see the baby in the womb. (For more about Coron, see page 130.)

Helen Hiebert, *Interluceo*, edition of 25, 2015. Artist-made watermarked cotton papers and deeply pigmented abaca papers, papercut illustrations by Béatrice Coron; page size: 9¼" × 9¼".

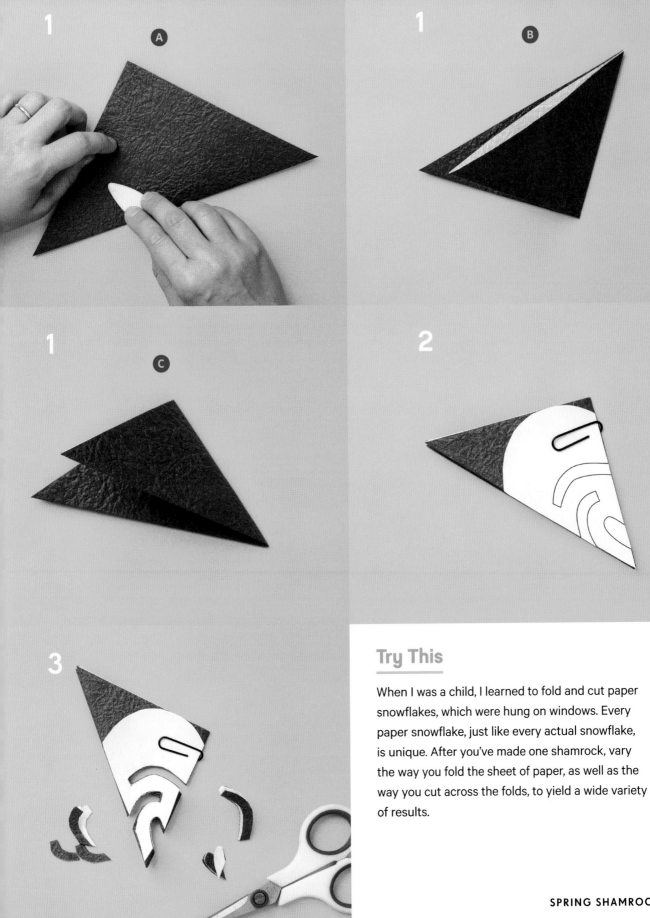

Try This

When I was a child, I learned to fold and cut paper snowflakes, which were hung on windows. Every paper snowflake, just like every actual snowflake, is unique. After you've made one shamrock, vary the way you fold the sheet of paper, as well as the way you cut across the folds, to yield a wide variety of results.

The Sheet's
the Stage

DESIGNED BY Paula Beardell Krieg

PAPER USED 90 lb. (150 gsm) Daler-Rowney Canford cover stock in aqua

LOOK FOR I purchased this paper at my local art supply store; it comes in many colors. Your paper needs to be sturdy enough to stand up and thin enough for the doubled folds.

TIP

You can embellish your stage by drawing designs with markers and/or collaging with decorative papers and glue. For even more fun, try making puppets to use with your stage.

Children are natural storytellers: Build a stage and they will create performances. This is an especially exciting project for young children who haven't mastered reading and writing but still have so much to say. Any size square can be used to make this stage, and it can be one of those perfect projects to create anytime, either with a child who is looking for an on-the-fly activity, or with one who wishes to go into stage design. Puppets can be as simple as three dots—two for the eyes and another for the mouth—on a fingertip.

Material

- Large square of paper (I started with 20" × 20")

Tools

- Bone folder and straightedge (optional)
- Pencil
- Scissors

Instructions

1 Fold the large square of project paper in half, corner to corner, to create a triangle. If needed, use a bone folder and straightedge to score the folds first.

2 Fold the lower right corner over to meet the lower left corner to form a smaller triangle.

3 With a pencil, draw a half arch on the center fold (A). With scissors, cut out the shape through all the layers of paper (B). Unfold the triangle to reveal the arch-shaped opening (C).

4 Fold both bottom corners to the bottom center to create a stand for your stage. Fold the upper tip of the triangle down to meet the top of the arched opening.

Paula Beardell Krieg, *Shades of Gray, Zhen Xian Bao,* 2019. Inkjet printing on Arches Johannot paper, Japanese Asahi bookcloth; 14" × 14" × 2" when fully opened.

ARTIST

PAULA BEARDELL KRIEG is an artist and educator who uses paper for drawings, decoration, and building. She loves to explore the internal structure of books, including the patterns of folds, the sewing and knotting of bindings, and how everything fits together. Krieg's work lies at the intersection of art and math, using color and line to illuminate symmetries and geometry in and on paper. She often collaborates with classroom teachers to design projects for arts-in-education classes and writes about her work in classrooms, as well as her own adventures with paper, on her blog (see Contributing and Referenced Artists on page 276).

"It seems to me that those of us who think about and make books have mathematical minds. We are always considering scale, visual relationships, transformations, and symmetries; we do lots of precise measuring and we need to be comfortable with numbers." —Paula Beardell Krieg

1

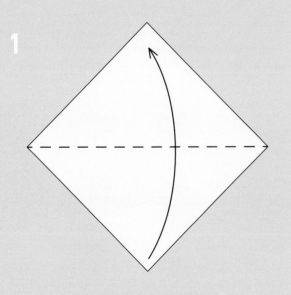

2

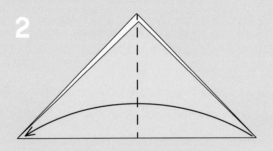

3 The cut-out pieces can be used as pages to write the script.

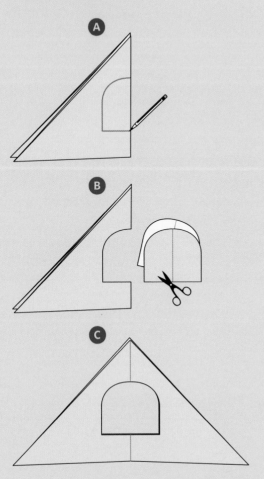

4 Make some puppets, set up your stage, and put on a show.

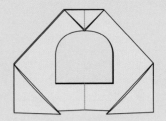

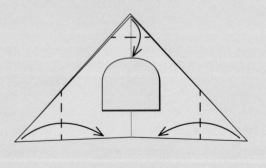

One-Sheet
Tree

DESIGNED BY Helen Hiebert; special thanks to Elissa Campbell of Blue Roof Designs for creating the prototype with the punched light strands.

PAPER USED Clear Path Paper fern green linen card stock

LOOK FOR You'll need a stiff card stock so that the finished project stands up tall like a tree. But the paper shouldn't be so stiff that your fingers ache from cutting.

Since we use trees to make paper, why not also create paper trees? This sleek design turns a flat sheet of paper into a dimensional tree with branches, without actually removing a thing (unless you decide to punch a few holes). One sheet of paper makes one tree, or you can easily create a small forest.

Materials

- Template (page 281)
- 9" × 12" sheet of card stock
- Printer paper (optional)
- Removable tape (optional)
- Stickers, beads, tinsel, sequins, and/or other decorations (optional)

Tools

- Bone folder
- Straightedge
- Craft knife
- Cutting mat
- Star or other hole punch (optional)

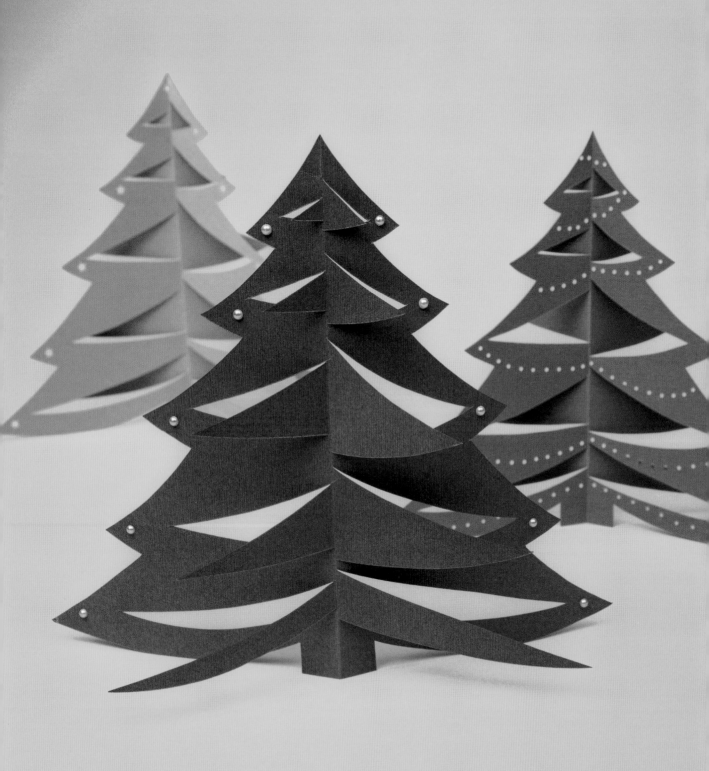

Instructions

1 Photocopy or print the template onto the back of the project paper (see Working with Templates on page 28 and the Template Key on page 280). If you can't print directly on the card, print the template on printer paper and tape it to your project paper, placing the bottom edge of the template along the 12" edge of the card stock (this ensures that the base of the card will be flat and will stand up when displayed). Use a bone folder and straightedge to score along the centerline.

2 Use a craft knife and cutting mat to cut out the card stock along all solid lines.

3 Trim your tree with stickers, beads, sequins, tinsel, or any other decorations, if you'd like. Another option is to use a hole punch to add interesting see-through shapes.

4 With the display side of the tree facing you, carefully valley-fold the outer edges of the branches along the vertical centerline, bringing them toward you, and mountain-fold the inner branch sections, pushing them away from you.

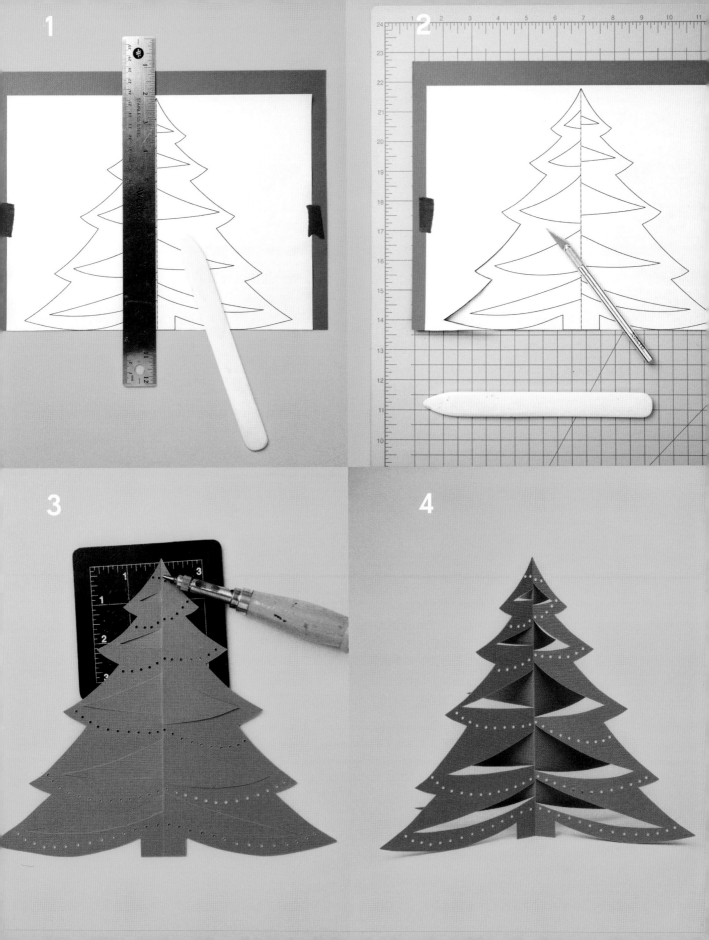

Pop-Up Alphabet

DESIGNED BY Helen Hiebert
PAPER USED 160 gsm Fabriano Tiziano
LOOK FOR Since there are so many folds, it is a good idea to have the grain of the paper running in the 8½" direction.

When I was in college, I saw a two-dimensional rendering of a font called BlockUp in a printed catalog. I took it on as a challenge to render the font in three dimensions. It isn't as simple as you might think! Create your own 3D alphabet and then arrange the letters to create fun pop-up messages. If you'd like, decorate each letter before folding it into its final form.

Materials

- Templates (pages 290–294)
- 5 sheets of 8½" × 11" card stock

Tools

- Craft knife
- Metal straightedge
- Cutting mat
- Bone folder

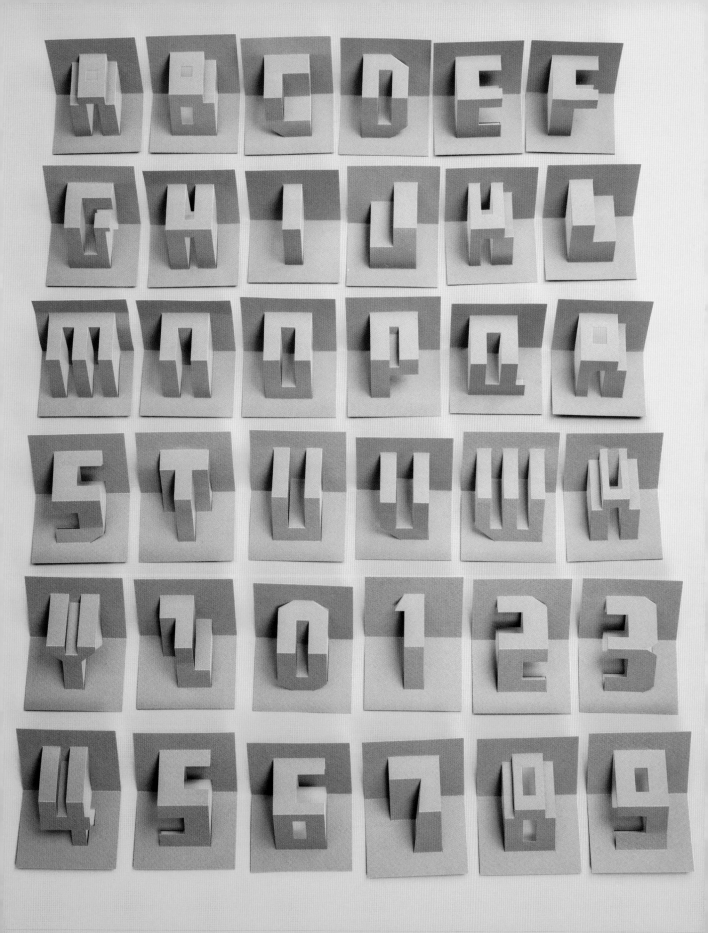

Instructions

1 Photocopy or print the templates onto five sheets of your project paper (see Working with Templates on page 28 and the Template Key on page 280).

2 Using a craft knife, straightedge, and cutting mat, cut along the solid outer lines to create 26 rectangular cards.

3 Cut along the solid inner lines on each card, and score along the dotted lines with a bone folder.

4 Follow the scoring patterns to create mountain and valley folds as indicated on the templates as you construct a three-dimensional alphabet. The scoring lines from the templates will likely show up on your folded models, but I think this adds an interesting graphic element to the final letters.

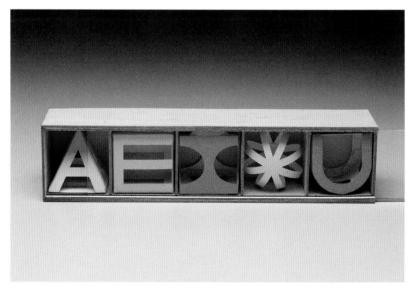

Helen Hiebert, *Sound Blocks*, 2010. Artist-made double-sided cotton paper, cherrywood box, glass; box size: 2" × 8½" × 2"; individual letters are approximately 2" × 2" × 2".

This is a series of one-sheet vowels that can be lined up, stacked, or scattered, creating a visual and tactile play on letters and language.

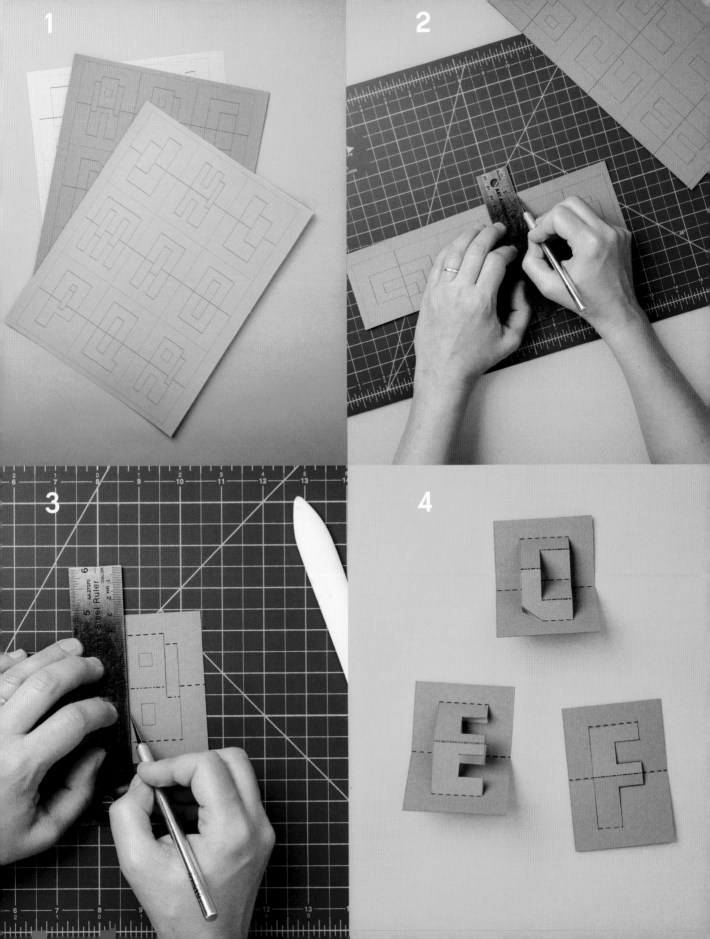

Slice-Form
Heart

DESIGNED BY Helen Hiebert
PAPER USED 100–110 gsm
Indian Soft-Hearted gold
LOOK FOR A lightweight but
sturdy card stock. Keep in mind
that you'll be cutting curves and
slits into it, so you'll want a paper
that isn't terribly difficult to cut.
I was able to use scissors for
most of the cuts.

This slice-form construction looks tricky at first, but once you've cut the parts and pieces, it turns into a puzzle that's similar to an interlocking house of cards. Assembling all of the parts and pieces takes a bit of mental work, just like the emotion this card symbolizes: LOVE.

Materials

- Templates (page 288)
- 8" square of decorative light-weight card stock

Tools

- Pencil (optional)
- Scissors (optional)
- Craft knife and cutting mat
- Awl
- Ruler
- Small piece of foam core

Instructions

1 Photocopy, print, or trace the templates onto the back of your project paper (see Working with Templates on page 28 and the Template Key on page 280), then cut them out with scissors or a craft knife and cutting mat.

2 If tracing the template, use an awl to mark and pierce the ends of the slits. Carefully cut the slits in each heart using a craft knife and mat, then cut out the concentric hearts. You will end up with six hearts from each template, for a total of 12: four tiny hearts (to discard or use elsewhere), four identical medium hearts, and four larger hearts with a tab at their bottom. (Note that the two pairs of larger hearts have a different slit pattern.)

3 Connect the four large hearts by interlocking two alternating slit patterns at a time, using the innermost set of slits. Slip the top of one heart with a top slit into the bottom slit of the adjacent heart and then carefully manipulate the paper to interlock the bottom sections. Repeat to connect all four large hearts.

4 Add the second layer of smaller hearts by carefully slipping the rounded end of a larger heart into the long slit on the smaller heart. In other words, tuck the top edge of the smaller heart into the top slit on the larger heart, and then carefully bend and tuck the bottom slit on the larger heart and unfold it into place. Repeat to attach the remaining three hearts.

**Paul Johnson, spread one of
Septuagenarian Tree House Dwellers,
2021.** Watercolor paper, industrial textile dyes, pen, and watercolor; 11" × 7". This unique sculptural accordion book features stylized interlocking diamond-shaped trees.

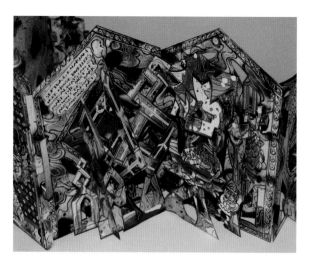

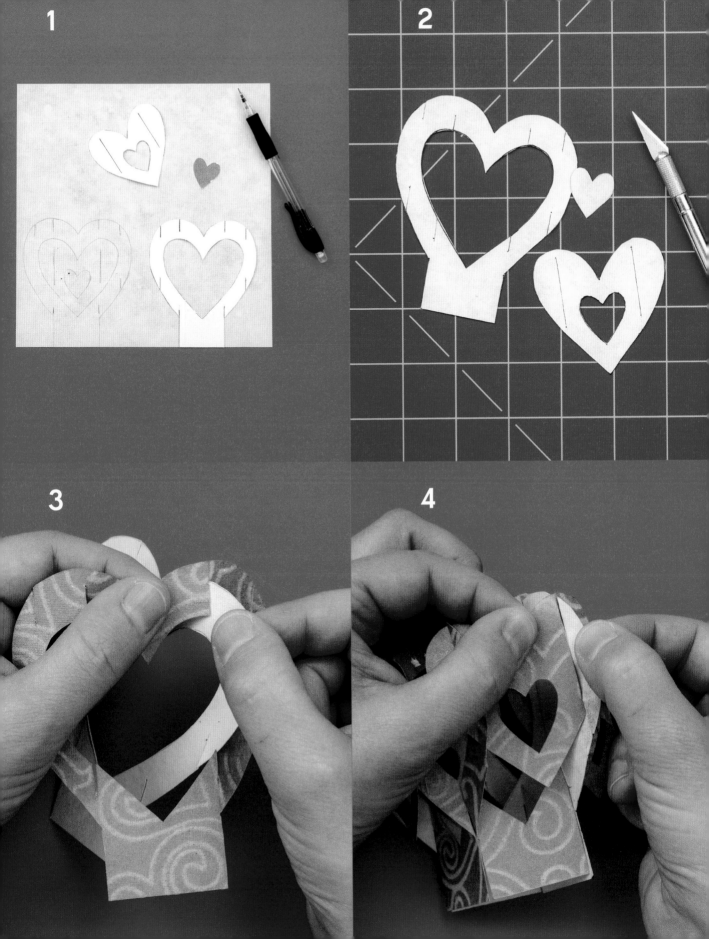

Reconstructed
Bauhaus
Exercise

DESIGNED BY Eric Gjerde
PAPER USED 140 gsm Mirri Sparkle. This is a sparkly paper with a lightly textured surface. To prevent glitter from flaking off, a special metallic sheet is laminated onto a pure white.
LOOK FOR Any cover-weight paper. It is best if the grain direction runs in the longer dimension.

The Bauhaus was a German art school that ran from 1919 to 1933 and became famous for its approach to design: combining beauty with function, while attempting to unify the principles of mass production with individual artistic vision. Eric Gjerde researches and reverse-engineers the paper exercises that were part of the Bauhaus curriculum. In this project, the simple act of repetition—cutting, scoring, and folding parallel lines of different lengths from a single sheet of paper, without removing any waste—results in a complex and beautiful architectural form that begs to be viewed (and studied) from all angles.

Materials

- Template (page 296)
- 8½" × 11" sheet of cover-weight paper

Tools

- Craft knife
- Metal straightedge
- Cutting mat
- Bone folder
- Scissors (optional)

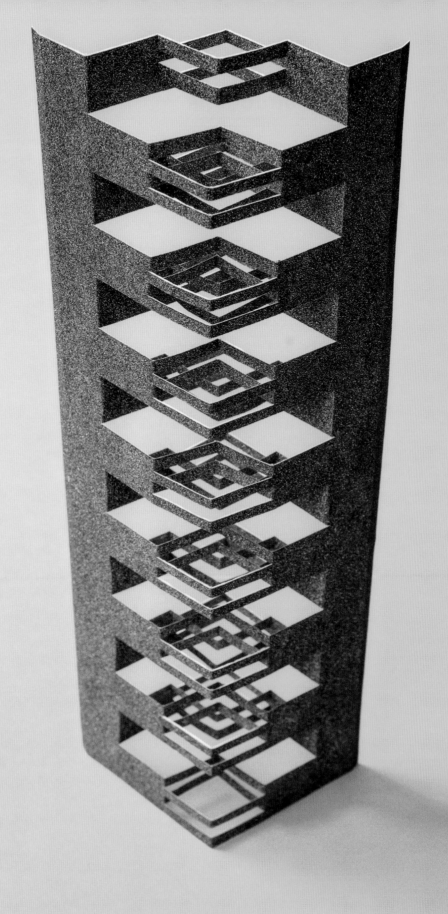

When asked by his parents what he wanted to be when he grew up, 5-year-old **ERIC GJERDE** replied, "A paper-ologist." Throughout his childhood and adolescence, Gjerde enjoyed paper crafts and origami—and his spark for experimentation and knowledge sharing has carried him to several corners of the paper art and design world, from reverse-engineering Bauhaus paper-folding exercises to offering professional insight into traditional Islamic geometry techniques in Istanbul. Gjerde shares his talent through hands-on workshops, origami conventions, art exhibitions, and his popular website (see Contributing and Referenced Artists on page 276).

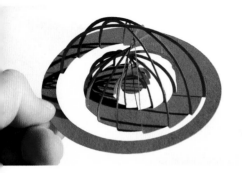

Eric Gjerde, *Bauhaus Exercise,* **2017.**
Laser-cut handmade flax and abaca
paper; 4" × 4" × 3".

Instructions

1 For this project, it is best to photocopy or print the template onto the back of your project paper (see Working with Templates on page 28 and the Template Key on page 280). Cut out along the outer lines.

2 Using a sharp craft knife, straightedge, and cutting mat, carefully cut along all of the solid horizontal lines. Use a bone folder to score along all of the vertical fold lines.

 TIP: To create really sharp fold lines on thick paper, you can cut-score by cutting partway through the paper with a craft knife, as shown. Having sharp lines is helpful when making multiple small precise folds. You don't want to end up cutting so deep that the paper breaks, so make a few test cuts to see how they fold.

3 With the template side facedown, valley-fold the model in half lengthwise, and then mountain-fold the two long edges.

4 Use the template and/or the photo of the finished piece to guide you in folding and popping out the details in the paper column. I find it helpful to use the tip of my cutting knife or another pointed implement to prod the small pieces in and out. Collapse the folded column in half to reinforce all of the folds.

 TIP: You can make this model with scissors by folding the sheet of paper in half, cutting along the guidelines, and then folding each small section back and forth along the score lines. Unfold and refer to the photo of the finished piece to guide you in popping out the details.

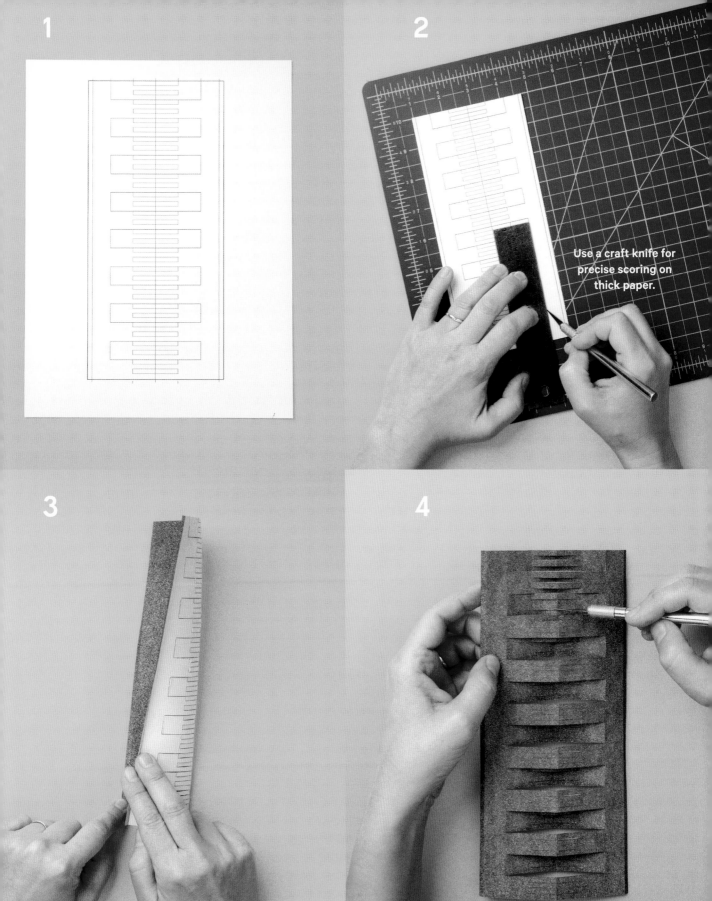

1

2

Use a craft knife for
precise scoring on
thick paper.

3

4

Storytelling
Mask

DESIGNED BY Béatrice Coron
PAPER USED Tyvek
LOOK FOR A sturdy paper that won't tear easily works best.

Béatrice Coron designed this charming face mask and claims "masking and revealing are essential to storytelling. Make this mask to wear, use as room décor, or send in an envelope, and the stories will develop by themselves." Put on this mask and tell *your* story.

Materials

- Template (page 294)
- Printer paper
- 9" × 12" piece of Tyvek
- Ribbon or string (optional)

Tools

- Pencil (optional)
- Acrylic or watercolor paint or liquid matte medium
- Foam brush
- Paper towel (optional)
- Stapler
- Craft knife
- Cutting mat
- Scissors (optional)

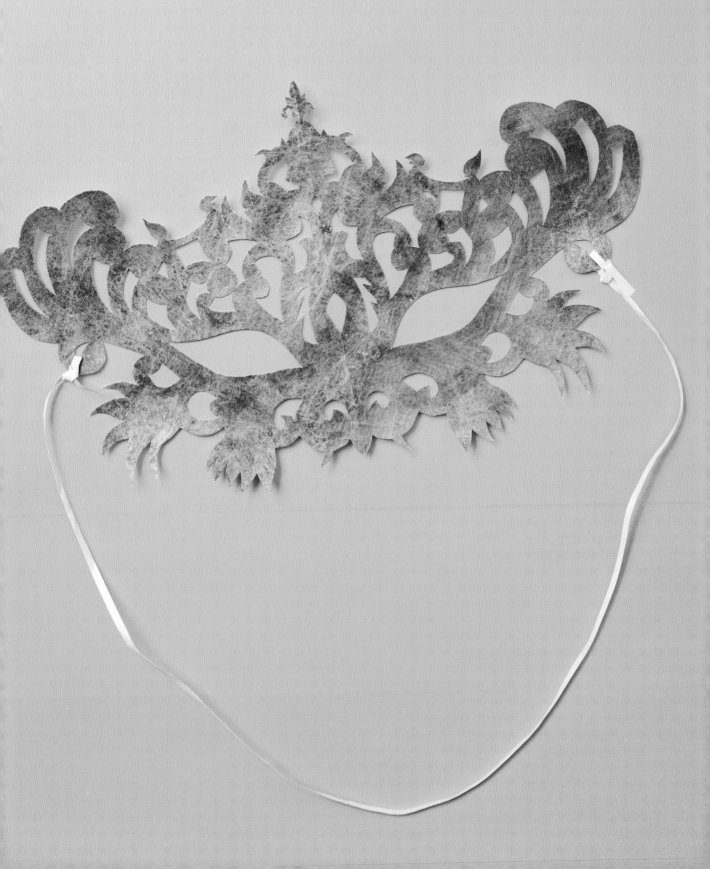

ARTIST

Born and raised in France, **BÉATRICE CORON** lived in Egypt, Mexico, and China before moving to New York, where she became an artist. For the last 25 years, Coron has explored visual storytelling through artist's books, paper cutting, and public art. All of her visual stories can be read with multiple interpretations. She adapts her paper-cut designs in metal, stone, and glass, and she favors creative expression that encompasses all of her creative instincts. Coron has spoken about her creative process in a TED Talk, and you can see her public art in New York, Chicago, Los Angeles, Cleveland, and Asheville.

Béatrice Coron, *Listen to Your Dreams*, Fashion Warriors series, 2018.
Hand-cut Tyvek; 83" × 33".

Instructions

1 Photocopy, print, or trace the template onto printer paper (see Working with Templates on page 28 and the Template Key on page 280). Do not cut it out; set it aside for now.

2 Stain the Tyvek, if desired, by brushing the paint onto it with a foam brush. Rub the paint into the Tyvek with the foam brush or a paper towel and let dry.

3 Fold the Tyvek in half, short side to short side, and align the template on the center fold. Staple together the template and the two halves of Tyvek, placing the staples in areas that will be cut away, such as around the outside edges of the template and in a few of the larger holes, like the eyes.

4 Holding your craft knife like a pen, place the Tyvek/template on a cutting mat and cut out the template, cutting through all the layers. Make the cuts by bringing the knife toward you, and turn the paper (rather than your arm or your hand) so that you are in the correct position as you cut. First cut the holes that are not stapled, then cut the outside edges, and then cut out the stapled holes.

 TIP: To produce clean angles when cutting with a craft knife, start from the point of the paper and finish the cut in the middle of a curve. I like to cut the outer edges of the mask with fine scissors.

5 Unfold the mask. Cut some thin Tyvek ribbons or use another type of ribbon or string to tie your mask.

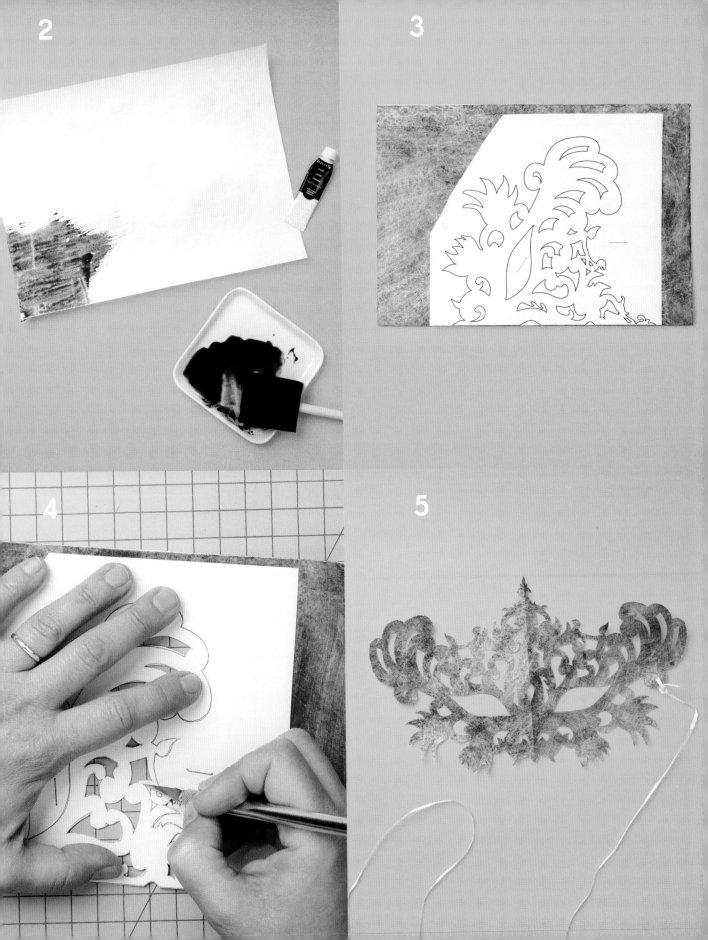

CHAPTER 6

Constructing

Adhesives, Embroidery, Electronics & More

LET'S ADD A FEW MORE ELEMENTS beyond folding and cutting. In this chapter, we'll use adhesives, which allow you to bring paper into even more sculptural arenas. You can also explore making a sheet of paper, connecting sheets with other types of fasteners, and creating one long strand of paper thread, all from single sheets of paper.

One-Sheet Book
Luminaria

DESIGNED BY Helen Hiebert
PAPER USED Vibrant Striped Batik Lokta. Nepalese lokta paper is a strong, durable, and eco-friendly paper handmade from the fiber of the daphne shrub, or lokta bush.
LOOK FOR Use any paper that looks good when held to the light.

This is a quick and easy adaptation of the O-Cut one-sheet book (see page 88) that uses the same central box shape and changes the proportions of the folds. It can easily be adapted in multiple sizes. Place a battery-operated tea light inside and watch your lantern glow.

Materials

- 6" × 9" sheet of paper
- PVA glue or double-sided tape
- Battery-operated tea light

Tools

- Pencil
- Ruler
- Bone folder
- Craft knife
- Cutting mat
- Glue brush (to spread the glue, if desired; optional)

Instructions

1 Fold the sheet of project paper in half lengthwise to 4½" × 6". Fold the sheet in half the other way, creating four layers of paper, then unfold so the paper is again just two layers. Use a pencil and ruler to mark ½" in from both short edges. With a bone folder and ruler, score through both layers of paper along the short edges, at the ½" marks you just made, to crease and form the side seams.

2 Unfold the paper completely. Use a craft knife and cutting mat to cut along the creased line between the two side seams.

3 Apply glue or double-sided tape to the side seams.

4 Fold along the scored and creased lines to create a boxlike structure. Set up your lantern, turn on the tea light, and watch it glow.

Helen Hiebert, *Cosmology*, edition of 50, 2012. Artist-made 100 percent cotton paper featuring a pigmented pulp lamination; approximate size when folded 6" × 12" × 6". Letterpress printing by Diane Jacobs; laser cutting by Joe Freedman.

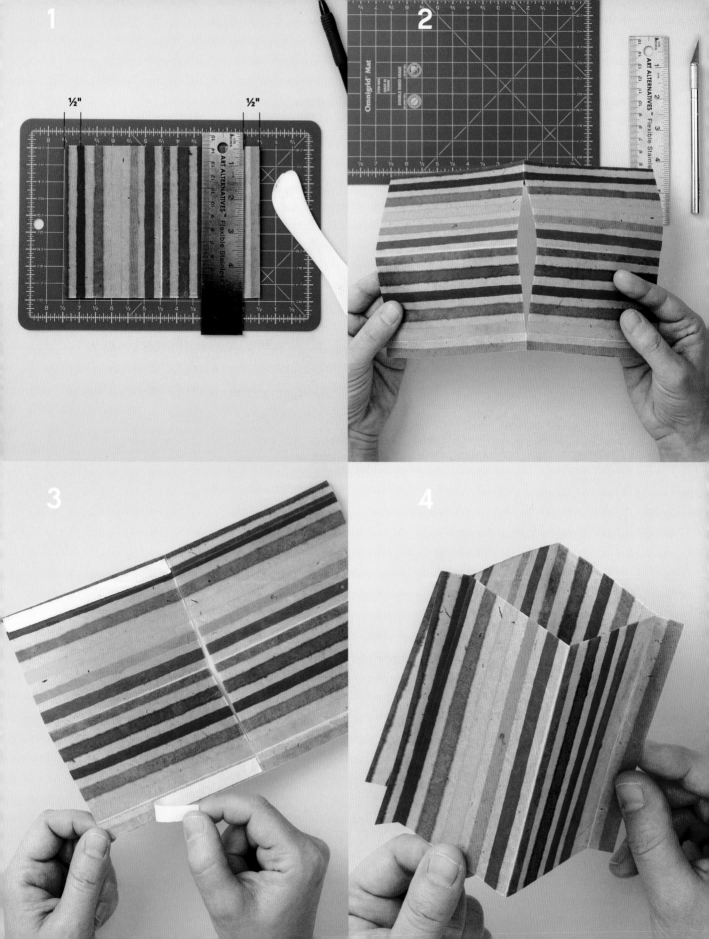

Floral
Lantern

DESIGNED BY Helen Hiebert
PAPER USED Narcissus
Reminiscence Paper

LOOK FOR A stiff text-weight paper or a lightweight cover paper. Not all papers will curl like this one did. Test the curl factor on a small strip of the paper you are considering.

Turn a sheet of paper into this uniquely shaped lantern or vase by connecting a square, four triangles, and a few tabs. Then add a twist to those geometric shapes by curling the papery ends. Just pull the paper along the edge of a pair of scissors—like with a ribbon—and watch curlicues form. This project was inspired by a tea bag pouch. I'm always looking at packaging and other printed materials for inspiration— it is a great way to come up with new designs.

Materials

- Template (page 287)
- 8½" × 11" sheet of decorative text-weight paper
- Double-sided tape
- Battery-operated tea light

Tools

- Pencil (optional)
- Craft knife
- Cutting mat
- Bone folder
- Straightedge
- Eraser
- Scissors

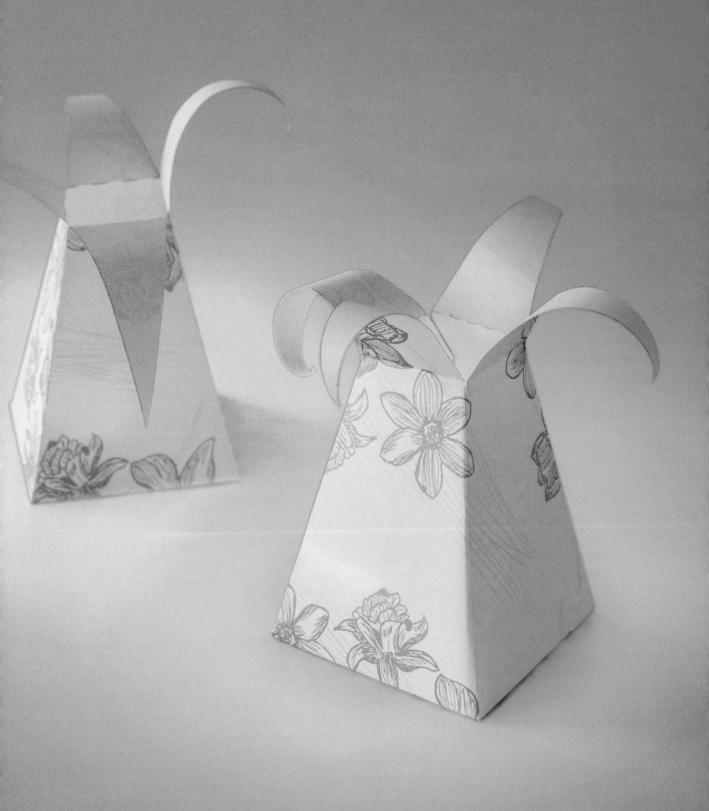

Instructions

1 Photocopy, print, or trace the outline of the template onto the back of your project paper (see Working with Templates on page 28 and the Template Key on page 280). Use a craft knife and cutting mat to cut along the solid lines and a bone folder and straightedge to score along the dashed lines as indicated on the template.

2 Mountain- and valley-fold according to the template. Erase any pencil marks.

3 Apply double-sided tape to the four ½" flaps on the display side of the paper (you don't need any adhesive on the square base). Adhere the side flap to the body. Connect the bottom square to the three remaining flaps to create the base of the lantern. You may need to stick your bone folder inside to press the adhesive into place.

4 For curling the triangular flaps, try this first on a piece of scrap paper: Open the scissors wide and hold the blade behind one of the triangular flaps. Anchor the scissor blade with your thumb and slowly draw the scissor upward, pressing the flap between your thumb and the blade, while pinching the bottom of the flap in place between your other thumb and forefinger. Repeat on all four triangles to curl the flaps.

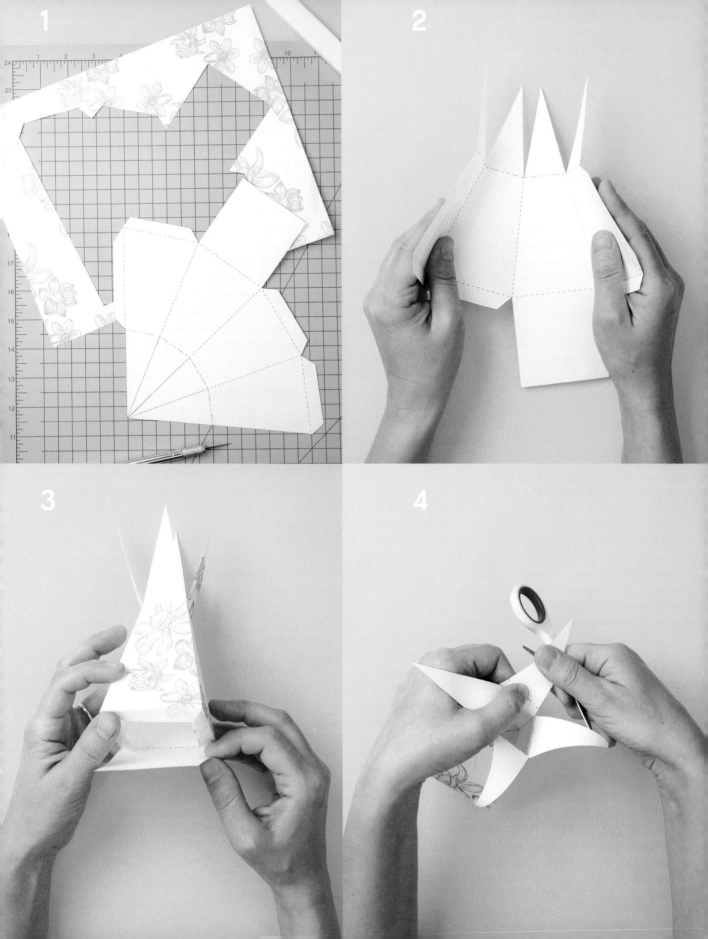

Plantable
Paper

DESIGNED BY Arnold Grummer
PAPER USED Toilet paper

LOOK FOR If you wish to use more refined pulps, such as junk mail, recycled paper, or preprocessed papermaking fibers, you can process them in a blender or a Hollander beater.

This is probably the simplest form of papermaking, adapted from Arnold Grummer's tin can papermaking method. You need very little equipment to create sweet little shaped sheets of paper. This plantable paper project has three lives:

1. Embed seeds into a shaped sheet of handmade paper.
2. Once it dries, turn it into a gift tag, ornament, or card.
3. Plant the card and watch it grow. Now that's recycling.

Materials

- Toilet paper
- Hardy seeds (such as cosmos, cornflower, zinnia, and/or marigold)

Tools

- Glass jar with lid
- Plastic or wire mesh cut to 5" square
- Quart-size yogurt container or tin can
- Shaped cookie cutter
- Turkey baster (optional)
- Sheet of newspaper or paper towel
- Sponge or towel

Instructions

1 Add six squares of single-ply or three squares of double-ply toilet paper to 1 cup of water in a glass jar.

2 Put the lid on the jar and shake vigorously for 30 seconds or until the paper is completely broken up and the mixture is homogenous.

3 Place a mesh screen on top of a yogurt container or tin can, and set a cookie cutter on top of the mesh. Pour the paper pulp into the cookie cutter and give everything a little shake as the water drains so that the pulp settles evenly into the shape. If the pulp settles too quickly and doesn't fill the shape, put the pulp and water back in the jar, then adjust the amount of pulp and/or water as necessary, shake it up, and pour again.

4 Sprinkle 5–10 seeds on top of the sheet and press the seeds down into the fresh pulp, or use a turkey baster to squirt just enough additional pulp over the seeds to cover them.

5 Remove the cookie cutter and carefully flip your sheet of paper from the mesh onto a sheet of newspaper or a paper towel. Use a sponge or towel to press the excess water out of the pulp and allow the sheet to air-dry.

Kay Ferg, *Seed Paper Calling Card*, 2010. The pulp used to make the paper for this card came from recycled envelopes. Marigold, zinnia, and cornflower seeds were added to the pulp prior to forming the sheet using an Arnold Grummer's deckle box. The card is finished with embellishments from Club Scrap.

ARTIST

ARNOLD GRUMMER was an editor and faculty member of the Institute of Paper Chemistry in Appleton, Wisconsin, and served six years as curator of the Dard Hunter Paper Museum, housed at the institute. He wrote five books on papermaking and produced numerous instructional videos, still available on YouTube. His mantra, "wastepaper is not waste fiber," is the heartbeat of his simple and successful methods using wastepaper for pulp and household supplies for materials.

Along with his wife, Mabel, Grummer started his own company to share his books, educational programs, kits, and supplies to use at home and at school. In addition to products, you'll find a library of articles, projects, resources, and more on the Arnold Grummer's website (see Contributing and Referenced Artists on page 276).

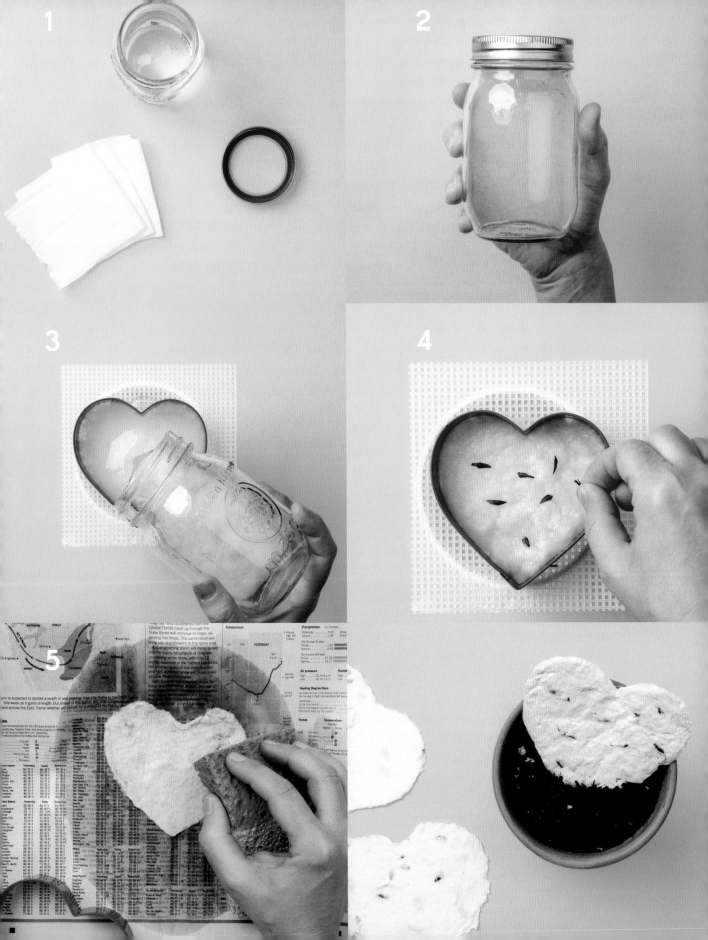

Gatefold
with Paper Washers

DESIGNED BY Susan Joy Share
PAPER USED Canson Colorline paper and handmade paper washers
LOOK FOR Any heavy card stock will work.

Gatefolds are commonly used in graphic design for printed brochures, custom announcements, and wedding invitations. The fold reminds me of a French door; it opens in an unusual way and provides an opportunity to print text that reads across a fold. Commercial gatefolds don't usually have a closure, but paper washers are a fun addition when you want to tuck something inside. These washers are stitched on but could also be attached with grommets or eyelets (see page 24).

Materials

- 6" × 18" sheet of heavy card stock, plus a smaller piece (approximately 4" × 4"), in a complementary color, if desired, for the washers
- Linen bookbinding thread
- 1" × 2½" strip of lightweight paper (for a bead; optional)
- PVA glue or glue stick (optional)

Tools

- Ruler
- Pencil
- Bone folder
- Craft knife
- Cutting mat
- Small drafting compass or circular object approximately 1" in diameter
- Scissors
- Awl
- Needle

Instructions

1 Using a ruler and pencil, divide the larger sheet of project paper into thirds lengthwise, making marks at 6" and 12". Score the paper widthwise at those marks with a bone folder. Fold the flaps, then unfold them.

TIP: You can start with any length of paper as long as the length is easily divisible by 3. (In this case, a 6" × 6" final product requires a strip 6" high by 18" long.)

2 Using the ruler as a guide, trim ⅛" off the outside edge of each flap with a craft knife.

3 Fold each flap in half, stopping just shy of the first fold. Then fold the doubled flaps in so their folded edges meet at the center. Adjust as needed.

TIP: If using a heavier card stock, measure, mark, and score these folds.

NOTE: If you plan on tucking something inside the gatefold, make double-scored folds, as described in Tips for Success on page 260, and adjust the outer flaps as needed.

4 With a pencil and compass, or by tracing around a small circular object, draw two 1"-diameter circles on the smaller piece of card stock and use scissors to cut them out. Use the awl to punch four small holes in the center of each circle (see Embroidery and Edging on page 151).

5 Place each circular washer about 1" from the center edge on either side of the two gate-folded panels. Punch corresponding holes through the doubled outer flaps.

6 Using a needle and linen bookbinding thread, sew a washer to the display side of each gate-folded panel. Leave a long tail of thread on one side for winding under the two washers. Be sure this tail rests between the washer and the project paper.

OPTIONAL FINISHING STEP: To add a paper bead at the end of the string for a nice finish, cover a strip of lightweight paper with PVA or glue. Then tightly roll the strip around the end of the string to form a bead.

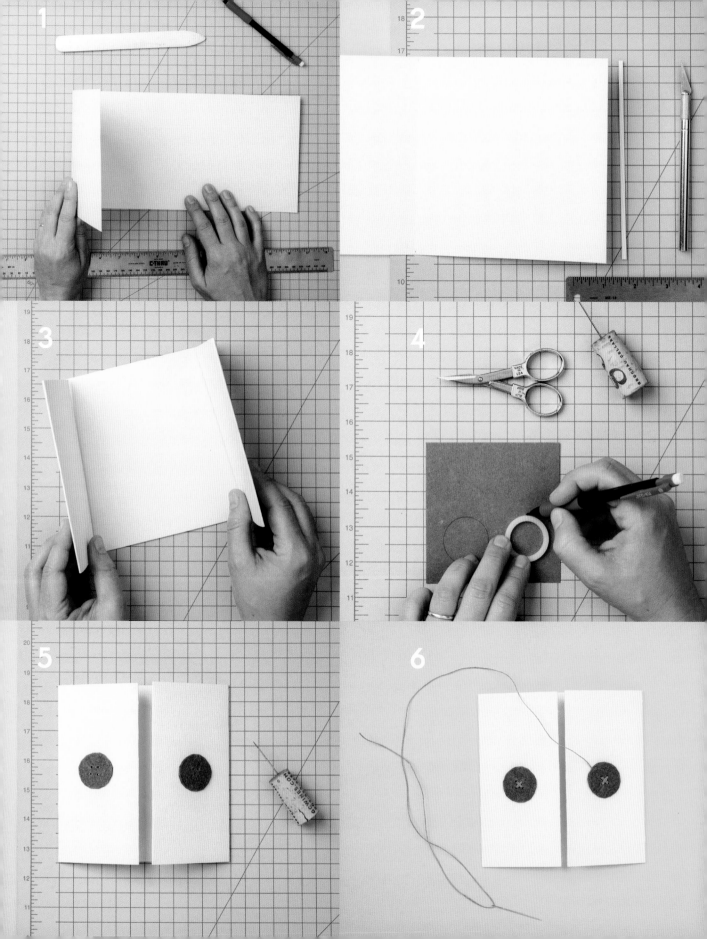

ARTIST

SUSAN JOY SHARE is a visual artist, bookbinder, and performer based in Anchorage, Alaska. Her passion for the book form—including its structural variations, materials, and potential for movement—blends with her interest in sculpture, painting, sewing, and collage. She creates kinetic forms, architectural spaces, costumes, and experimental books that integrate visual depth, movement, and sound.

Susan Joy Share, *Zip-off Fence*, 2005. Mixed media on paper, zippers, welding and fiberglass rods, cord, plastic, twist ties; 48" × 168" × 60".

This sculpture is composed of 26 panels connected by 36"-long zippers. It stands on delicate metal legs, and the surfaces contain perforations, cut shapes, drawings, and translucent areas. The scattered phrases—"a way of dividing" and "a way of distancing"—describe fences as barriers, yet the zippers indicate the possibility of opening.

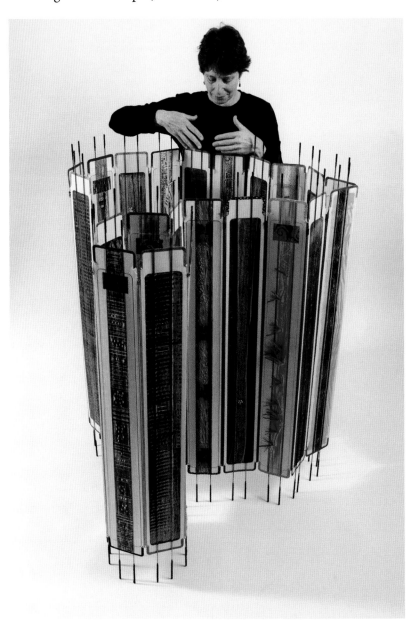

EMBROIDERY AND EDGING

When stitching on paper, you will want to prepunch the sewing holes. Mark the desired holes with a pencil, set the paper on top of a piece of cardboard, and punch through both with an awl. Adjust hole sizes as needed. Experiment with different embroidery stitches, such as blanket stitch, French knots, and chain. If you're not familiar with these stitches, you can learn them from any basic embroidery book or an online tutorial.

Swirling Flower

DESIGNED BY Helen Hiebert
PAPER USED Thai Marbled Momi. This marbled paper is machine-made from a pulp containing bamboo and kozo (paper mulberry) fibers. Oil-based paints floating on water are moved around to create a swirling pattern. The paper is then laid atop the water, where it attracts the swirling paint pattern. This artistic technique creates a one-of-a-kind design each time.
LOOK FOR A thin paper that folds well. Marbled patterns create lovely designs when folded and swirled.

Accordion folds seem so basic, yet they can yield a wide variety of results. The tighter you fold, the more flexible the sheet of paper becomes. This swirling flower form is particularly striking with a marbled paper. Just cut a sheet in half, accordion-fold, snip the edges, and swirl it around a miniature spool.

Materials

- 8" × 11¼" sheet of paper, cut in half to yield two 4" × 11¼" pieces
- Double-sided tape or PVA glue
- ¾" × ⅝" wooden thread spool (see Resources on page 275) and 1"-long screw that will fit into the hole of the spool (optional)

Tools

- Bone folder (optional)
- Scissors or craft knife and cutting mat
- Glue brush (if using PVA glue)

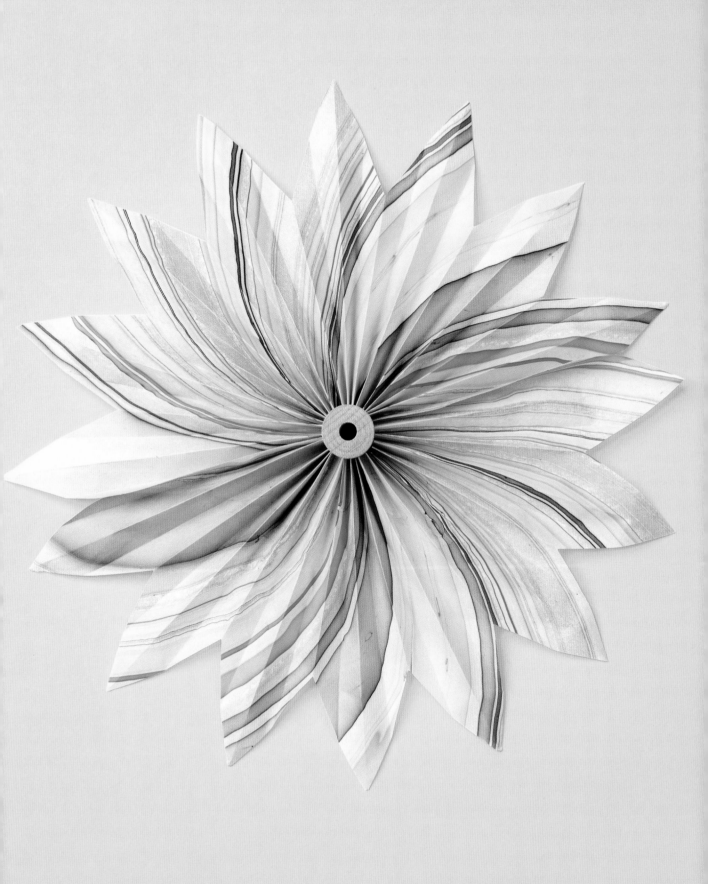

Instructions

1 Accordion-fold (see page 26) both pieces of project paper into 16 sections. If you like, use a bone folder to reinforce the creases as you fold.

2 For this step, shape one end of each piece of folded paper, one at a time, using scissors or a craft knife and cutting mat. Gathering the accordion folds, start approximately 1" down on an open (single-layer) edge and carefully cut a straight line or curve up to the point on the first fold. Use that first cut as a guide to cut through all of the layers, cutting through one or two accordion-folded sections at a time.

3 Fold another set of accordion folds on both pieces so that you end up with 32 accordion-folded sections on each.

4 Apply double-sided tape or brush a light layer of glue over the full length of one end of one piece, and attach the second piece to the first. Repeat to connect the two ends, forming a closed circle.

OPTIONAL FINISHING STEP (PICTURED BELOW): If you'd like to display the flower, affix the small spool to the wall with the screw, then carefully stretch the center of the flower and fit it over the spool. There is a lovely tension that holds this flower around the spool and to the wall. Alternatively, you could affix the back of the flower to a card, a gift, or whatever you'd like.

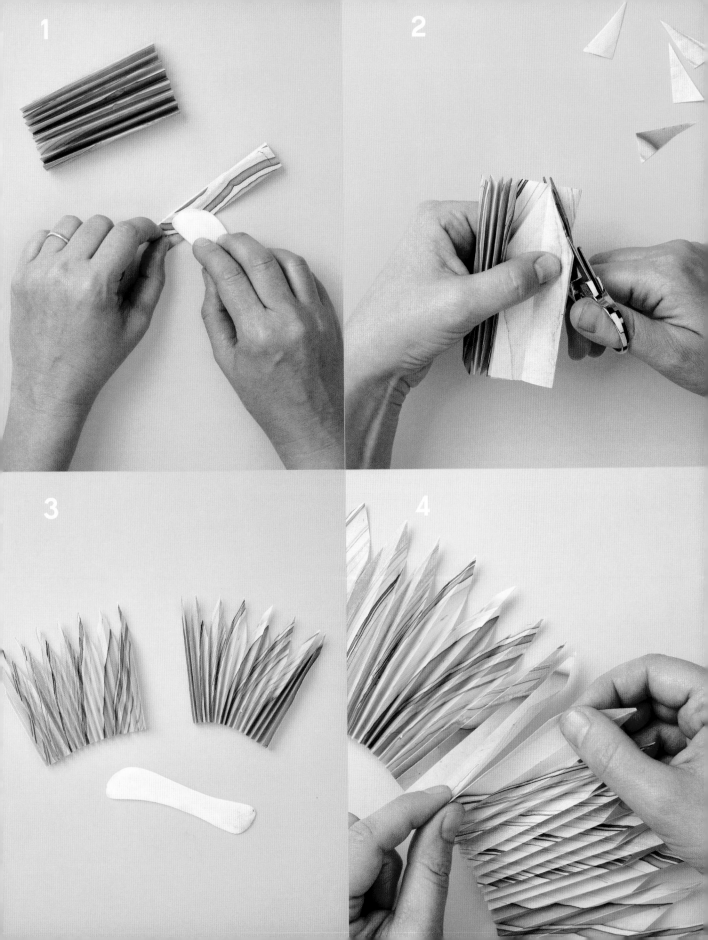

1

2

3

4

Wrist Cuff

DESIGNED BY Helen Hiebert
PAPER USED Kraft-Tex (see the sidebar on page 158)
LOOK FOR A thick and rugged paper works best.

TIP

It is a good idea to plan your design prior to punching holes.

Kraft-Tex is a washable leathery paper product that is used commercially to make all sorts of bags, backpacks, and containers. I discovered it in a specialty fabric shop, where I bought a couple of yards in earth tones, and it comes in bright colors, too. I paired the eyelets with some strips of leftover Kraft-Tex and a snap to create this wrist cuff. You can wash Kraft-Tex (prior to creating with it) to make it softer and to give it more of a worn leather look.

Materials

- 1¾" × 8½" strip (or desired size) of Kraft-Tex
- Eyelets in an assortment of shapes and sizes
- ⅝"-diameter snap

Tools

- Japanese screw punch
- Eyelet setter
- Hammer
- Cutting mat
- Snap-setting tools
- Mallet or hammer

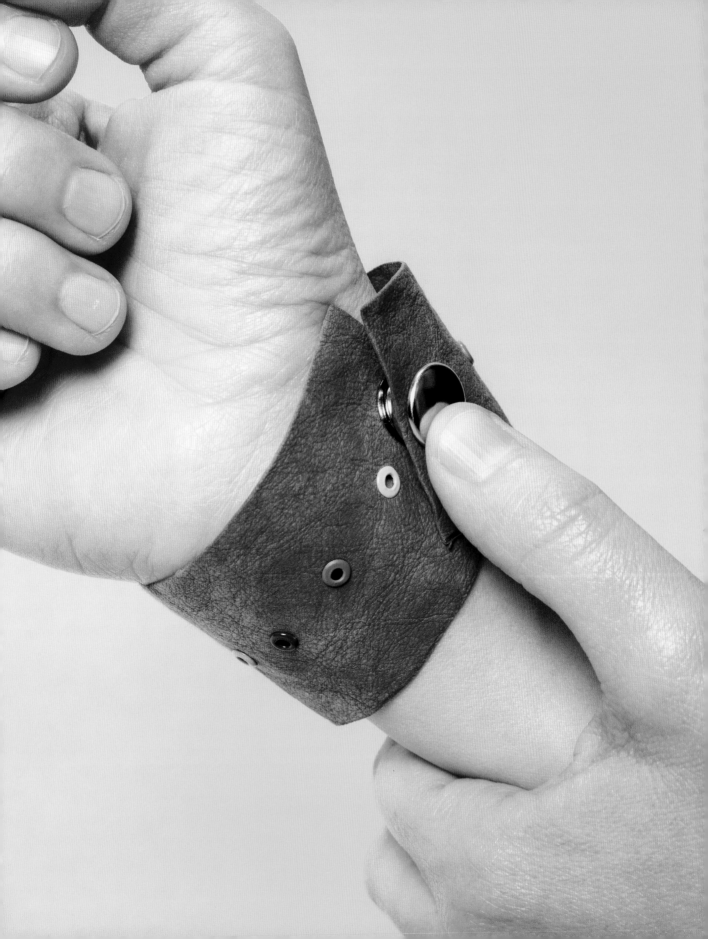

Kraft-Tex Kraft Paper Fabric is a thick, paper-based leathery material. It is sold by the yard in specialty sewing shops and online. You can also purchase packages of letter-size pieces, either prewashed or ready to wash.

Instructions

1 With a screw punch, make a hole in the Kraft-Tex strip slightly larger than an eyelet shank and placed wherever you would like an eyelet. (Leave about 1" at each end of the strip to accommodate the snap.) Secure the eyelet in the hole using the eyelet setter and a hammer (see page 24). To protect your work surface, set your eyelets on top of a cutting mat.

2 Repeat step 1 for as many eyelets as you want. Be sure to set the eyelets one at a time so that you can space them out as you like, especially if they are different shapes and sizes.

3 Follow these instructions to set the snap, making sure to place the male and female snap sections on opposite ends of the wrist cuff.

- About ½" from the end of the Kraft-Tex strip, and centered width-wise, measure, mark, and punch a hole slightly larger than the size of the snap shank. Repeat on the other end.

- On one side, push the snap cap through the Kraft-Tex, then place the socket over the cap with the wide-open part facing up. Place the cap on the die, concave side up, then place the flaring tool on the cap tube and tap it firmly with a mallet or hammer (A).

- On the other end, push the post through the Kraft-Tex and place the stud over the post (B). Place the post on the die, then place the flaring tool on the post tube and tap it firmly with a mallet or hammer.

NOTE: You might need to add a small square or two of Kraft-Tex between the snap parts so that the shanks are snug.

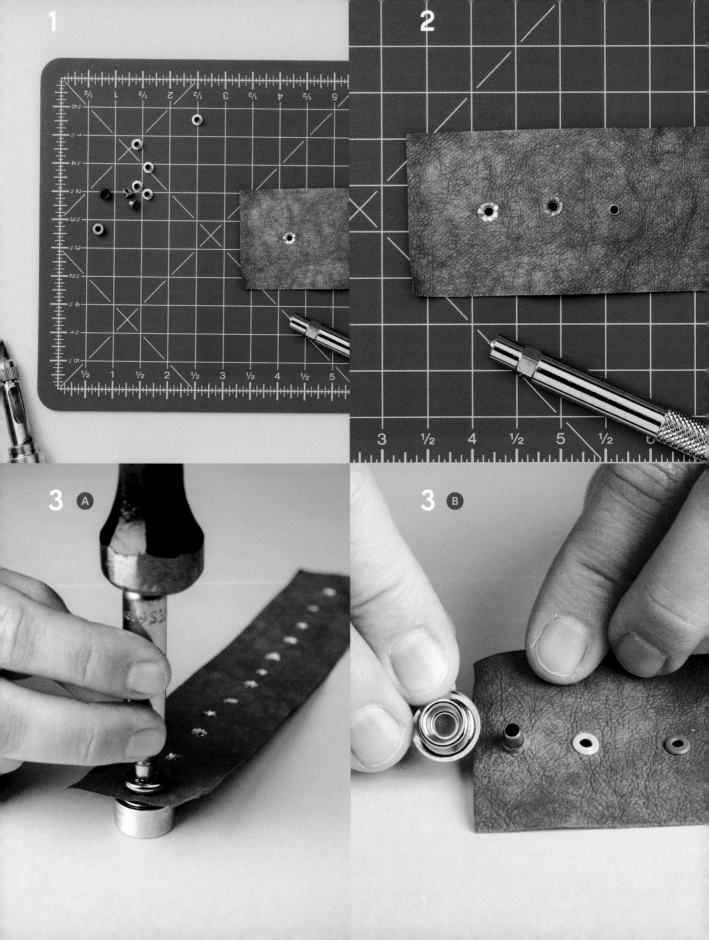

Pleated
Display
Stand

DESIGNED BY Hedi Kyle
PAPER USED Kraft paper
LOOK FOR Try with various papers and sizes. An 8½" × 11" sheet yields a small stand that fits business cards or small notes.

Kraft paper is one of those things we associate with groceries and school lunches, but here's a great way to elevate this simple material. With a series of pleats, right-angle folds, and a few minutes, you'll have a sweet little display stand to show off some paper ephemera.

Materials

- 12" × 18" sheet of paper, with the grain running in the 12" direction if possible
- Tape, PVA glue, or paper clips to secure the display stand
- 3 thin pieces of cardboard for stability (optional)

Tools

- Pencil
- Bone folder (optional)

Instructions

1 Place the project paper in a horizontal position (landscape). Align the bottom edge with the top edge. Don't fold; just pinch at the two sides to mark the middle.

2 Open up the paper. With a pencil, draw two small visible circles around the pinch marks. As you start to fold, the circles should face up. They will help ensure that you end up with mountain and valley folds in the proper locations.

3 Fold the paper in half, short side to short side, and then each half in half again, short side to the center fold. You will end up with four equal sections. Unfold. With the circles facing up, the first and third folds should be mountain folds.

4 Fold the two middle sections into an eight-section accordion (see How to Fold an Accordion on page 26).

5 Place the paper so that the wider extensions are at the top and bottom. Add two more accordion sections by bringing the bottom edge of the lower extension up to the first fold above it. Crease and reverse the fold you just made.

6 Fold the newly creased edge up again to that same first fold and crease it. Open up and flatten the piece. Starting at the top, number the folds from 1 to 11.

7 Reverse-fold #4 into a mountain fold and line it up with fold #2. Line up fold #7 with fold #5. Reverse-fold #10 into a mountain fold, and line up fold #10 with fold #8. You should now have three pleats, which will become the pockets.

8 Flatten the piece and turn it over. You will no longer see the circles, but the pinches you made in step 1 will be visible. Bring both pleated sides to the center to meet at the pinches.

Continued on page 165

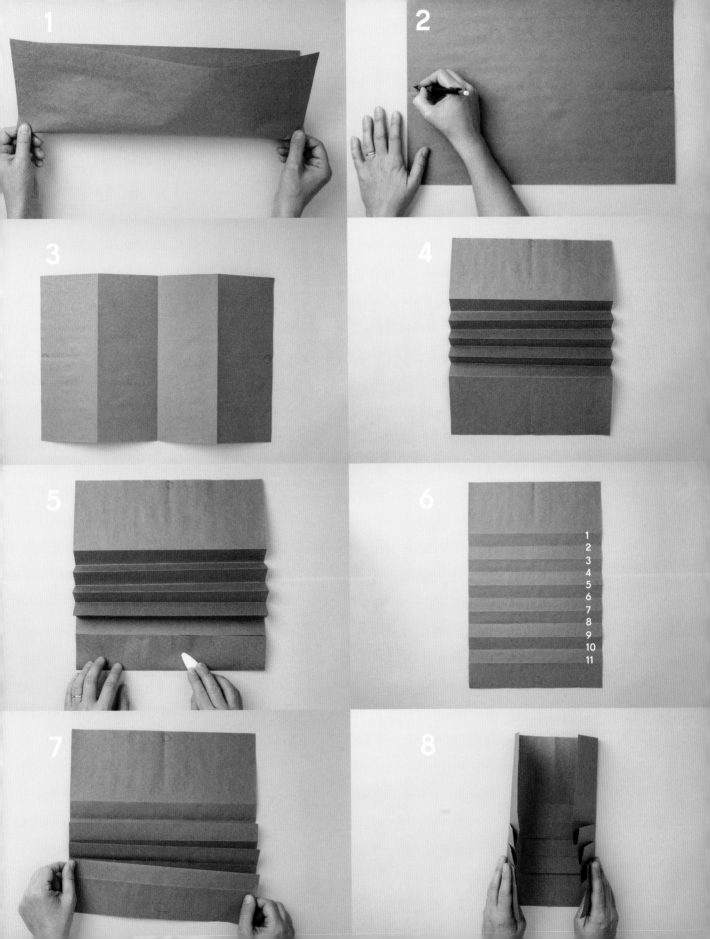

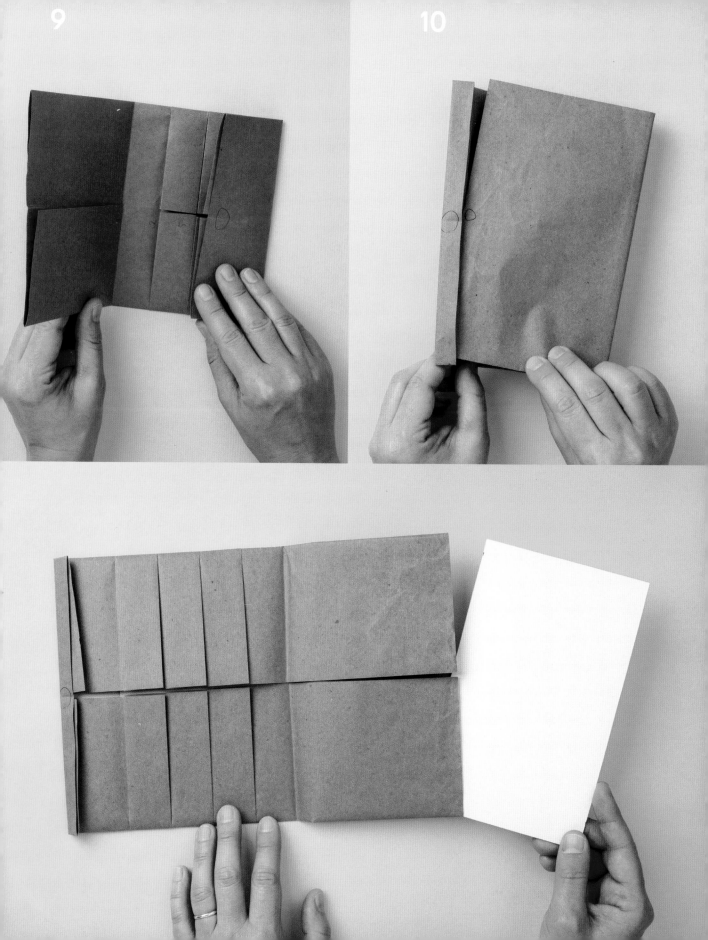

9 Fold the narrower extension over the pleats and the wider extension on top of the narrower one, along the folds you already made.

10 Open up the sheet and make a fold ¾" from the edge of the narrower extension to create a flap. Insert the wide extension into this flap and use tape, a little glue, or paper clips to secure the stand.

OPTIONAL FINISHING STEP (PICTURED AT LEFT, BOTTOM):
If you'd like to stabilize your stand, cut the three pieces of cardboard to the size of the upper and lower extensions and the pleated section. Insert the cardboard inside the two paper layers and secure them with a bit of tape.

Hedi Kyle, *One-Sheet Flag Book* models, 2005. French Paper Dur-O-Tone and French Paper Construction, offset printing, hand drawings; 7" × 3", folded from 7" × 17" sheets.

ARTIST

After 30 years of working as a book conservator at the American Philosophical Society in Philadelphia, **HEDI KYLE** retired as head of conservation. She continued to teach book arts at Philadelphia's University of the Arts for another decade, then moved to the Catskill Mountains in upstate New York. There she is active in her studio working on projects and picking up ideas that have been on the back burner for a long time.

Kyle has taught numerous workshops throughout the United States, Canada, and Europe, and she has inspired artists around the world to use and adapt her unique structures into their own work. She and her daughter, Ulla Warchol, wrote and illustrated *The Art of the Fold*, an instruction manual describing folded book and box structures. Kyle is an honorary member of the Guild of Book Workers and a cofounder of the Paper and Book Intensive.

Bendable Paper Sculpture

DESIGNED BY Helen Hiebert
PAPER USED 25 gsm Thai unryu paper. This is a lightweight, translucent paper made from the bark of the mulberry tree. Long natural fibers are visible in the sheet.

LOOK FOR A strong, thin paper. It needs to be malleable when layered, but not so thin that it falls apart when glued. Try laminating two different paper colors or styles, or use collage on one layer for another interesting effect.

Laminating wire between two sheets of paper creates a brand-new material: bendable paper! The wire lets you bend and form the paper so that it holds a shape, and the resulting structures are endless. I find that 18-gauge wire works the best, as it isn't too hard to bend.

Materials

- Approximately 25' of 18-gauge copper wire
- 2 sheets of decorative paper, each cut to 37" × 12½"
- Enough freezer paper to make a gluing surface slightly larger than your decorative papers
- ½ cup of PVA/methyl cellulose glue mix (see recipe on page 38)

Tools

- Needle-nose pliers with cutting tool
- Wide glue brush
- Foam brush
- Scissors (optional)

Early in my papermaking career, I learned about embedding objects and materials between layers of handmade paper, which bond as they dry. Over the years, I have used wire and string embedded in handmade abaca paper (made with fibers from the stalk of non–fruit-bearing banana plants) to create lamps, sculptures, and installations. I decided to try using ready-made papers when I wanted to teach this project in a space without a papermaking facility.

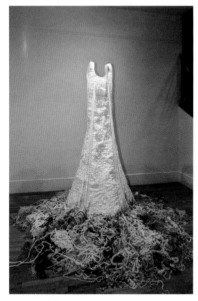

Helen Hiebert, *Mother Tree*, 2010.
Artist-made abaca paper with embedded thread; 84" × 84" × 84". This piece sits on a wooden armature, and strands of yarn, crocheted by hundreds of volunteers, form the roots of *Mother Tree*.

Instructions

1 Use the pliers to cut the copper wire into pieces that are approximately 15" long (you need about 20 pieces). Straighten them as best you can by pinching the wires between your thumb and forefinger.

2 Place one sheet of the project paper facedown on a larger piece of freezer paper. Starting at a shorter edge, brush glue over a section that is 7"–8" wide. Lay three or four wires on top of the glue, spaced approximately 1½" apart and with their ends sticking out evenly at the top and bottom.

3 Line up the second sheet of project paper with the first sheet and gently lay it on top of the glue and wires, with the decorative side faceup. Use a dry foam brush to press the two sheets of project paper together, laminating the wire in between.

4 Continue gluing, placing wires, and laminating, a few inches at a time, until the entire sheet is laminated, making sure to leave a seam at least 1½" wide at each end with no wire. Allow the paper and glue to dry for several hours or overnight. To speed up the drying time, you may place it in front of a fan for about 30 minutes.

 NOTE: The wire might slip a bit between the sheets when the paper dries. Metal will not truly adhere to paper.

5 Crunch and bend the paper in your hands to create a crumpled look before you begin bringing the sheets into the round. To make a cylinder that you can shape, apply a 1" band of glue along one of the shorter seam edges. If you used two paper colors, first decide which will be on the outside, then overlap the other edge to complete the cylinder. From here you can manipulate and sculpt the cylinder until you are happy with its shape. Have fun with the wire ends at the top of your vessel: Twist them into loops, clip them off, or put beads on them.

 TIP: Paper is easy to cut, so why not use scissors to shape the top and/or bottom of the cylinder?

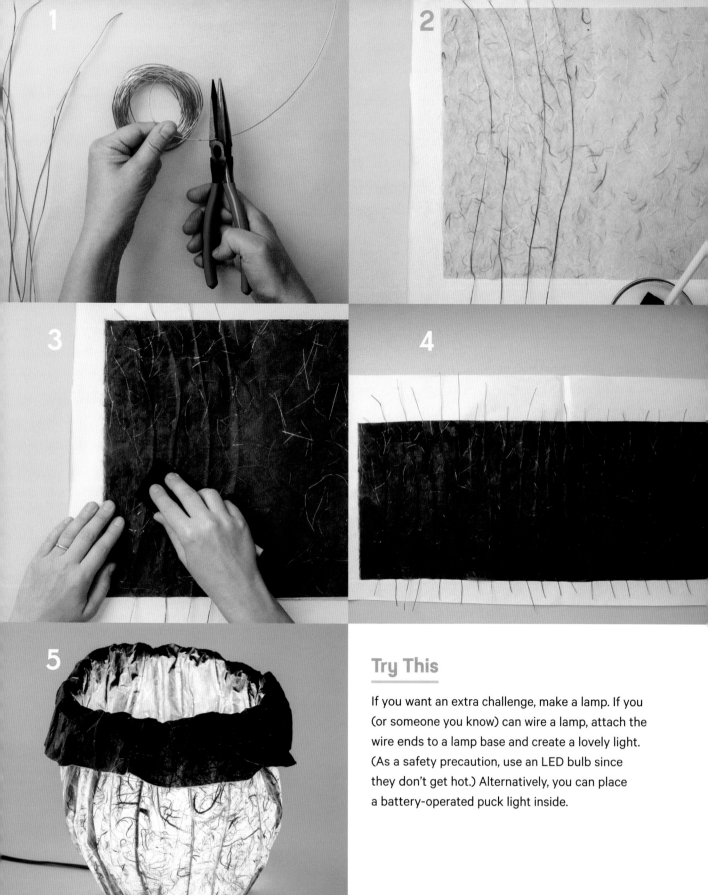

Try This

If you want an extra challenge, make a lamp. If you (or someone you know) can wire a lamp, attach the wire ends to a lamp base and create a lovely light. (As a safety precaution, use an LED bulb since they don't get hot.) Alternatively, you can place a battery-operated puck light inside.

Star-Top
Box

DESIGNED BY Peter Dahmen
PAPER USED Multiple decorative card stocks
LOOK FOR Any plain or decorative 65–100 lb. card stock

TIPS

- Vary the width of the middle section on the template to create boxes of different heights (see Paper Organizations & Other Useful Websites on page 275 for a link that makes this easy).

- If you print this on white card stock, you could easily decorate the panels before you start folding to create a unique package.

We've all closed the four corners of a moving box by folding one layer over the other, then tucking the last layer under the first. The process for making this box is similar in some ways, but the result is much more elegant. The length of the pieces on the top and bottom vary, creating two different looks and lots of possibilities for other designs. What will you store or gift in your box?

Materials

- Template (page 286)
- 8½" × 11" sheet of card stock
- Printer paper (optional)
- Removable tape
- ½"- or ¾"-wide double-sided tape

Tools

- Craft knife
- Cutting mat
- Bone folder
- Straightedge

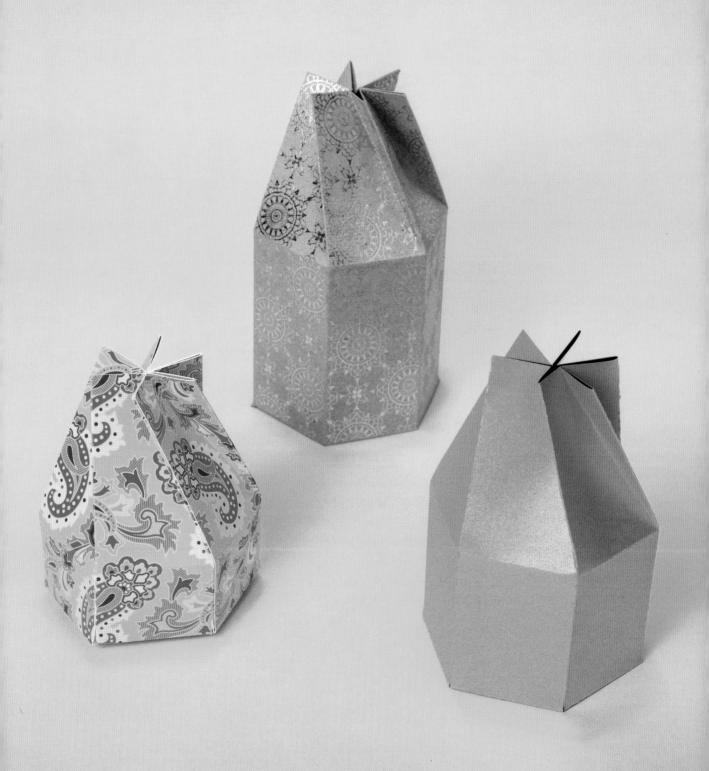

ARTIST

PETER DAHMEN studied communication design at the Dortmund University of Applied Sciences and Arts in Germany. He gained fame as a paper artist when fans discovered his pop-ups and paper engineering designs on YouTube, Facebook, and Pinterest. He receives commissions from companies worldwide—ranging from small-format packaging concepts to large-format stage sets—and he has produced amazing designs for major brands.

"Even though I have been creating with paper for more than 30 years, I am still impressed by the incredible possibilities this material has to offer. Paper can be used to create designs for which no other material (wood, glass, metal, plastic, stone, marble, fabric, etc.) would be suitable. I really love working with this material." —Peter Dahmen

Merry Christmas

Instructions

1 Photocopy or print the template directly onto the back of your project paper (see Working with Templates on page 28 and the Template Key on page 280), or print the template on printer paper and tape it (with removable tape) to your project paper. Use a craft knife and cutting mat to cut along the solid black lines around the perimeter of the box. Cut along the rest of the solid black lines in the interior of the box.

2 Use a bone folder and straightedge to score along all of the dotted lines, then valley- and mountain-fold as indicated on the template. Crease all folds well. (If you taped the template onto the project paper, score and crease through both the printer paper and the project paper.)

3 Flip the paper over so that the printed lines of the template are facedown (with the long tab on the right). Apply a strip of double-sided tape to the entire length of that tab.

4 Bring the box into the round and adhere the strip of tape to the inside edge of the opposite side of the box. Collapse the box flat with the tab folded inside (in half) to adhere the tab to the other side of the box. Unfold the collapsed box. You should now have a hexagonal tube.

5 Assemble the bottom of the box by overlapping the six small squares one at a time. Tuck the last square underneath the first square, as shown.

6 Set the box on its bottom and pinch all of the mountain and valley creases on the top, so that it resembles a star. Pinch and twist the box top to close it.

Peter Dahmen, *Modern Tree Pop-up Card*, 2019. Card stock; approximately 6¼" × 9" × 2½". Exclusive design for the Museum of Modern Art design store.

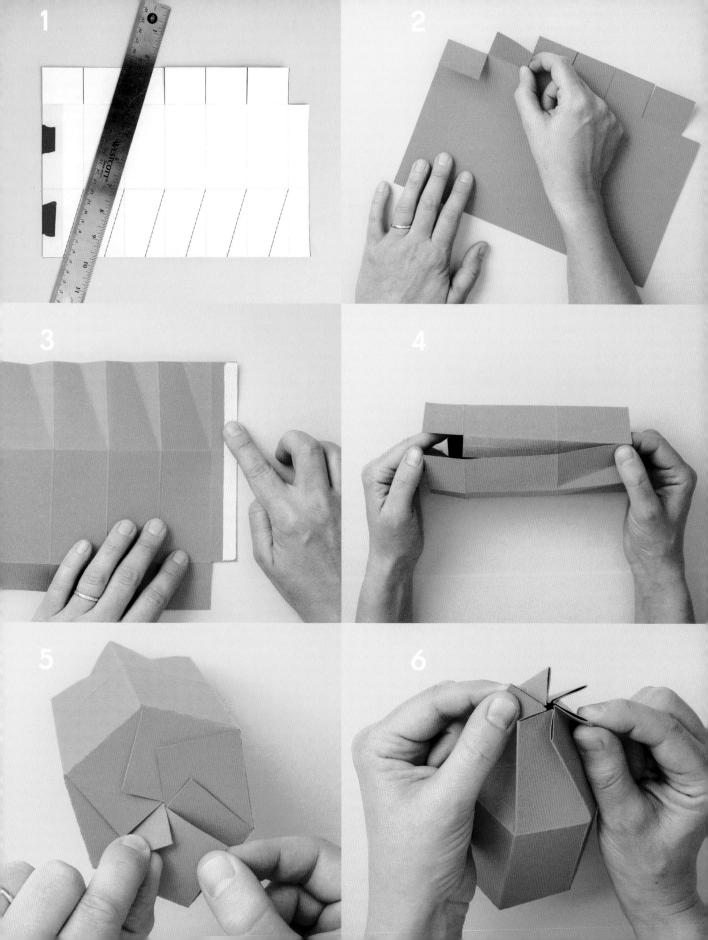

Mini Tunnel Book

DESIGNED BY Edward Hutchins and adapted by Laura Russell
PAPER USED 67 lb. card stock
LOOK FOR A lightweight card stock, since the pages in this structure are doubled up.

Tunnel books are viewed through a hole in the cover and a series of pages that are joined by accordion folds, allowing the reader to see through the entire book at a glance and to open and close it like an accordion. The first tunnel books appeared in the eighteenth century. Originally called "peep shows," they were inspired by theatrical stage sets.

While tunnel books are usually created from several sheets of paper, this unique design (which first appeared in Edward Hutchins's *Book Dynamics!*) was adapted by Laura Russell as a thank-you card to honor Sandra Kroupa, the Special Collections librarian at the University of Washington. Add your own photo or artwork to create your own unique tunnel book or tunnel card. The tunnel book you will create with the template will be tiny. If you'd like to make a larger version, have a print shop blow up the template to 200 percent.

Materials

- Template (page 301)
- 8½" × 11" sheet of card stock
- Printer paper (optional)
- Removable tape (optional)
- White glue or glue stick

Tools

- Bone folder
- Straightedge
- Craft knife
- Cutting mat

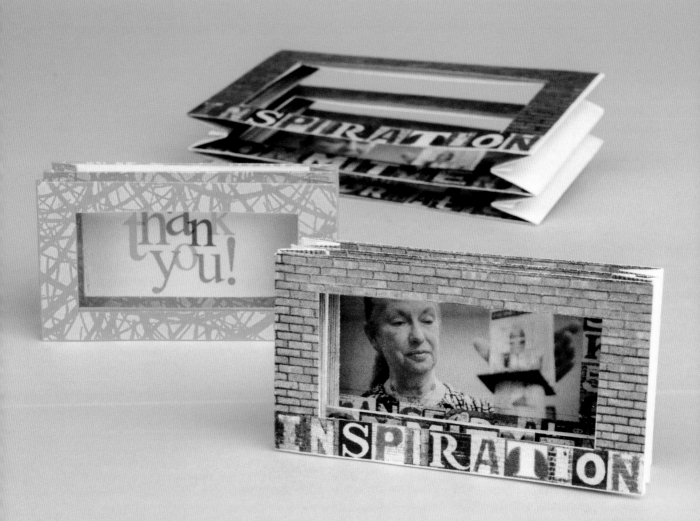

I met **LAURA RUSSELL** when she ran 23 Sandy Gallery, a gallery in Portland, Oregon, that specialized in artist's books. The tunnel book shown on page 175 was an entry in *Thank You Books,* a 10-part series of one-sheet books to celebrate the tenth anniversary of the gallery's sweet little purple storefront, which has since closed. She continues to make her own limited-edition artist's books, which feature her photographs combined with structural and material experiments to tell stories of our communities and commercial culture.

Laura Russell, *Hit the Road, Two!,* **edition of 10, 2013.** Accordion-fold "road" nestled in a case-style cover with a window featuring original photographs by the artist, archival pigment prints on Red River Polar Matte paper; 7" × 6¼ × ½".

Instructions

1 Photocopy or print the template onto the project paper (see Working with Templates on page 28 and the Template Key on page 280), or print the template onto printer paper and tape it to the project paper, as shown. Use a bone folder and straightedge to score along the horizontal dashed and solid lines connecting the five pairs of letter A (don't fold yet). Score vertically to connect both pairs of letter B and both pairs of letter C.

2 Use a craft knife and cutting mat to cut along all solid lines: Cut around the perimeter of the template, removing all exterior white space; cut and remove the window panels in the center of each page; and cut along additional solid lines as indicated on the diagram below.

3 With the display side of the project paper faceup, fold the B score lines (inside hinge) as valley folds. Fold the C score lines (between hinge and glue tab) as mountain folds.

4 Fold the A score lines. Start with a mountain fold on the front cover and then alternate valley and mountain folds to the back cover, ending with a mountain fold.

5 To create three pages, fold the three mountain folds you made in step 4 and glue each panel back to back.

6 Glue the hinge tabs together to create miniature accordion hinges.

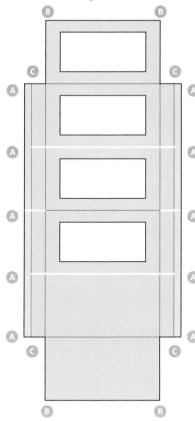

Cut along the white lines.

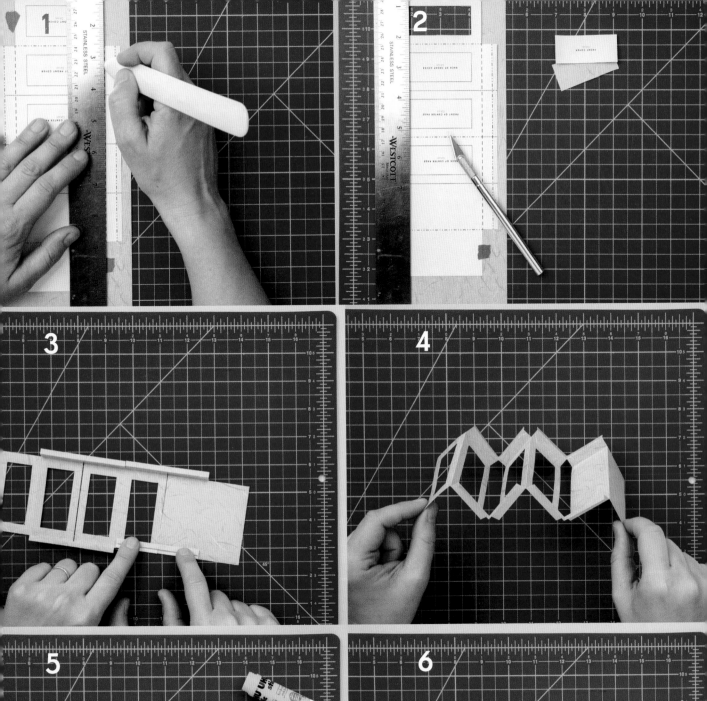

Pop-Up
Dragonfly

DESIGNED BY Shawn Sheehy
PAPER USED Madeleine Durham paste paper (129 gsm) on Arches Text Wove paper
LOOK FOR Any card stock will work. You can make this card with two different papers: one for the base and another for the dragonfly.

TIP

The tabs work as fasteners, so this card can be created without glue, but I glued down the antennae and the tabs.

Pop-ups are magical, and this delightful dragonfly not only pops up but seems to fly when you fold and unfold the card. Cut, fold, glue, and you'll be amazed by the simplicity of the construction. The paste paper by Madeleine Durham really brings out the colors in this dragonfly.

Materials

- Templates (pages 282 and 283)
- 8½" × 11" sheet of decorative paper
- Printer paper (optional)
- Removable tape (optional)
- White glue

Tools

- Scissors or craft knife and cutting mat
- Bone folder
- Straightedge
- Glue brush (optional)

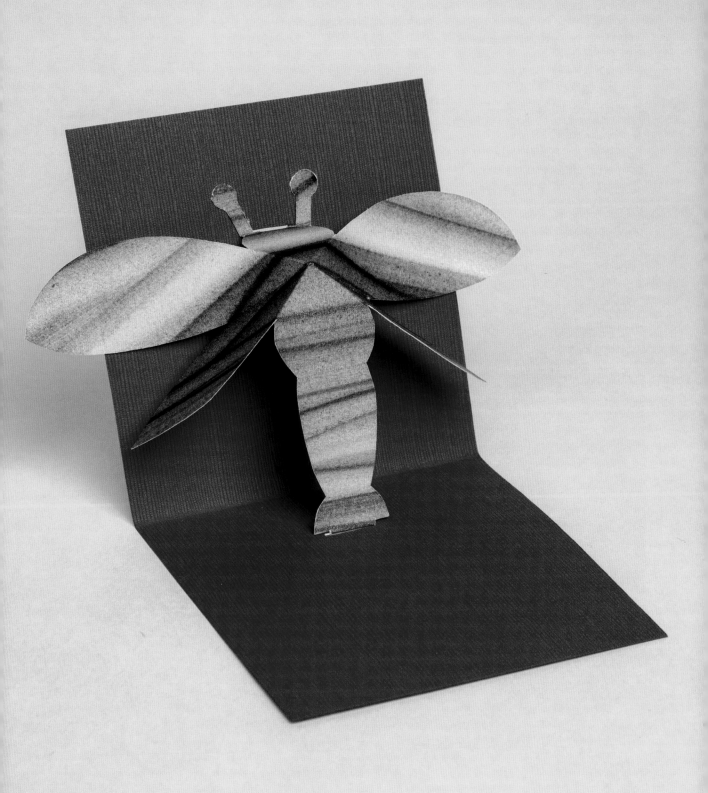

ARTIST

SHAWN SHEEHY has been making artist's books for more than 20 years. His first books were some of his favorites because he had his hands in all of the elements: concept, design, writing, illustration, engineering, papermaking, binding, letterpress printing, and assembly. The hand-made paper allowed him to con-trol the exact color, weight, fiber content, surface, and size. Sheehy teaches workshops around the country and serves as director of the Movable Book Society.

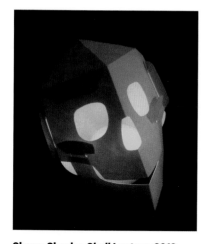

Shawn Sheehy, *Skull Lantern*, 2019.
110 lb. index stock, LED candle;
9" × 3" × 6".

Instructions

1 Photocopy or print the card and dragonfly templates directly onto the back of your project paper, or print the templates onto printer paper and affix them to your project paper with removable tape (see Working with Templates on page 28 and the Template Key on page 280). Use scissors or a craft knife and cutting mat to cut on all solid lines. Use a bone folder and straightedge to score along all dashed lines. (Note that the dragonfly's head tab will separate from each antenna, and a small waste piece will be removed on each side.)

2 With the display side of the paper facedown, create a valley fold on the score line that runs across the center of the card. On the dragonfly, valley- and mountain-fold as indicated on the template. Fold along the score lines to create the head and tail tabs.

3 Turn the dragonfly over so the display side is faceup. Slip the tail tab into the larger slot on the card, then open out the tabs on the back side of the card to lock the tab in place. Slip the head tab into the smaller slot on the card, then open out the tabs on the backside of the card.

4 Carefully close the card, engaging all folds in the dragonfly's body so that it collapses entirely into the closed card. Glue the tabs in place on the back of the card, using a brush to even out the glue, if you'd like.

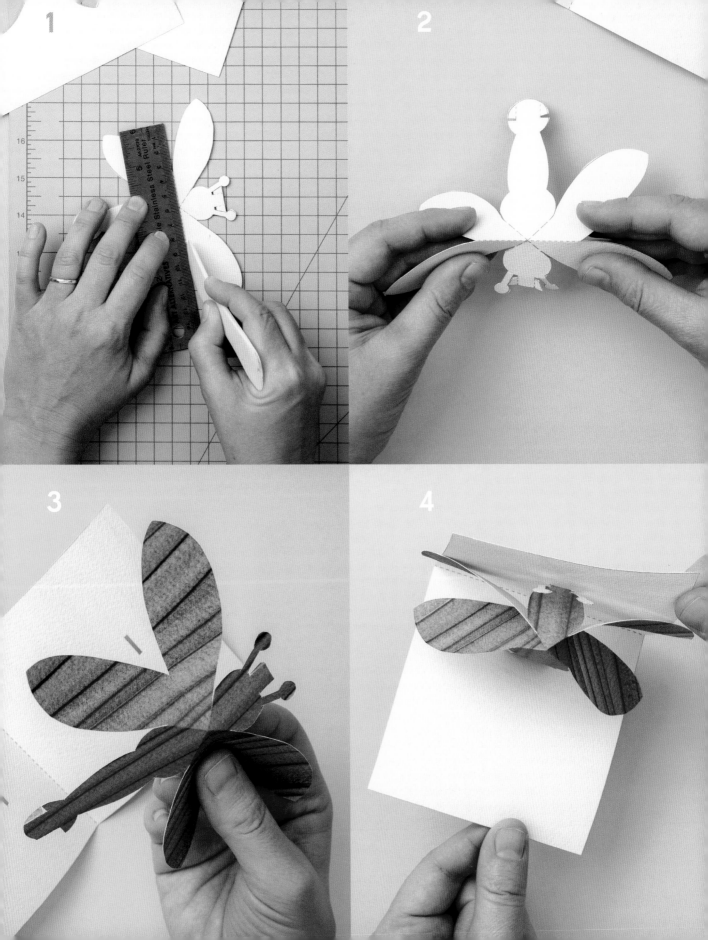

Blushing Tiger Card

DESIGNED BY Jie Qi

PAPER USED 100 gsm Pink Mingei

LOOK FOR You can use almost any paper for this project.

Press the bouquet in this friendly tiger's hands and watch her blush! I have to admit that I was intimidated by the electronics involved in creating this card, but it is actually quite simple. And once you create this card, you'll have the skills to design your own light-up cards.

Materials

- Templates (page 297)
- 8½" × 11" sheet of decorative or plain card stock
- ¼"-wide adhesive-backed copper tape*
- 2 red LED stickers*
- 1 CR2016 coin battery (3 volts)
- Small patch of pressure-sensitive plastic*
- Extra-thick double-sided foam tape (from a hardware or craft store)

Tools

- Craft knife
- Straightedge
- Cutting mat
- Scissors

*Available from the artist's company, Chibitronics (see Specialty Suppliers on page 275)

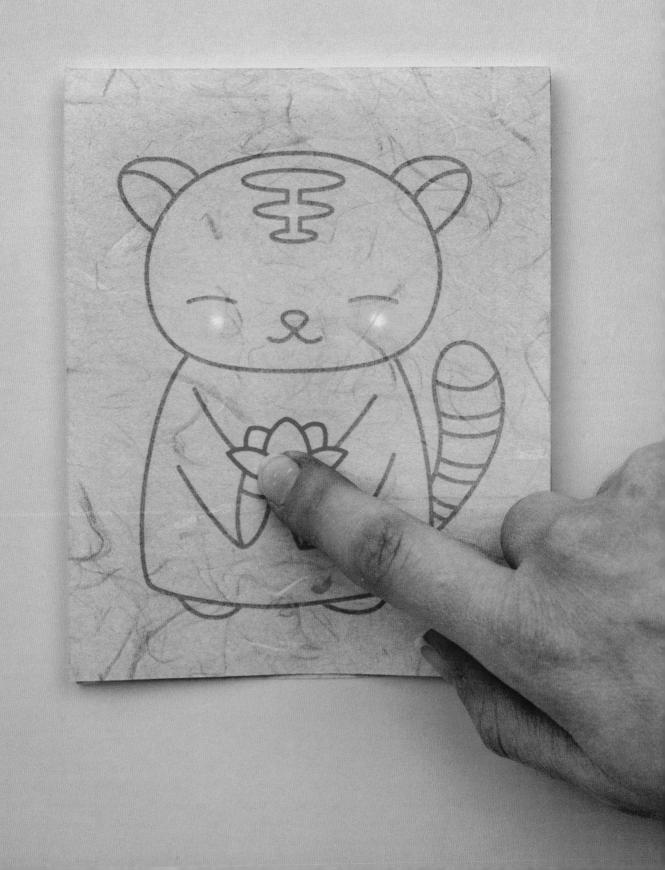

ARTIST

JIE QI is a designer, educator, inventor, and entrepreneur based in Florida. She has been obsessed with paper ever since she folded her first origami at age 3 and loves to see this friendly, versatile material turn from an ordinary flat sheet into something magical with a few cuts, folds, or marks, or by blending it with some simple circuitry and code.

Jie cofounded Chibitronics, which produces creative learning tool kits that combine paper crafts with electronics and programming. She holds a bachelor's degree in mechanical engineering from Columbia University and a master's and doctorate in media arts and sciences from the Media Lab at the Massachusetts Institute of Technology.

Jie Qi and Tungshen Chew, *Electronic Popables,* **"Cityscape" (pop-up page of the New York City skyline lit by LED paper circuit), 2009.** Mixed card stock, circuit boards, LEDs, conductive inks, and conductive fabric.

Instructions

1 Photocopy or print the template onto your project paper (see Working with Templates on page 28 and the Template Key on page 280), and use a craft knife, straightedge, and cutting mat to cut out the two 5½" × 4¼" cards.

2 Stick a strip of copper tape onto each of the gray lines in the center of the circuit template. Crimp and fold the tape (do not tear it) at each corner.

3 Stick the LED stickers over the red triangular outlines on the inside of the card. Make sure the LEDs match the orientation of the outline.

4 Cut along the solid lines to create a flap for the battery holder. Place a battery over the red circular outline, positive (+) side facing up. Fold the flap over so that the battery is sandwiched between the flap and the paper. When you press on the closed flap, the LEDs should light up. If they don't, try pressing down harder on the LEDs to make sure they are adhered securely.

5 Use scissors to cut a small patch of pressure-sensitive plastic the size of the yellow region on the inside of the battery flap. Place it between the battery and the flap. The tiger's cheeks will glow brighter the harder you press.

6 Stick pieces of double-sided foam tape over the light blue markings around the battery to keep the battery in place. Remove the adhesive backing from the foam strips and attach the battery flap.

7 Place pieces of foam tape over the blue lines on the corners. Personalize the tiger as desired by adding color, collage, or other decorations.

8 Remove the adhesive backing from all of the foam pieces and attach the tiger illustration on top of the electronics.

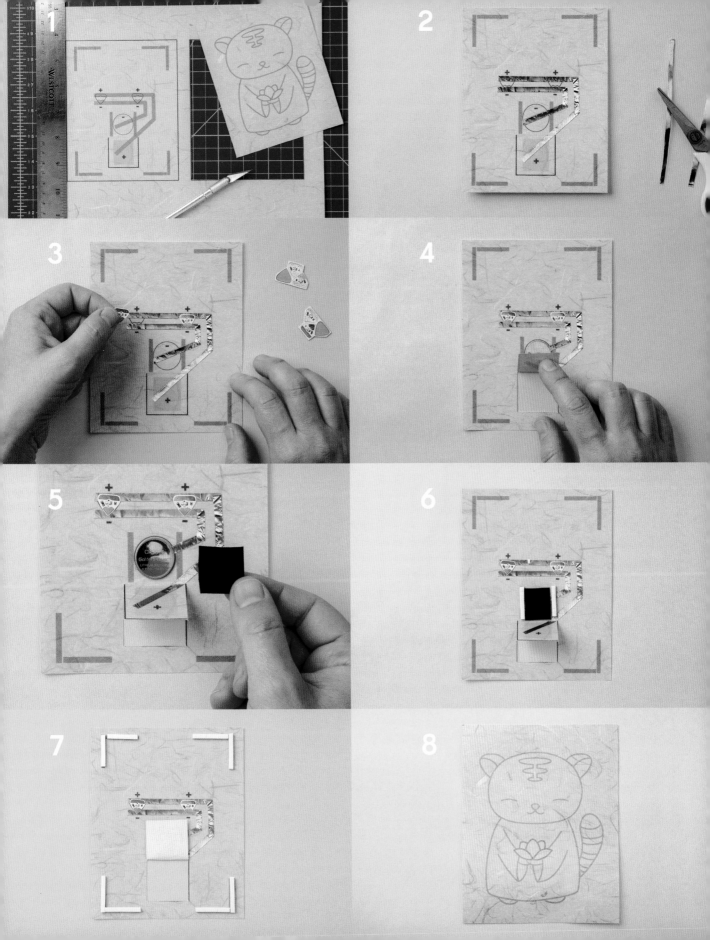

Tiny
House

DESIGNED BY Debra Glanz
PAPER USED 28–32 lb.
Reminiscence Papers
LOOK FOR Any text-weight
or lightweight cover paper will
work. Mix and match the bases
and roofs.

Build your own tiny home. These houses make great party favors, and the roofs are removable, so you can tuck a tiny gift inside. They also make a special house-warming gift.

Materials

- Templates (pages 298–299)
- 8½" × 11" sheet of decorative text-weight paper
- Double-sided tape or glue stick
- Heavy cardstock or light-weight chipboard (for roof reinforcement; optional)

Tools

- Pencil (optional)
- Craft knife and cutting mat or scissors
- Straightedge
- Bone folder

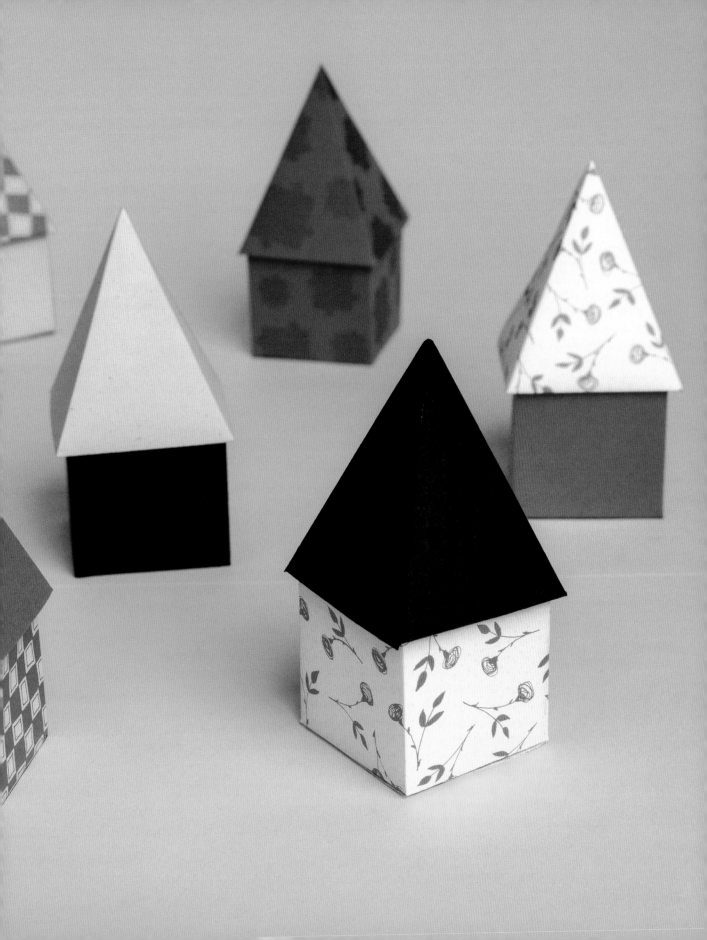

Instructions

1 Photocopy, print, or trace the three templates onto the back of your project paper (see Working with Templates on page 28 and the Template Key on page 280). Cut out all of the pieces along the solid lines using a craft knife, metal straightedge, and cutting mat, or use scissors. Set aside the roof and the triangular roof reinforcement pieces.

TIP: This project can be created with one sheet of paper, but I recommend choosing two complementary papers so that you can mix and match the roofs and bases.

THE BASE

2 On the house base piece, score along all dotted lines using a straightedge and bone folder.

3 Fold section 1 over onto section 2, as shown. Crease to reinforce this fold with your bone folder. Beginning on the end without the tab, valley-fold and then unfold both layers together along each of the three short horizontal score lines (A). Then fold all of the flaps over along the scored lines where they attach to section 2 (B).

4 Apply a thin layer of low-moisture adhesive, such as double-sided tape or glue stick, along the display side of the tab. Insert the tab between the two layers on the opposite end to form a box shape, aligning the edge of the paper with the tab fold. Press to adhere.

Continued on page 191

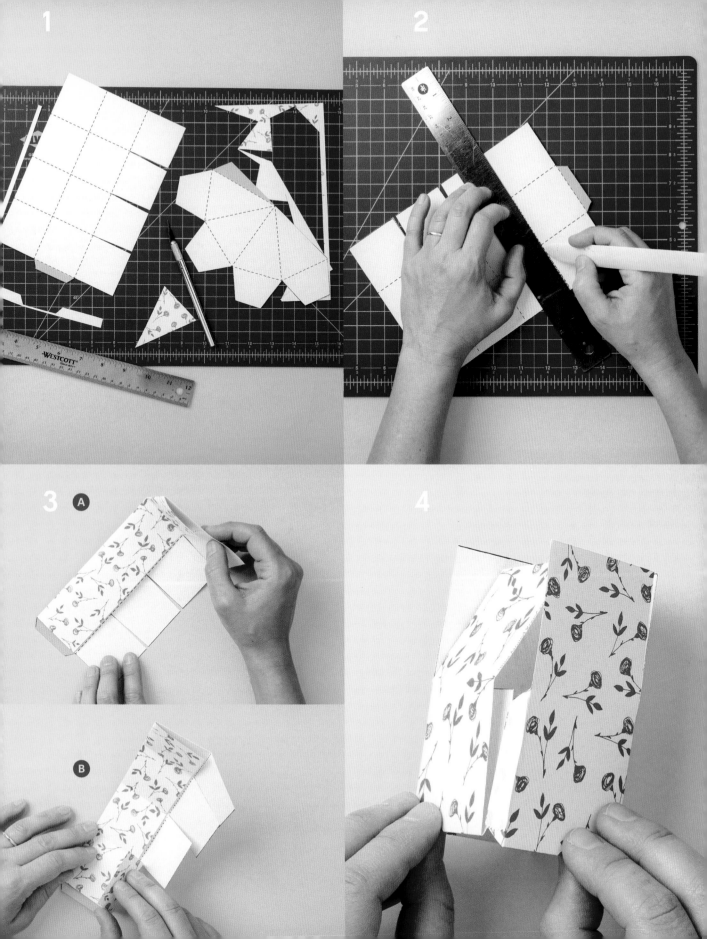

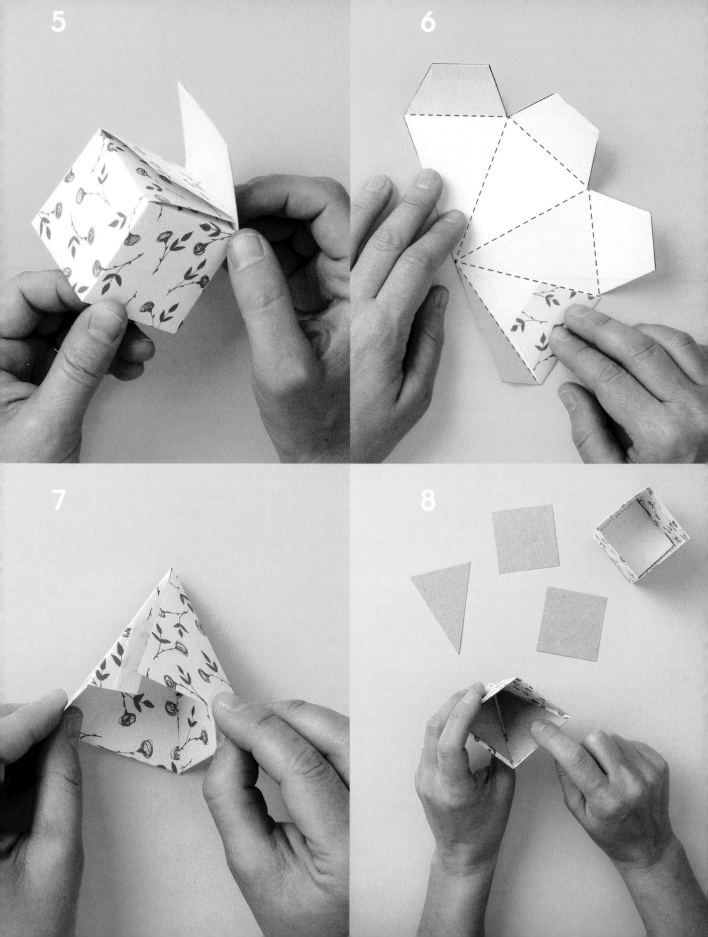

5 Fold in flap A, then B, then C. Apply low-moisture adhesive to the back side of flap D and then fold it in to adhere it to flap C. Set the completed base box on a flat surface and press to adhere.

THE ROOF

6 Score, fold, and unfold the roof piece along the valley fold lines. Apply a low-moisture adhesive to the back sides of all the flaps, then fold and adhere them to the back sides of each triangular section. Refold and crease the remaining fold lines to ensure they are sharp.

7 Apply a low-moisture adhesive to the display side of the roof tab, then tuck and align the fold of the tab with the underside of the opposite roof edge, pressing to adhere. Place the roof on top of the base.

REINFORCEMENT

8 Optional but highly recommended:

- Use the triangular roof reinforcement piece that you cut in step 1 as a template to cut four pieces from heavy card stock or lightweight chipboard. Also cut two 2" square pieces from the same card or board.

- Apply adhesive to one side of each piece.

- Insert and adhere one triangular piece to each section inside the roof, pushing the tip of the triangular piece up to the very tip of the roof. Apply pressure to adhere.

- Place one 2" square in the bottom of the box, with the adhesive side facing down, and press it to adhere. (It should be a very snug fit.) Adhere the remaining 2" square to the base of the box for additional reinforcement.

ARTIST

DEBRA GLANZ began her career working as a textile artist, producing weavings and sculptural pieces. A chance bookbinding class in 1983 changed her medium forever. Glanz, an avowed "function freak," now produces boxes constructed of paper, board, and any other materials that strike her fancy. These boxes are meant to be used as containers for any treasures that need a special place to rest and are often used as gift boxes for jewelry, chocolates, poetry, promises, and—on at least one occasion—a live frog.

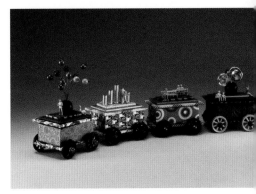

Debra Glanz, *All Aboard*, 2015. Paper, metal, plastic, wood; 4" × 15" × 3½".

Exploding
Cube

DESIGNED BY Bhavna Mehta
PAPER USED 98 lb. Canson
Mi-Teintes

LOOK FOR White paper is so
lovely for this project, but try
other colors. This particular paper
comes in a wide variety of colors,
or any card stock will work.

This design adds a paper-cut element that spans the folds
and makes the box explode into a sculpture. You're in charge
of the cut-out design on this one—feel free to add colored
papers behind the cutouts before you assemble the cube
and/or create window flaps.

Materials

- 12" × 16½" sheet of card stock
- ¼"- to ½"-wide
 double-sided tape

Tools

- Pencil and eraser
- Ruler
- Craft knife
- Cutting mat
- Bone folder
- Tweezers (optional)

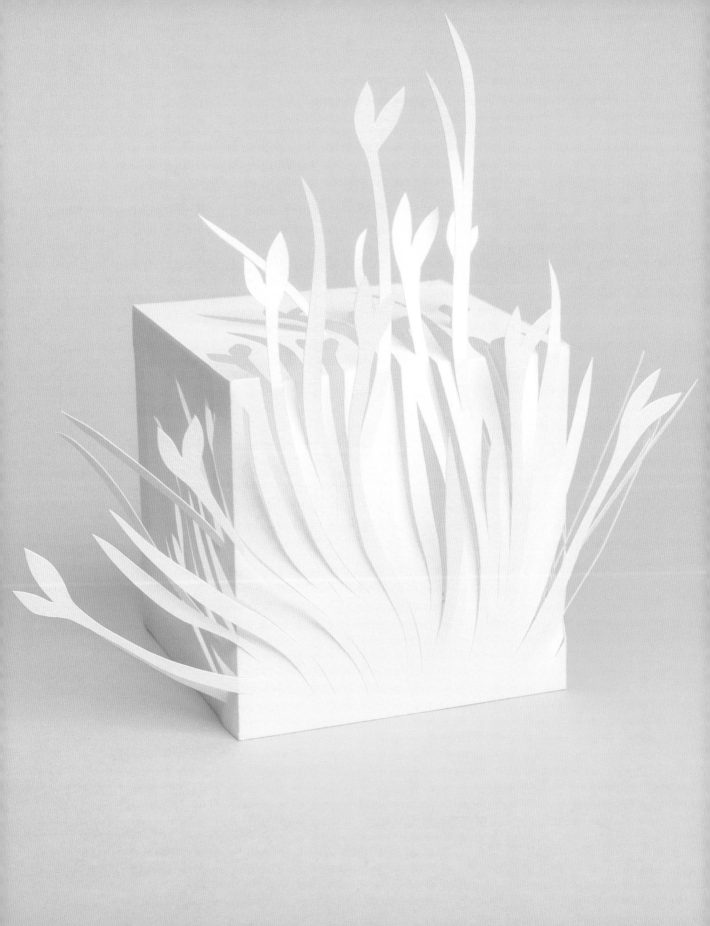

BHAVNA MEHTA has engineering degrees from universities in both India and the United States and worked as a software engineer for many years before turning to art. She lives in Southern California and works with paper cutting and embroidery to tell stories about relating and remembering, combining figurative imagery with botanical motifs, text, and shadows.

Using paper as skin, and thread as a tool to connect and mend, Mehta cuts and sews to portray exposing and hiding. Her style is influenced by the folk-art traditions of her native India, where she was raised in an extended family surrounded by women who constantly embroidered, knitted, sewed, and created for the home.

Bhavna Mehta, *How We Remember #1*, 2015. Handcut on Canson paper; 25" × 20".

Instructions

1 With a pencil and ruler, use the diagram below as a guide for drawing a cross shape onto your project paper. Use a craft knife and cutting mat to cut out the shape, then use a bone folder and the ruler to score the fold lines. Lightly label the top and bottom as shown on the diagram.

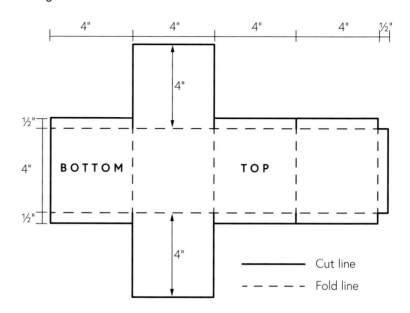

Cut line
— — — Fold line

2 Set the cut-out cross on your cutting mat with the bottom closest to you. There are four square surfaces to cut your design into: the three squares forming the horizontal part of the cross and one square above that row (the top). Aim for a design that flows across all four sections, with the paper cut on most edges except the bottom, where it needs to stay attached to the bottom piece. Erase stray marks as necessary.

TIP: Smaller repeated shapes (especially with long stems) work best for the cut-out design. The longer the shape(s), the nicer the explosion.

3 Pop out the cutout shapes. Use a bone folder or tweezers to pop out small pieces.

4 Apply double-sided tape to the seven tabs on the face-up side of the paper, and assemble the cube.

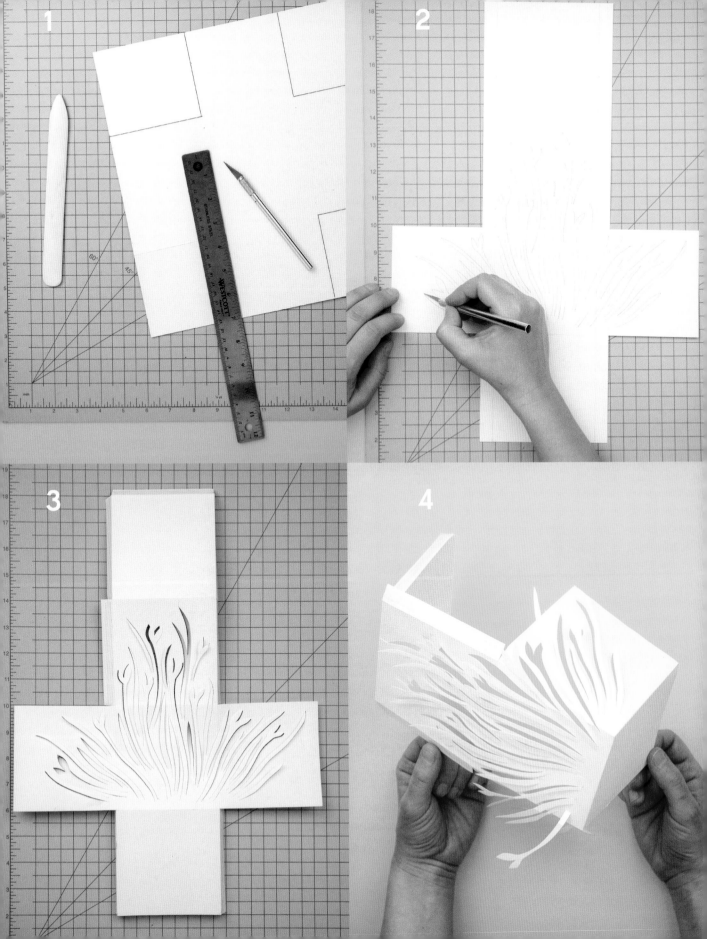

Dudleya
Succulent

DESIGNED BY Janna Willoughby-Lohr

PAPER USED 180 gsm Italian crepe paper in ivy green

LOOK FOR Thick, heavyweight crepe paper with a pliable fabric-like consistency. You can purchase it through several suppliers, including Carte Fini. Lightweight crepe paper and the kind used to make streamers aren't stretchy enough for this project.

Paper flowers and succulents last much longer than real ones, making them more affordable as home décor and more memorable as keepsakes for special occasions. And they look so real. This Italian crepe paper comes in luscious colors and has a fantastic texture that allows for stretching and manipulating.

Materials

- Piece of card stock for making templates
- 8½" × 11" sheet of crepe paper
- Small piece of matching text-weight paper for the backing piece
- Low-temperature hot glue or PVA glue
- Eye shadow or metallic oil pastel (optional; I used PanPastel Artists' Pastels, 931.5 metallic copper)

Tools

- Pencil
- Ruler
- Cutting mat
- Craft knife
- Drafting compass or jar lid
- Fine-point scissors
- Low-temperature hot glue gun (if using hot glue)
- Paintbrush, eye shadow brush, or foam wedge

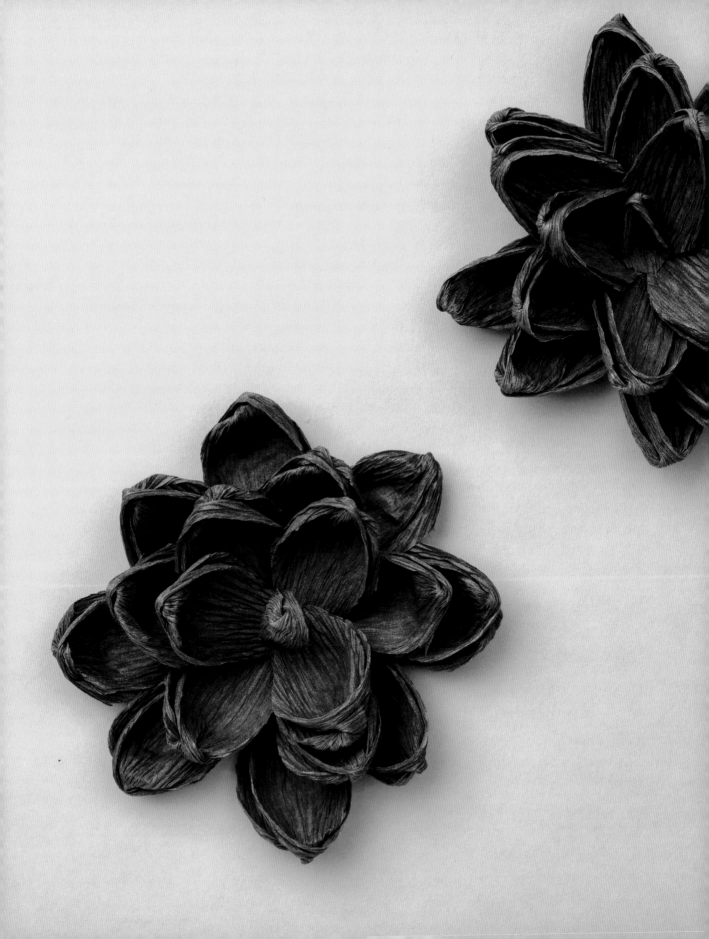

ARTIST

JANNA WILLOUGHBY-LOHR

is the artist behind Papercraft Miracles, an environmentally conscious handmade paper company in Buffalo, New York. She learned about papermaking and bookbinding as a student at Warren Wilson College, where she studied with celebrated artist and author Gwen Diehn. Willoughby-Lohr loves that through Papercraft Miracles her creations are part of so many special moments, including weddings, graduations, and births. Because much of daily life now happens digitally and on a screen, Willoughby-Lohr enjoys preserving and promoting the physicality of book and paper arts.

Janna Willoughby-Lohr, *Floral Hoop Wreath*, 2019. Carte Fini 180 gsm Italian crepe paper in cream, white, Tiffany blue, and yellow; Lia Griffith extra-fine crepe paper in juniper; 48" × 60".

Instructions

1 Use a pencil and ruler to draw two rectangular templates on the card stock: one that is 1" × 4" and the other ½" × 2". Cut these out. On a cutting mat, use a craft knife and the templates to cut out 17 large rectangles and 1 small rectangle from the project paper, making sure to line up the longer dimension with the grain of the crepe paper. Use a compass (or trace around a small jar lid) to draw a 1½"-diameter circle on a matching sheet of text-weight paper, then cut it out.

2 Twist each end of the larger rectangles in opposite directions (A). While the paper is still twisted, fold the rectangle in half. Use glue to attach the straight ends together (B).

3 Using scissors, cut the straight, nontwisted edges of each folded rectangle at an angle to make a leaf or petal shape. Stretch and mold each "leaf" into a cup shape with your thumbs. Repeat with the small rectangle.

4 Apply eye shadow or pastel to the top edges of all of the leaves.

5 Glue eight leaves around the outer edge of the circle.

6 Glue six leaves on top of the outer layer of leaves, and then glue three leaves on top of those. The smallest leaf gets glued in the center.

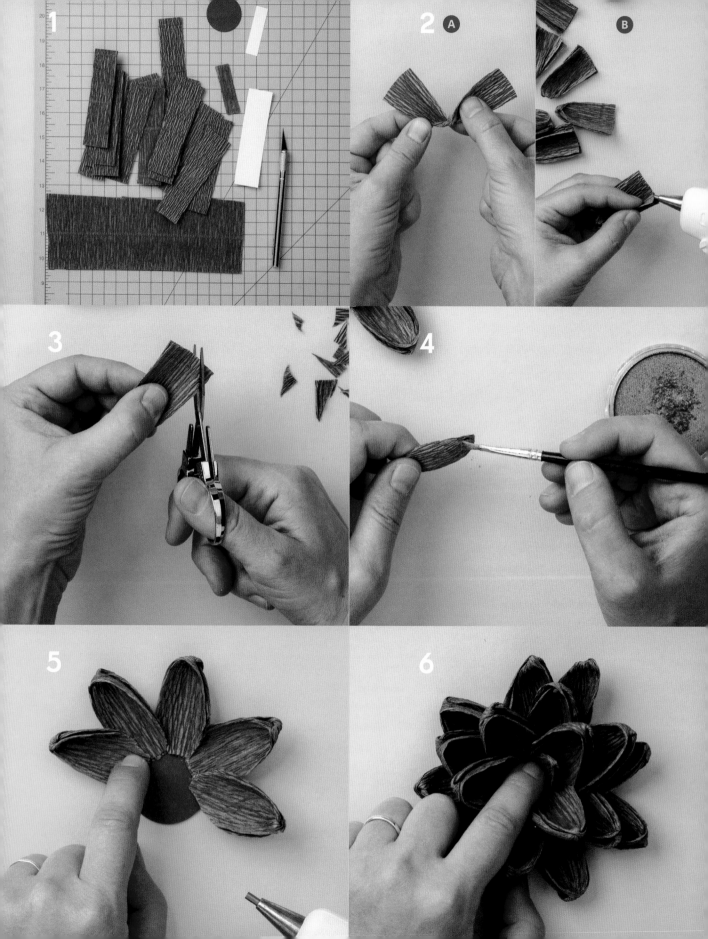

Curved Flip
Mechanism

DESIGNED BY Jean-Paul Leconte
PAPER USED 65 lb. (160 gsm) card stock
LOOK FOR Any card stock will work.

Paper engineering is a field that involves doing some of the craziest things with paper. I am pretty good at envisioning how something flat can transform into three dimensions, but I had to build this piece to understand how it works. The curved flip mechanism has a lovely movement when you open and close the page.

TIP: If you design your own curved flip card, keep in mind that you'll want the object that flips to stay inside the card when you fold and unfold it.

Materials

- Templates (page 295)
- 8½" × 11" sheet of card stock
- White glue, glue stick, or double-sided tape

Tools

- Craft knife and cutting mat or scissors
- Bone folder
- Straightedge

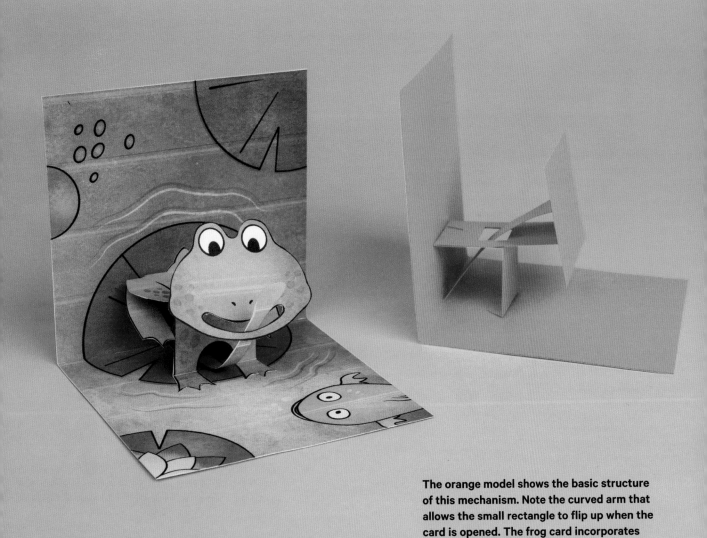

The orange model shows the basic structure
of this mechanism. Note the curved arm that
allows the small rectangle to flip up when the
card is opened. The frog card incorporates
this structure into a playful design. You can
find a template for the frog variation with the
online templates.

ARTIST

JEAN-PAUL LECONTE is an illustrator, graphic designer, and web designer from the Netherlands. He became interested in paper engineering when he bought his first pop-up books. Since then, Leconte and his girlfriend, Denice Schoenmaker, have started Best Pop-Up Books, an online fan platform and YouTube channel specializing in pop-up books. Leconte also creates his own unique and adventurous pop-ups, and he shares his process and projects on Instagram.

Jean-Paul Leconte, ***Nintendo LABO Piano,*** **2019.** 300 gsm colored paper and cardboard; approximately 21⅔" × 15¾" × 6⅞".

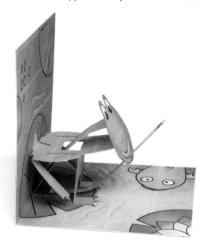

Instructions

1 Photocopy or print the templates onto the project paper (see Working with Templates on page 28 and the Template Key on page 280). Use a craft knife and cutting mat or scissors to cut out along the solid lines as indicated to generate three pieces from the sheet of paper. Cut along the internal solid lines on template piece #1.

2 Use a bone folder and straightedge to score along the dotted lines on template piece #1, and fold the mountains and valleys as indicated.

3 Fold template piece #2 in half to create the card base. On template piece #1, use glue or double-sided tape to attach E to E and F to F. Attach tabs A and B to their respective spots on template piece #2.

4 Thread the loose end of template piece #1 through its own hole and attach tab C to C on the card base. Take care not to fold the loose end during this process. This curved arm is what controls the flipping mechanism, and it will not work well if it is damaged.

5 Attach template piece #3 to D on template piece #1. Carefully open and close the card to ensure the glue is in the right spot and the mechanism operates correctly. Make any adjustments before the glue dries.

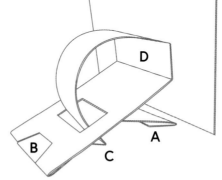

Variations

Try attaching other shapes, such as a circle or a star, to the flipping mechanism, decorate it, or download the frog design variation at www.storey.com/papercraft-projects.

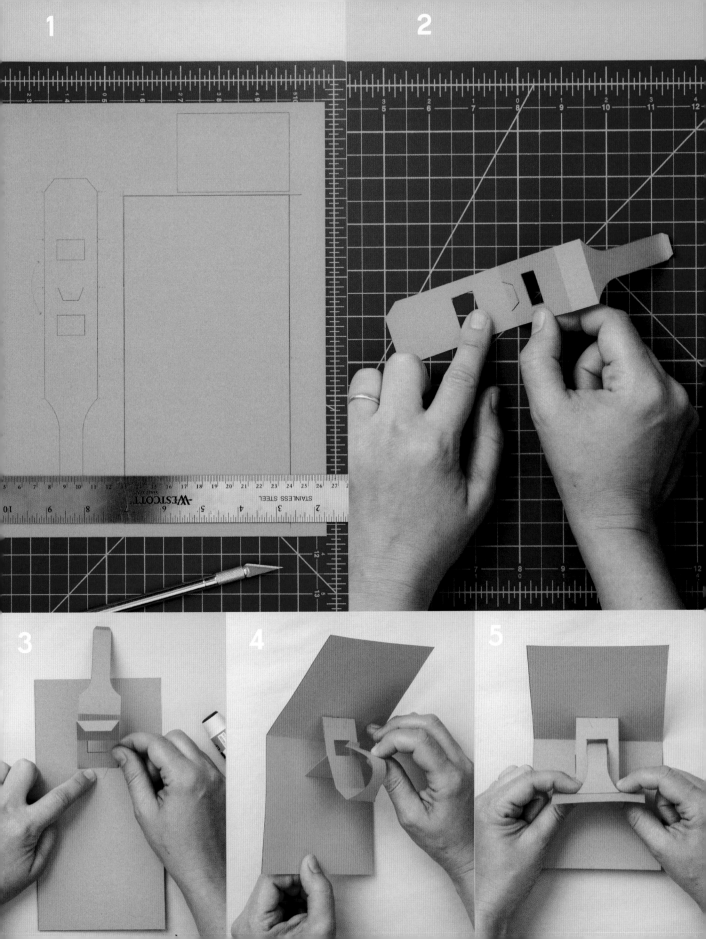

Woven Wall Hanging

DESIGNED BY Helen Hiebert
PAPER USED 65 gsm Thai Reversible Unryu

LOOK FOR Almost any paper can be used for this project. The instructions here call for two sheets of paper, but if you use a double-sided sheet, like I did in the example on the facing page, you need only one sheet.

Create this wall hanging while learning an innovative paper weaving technique. It's easier than it looks when you break it down into steps: 1. Cut curvy strips. 2. Weave them together. 3. Cut windows into your weaving to reveal what's beneath and integrate the layers. If you want to, you can then hang your piece in a window for an interesting effect. I used a double-sided sheet of paper that I flipped over for the horizontal weft strips, so this weaving is technically made from one sheet.

Materials

- 18" × 8" sheet of paper for the warp
- 12" × 6½" sheet of paper for the weft
- White glue
- Small strip of plastic to use as a cutting mat (such as a strip cut from a thin flexible kitchen cutting mat)
- ¼"-wide double-sided tape (optional)
- Two 12" bamboo sticks or dowels

Tools

- Ruler
- Pencil and eraser
- Cutting mat
- Craft knife
- Glue brush

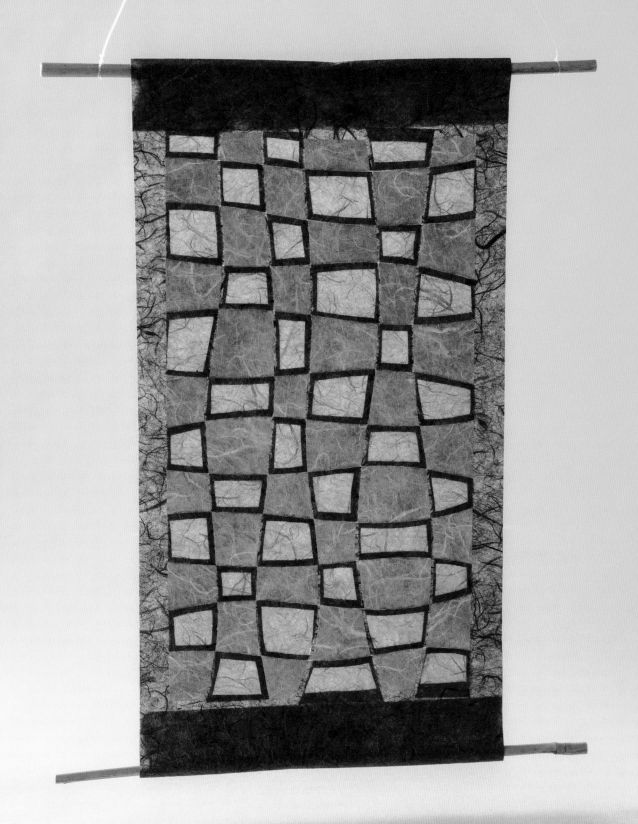

Instructions

1 With the display side of the warp sheet facedown, measure and fold over the top and bottom edges 1½" to create hanging sleeves. Center the smaller weft sheet of project paper on the back of the warp sheet and trace the outline with a pencil.

2 **Warp:** Lay the warp sheet on the cutting mat with the length running vertically and the back side (with the pencil lines) facing up. Draw and cut horizontal curved slits approximately 1"–1½" apart, starting about ⅛" to the left of the leftmost pencil line and ending just beyond the pencil line on the right.

Weft: To make the strips for weaving, lay the weft sheet on a cutting mat in a portrait orientation. Draw vertical wavy strips along the length of the paper that are approximately 1" apart. You should end up with five or six strips. Use a craft knife to cut them out, keeping the strips in order on your cutting mat. The left and right strips will each have one straight edge.

3 Start weaving the weft strips, in order, into the warp, using the pencil line on the back as a guide and butting the strips up against each other. I like to use the tip of my cutting knife to prod the paper along as I'm weaving. When you weave in the last strip, you might have to trim the straight edge to make it fit.

4 After all of the pieces are woven and fitted, use white glue and a brush to adhere all of the loose weft ends to the warp on both sides of the weaving.

Continued on page 208

TIP

In this project, the warp is the full sheet and the weft pieces are the loose strips.

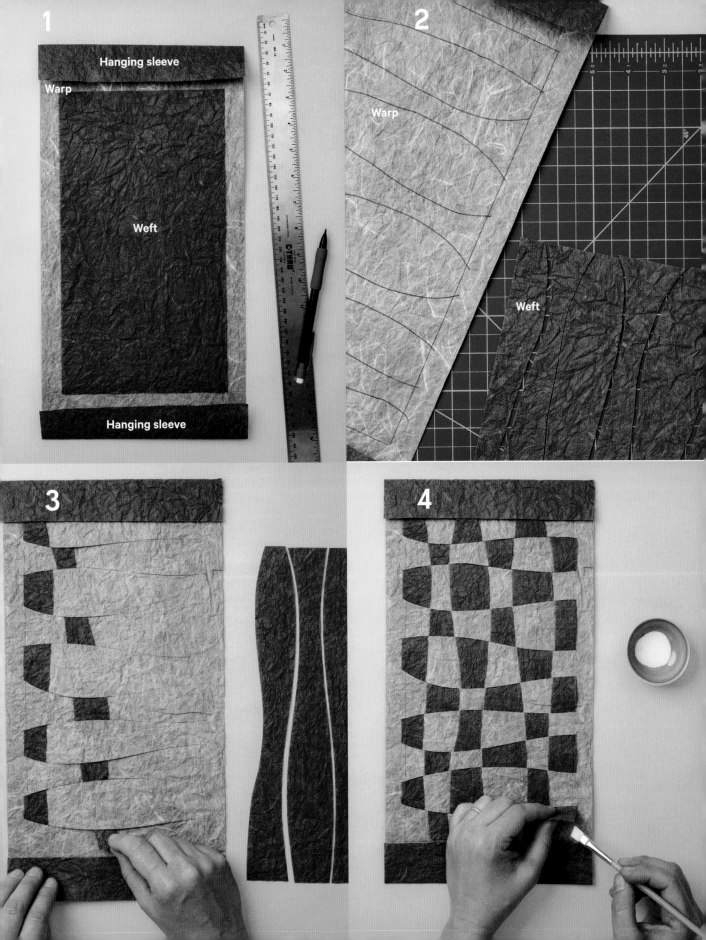

1

Hanging sleeve

Warp

Weft

Hanging sleeve

2

Warp

Weft

3

4

5 Now you can cut little windows (if desired) in the woven sections where warp paper covers up weft strips. To keep from cutting a hole through both layers, cut a strip of plastic cutting mat about 1½" wide and 6" long and taper one end down to about ¼". One section at a time, slip the cutting mat between the woven layers and cut a window in the warp paper to reveal the weft strip beneath. Take care not to cut entirely through the edges of the warp.

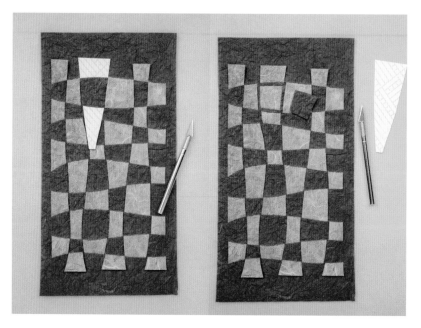

TIP: These instructions are for making the weaving shown, but feel free to create your own design. Experiment with cutting through weft strips, as well, to reveal warp paper beneath. Cut smaller or larger windows of different shapes, as few or many as you like. Note that if you cut a window in the warp paper on one side, you should not cut a window in the weft paper in the same area on the opposite side, because you will create a hole, as seen in the example at left.

6 Apply double-sided tape or glue to the folded-over top and bottom edges of the warp paper to create sleeves for the hanging. Slip a dowel or bamboo stick into each of the sleeves.

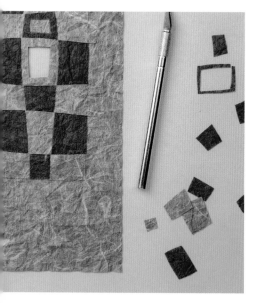

FUN FACT

There are so many ways to weave paper, and it is such fun to mix and match papers. In 2013, I worked on a project that involved creating one new weaving each day for 100 days in a row. This gave me a chance to explore papers and weaving styles, and I couldn't help but come up with new ideas as the days progressed. Now, each January, I teach an online class called Weave Through Winter, and a group of us explore paper weaving for 30 days in a row.

I discovered cutting windows between layers of paper when I was making paper lampshades. I had the idea to weave two sheets of paper, thinking they would look interesting when illuminated. But when I turned the light on, the two papers blended instead. I tried cutting windows in the lampshade to let in more light and was intrigued with the results.

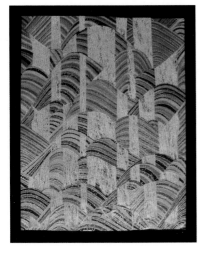

Helen Hiebert, *Mountains*, 2013.
Japanese chiyogami and hand-beaten kozo fiber; 12" × 9".

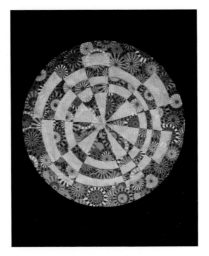

Helen Hiebert, *Circular Weave*, 2013.
Japanese chiyogami and artist-made abaca paper; 12" × 12".

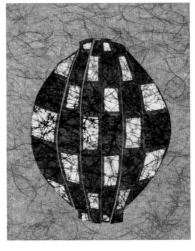

Helen Hiebert, *Lantern Weave*, 2020.
Batik marbled paper and decorative Japanese paper; 14" × 10".

Bojagi Curtain

DESIGNED BY Steph Rue
PAPER USED 25 gsm hanji made by the artist from 100 percent dak (mulberry) fibers
LOOK FOR You will need a strong, thin paper that looks good when held to the light.

Bojagi is a traditional Korean stitched textile. Artists have their ways of bending tradition, though, and Steph Rue's use of small pieces of paper relies on the same principle as traditional bojagi. These instructions show you how to make a bojagi curtain, which looks so beautiful when hung in a window.

Materials

- Approximately 24" × 36" sheet of hanji
- Wheat paste (see recipe on page 39)
- Curtain rod or wire and curtain hooks (see step 11 on page 216)

Tools

- Short and long straightedges (12"–36")
- Pencil
- Hollander's paper knife (see Resources on page 275) or paring knife
- Cutting mat with grid lines
- Awl or very fine bone folder
- Iron
- Ironing board or cloth to iron on
- ⅛"-wide glue brush
- Interfacing or a piece of fabric
- Craft knife

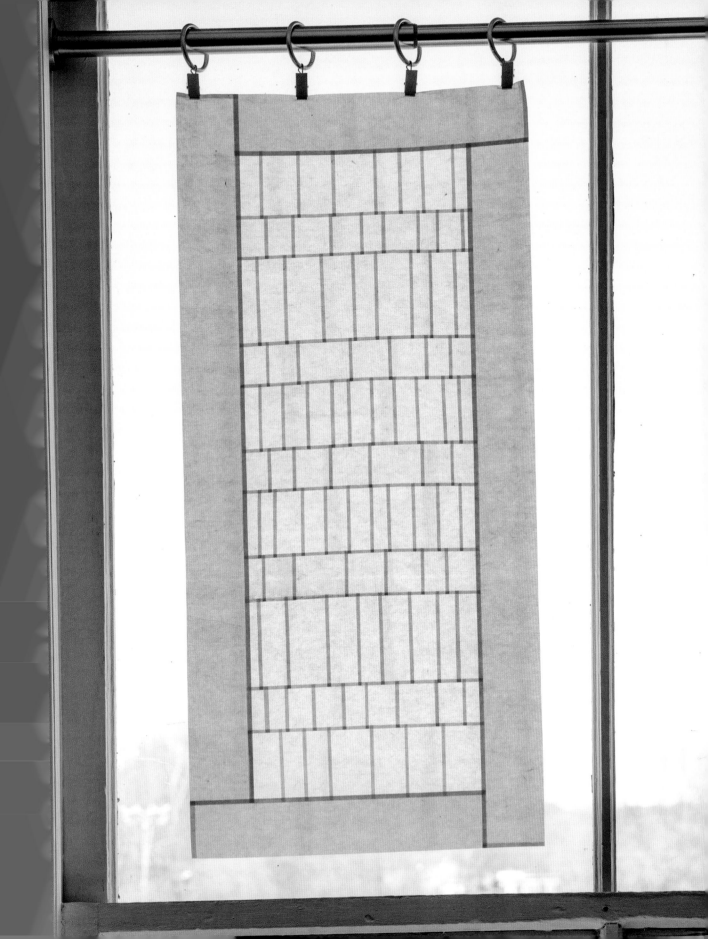

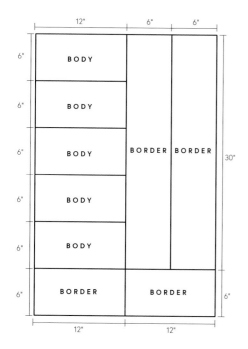

Instructions

1 To cut the sheet of hanji, refer to the diagram at left for the dimensions and follow the steps below, using a straightedge, pencil, paper knife, and cutting mat to measure, mark, and make the cuts:

(A) Measure and mark 6" from the bottom, fold, and cut. This is your first piece. Fold and cut this first piece in half so you end up with two pieces that are each 12" long and 6" wide. These are the top and bottom pieces of the border.

(B) Fold the remaining hanji in half lengthwise and cut it so that you have two pieces that are each 12" wide and 30" long.

(C) Fold one of these 12" × 30" pieces in half lengthwise, then cut it so that you end up with two long pieces that are each 6" × 30". These are the two long side pieces of the border.

(D) With the remaining 12" × 30" piece, measure five sections that are each 12" × 6". Fold and cut these pieces, which will be the main body of the bojagi.

2 **PREPARE THE MAIN BODY OF THE BOJAGI.** Lay one of the five body pieces horizontally on the cutting mat. Use the tip of an awl and a straightedge to score 6 to 10 pairs of vertical lines that are spaced apart evenly. The lines in each pair should be spaced about ⅛" apart. Use the grid lines on your cutting mat as a guide.

3 Fold each pair of vertical lines like a Z, creating pleats, and then iron all of the folds flat. Repeat step 2 and this folding process with the remaining four body pieces.

4 With wheat paste and a brush, paste the folds down one at a time. Use an iron to make sure each fold stays flat: Paste one side, iron flat and dry, and then paste the other side, where necessary (the glue from the initial pasting might seep through and adhere both layers).

TIP: When ironing, put a piece of interfacing or fabric between your paper and the iron to avoid getting glue on the iron.

5 With a craft knife and straightedge, cut your strips in half lengthwise. Arrange your cut strips on a large cutting mat or table, as shown, avoiding lining up the pleated lines.

Continued on page 214

TIP

You'll need a long straightedge when cutting the large sheet of hanji paper in step 1 and a smaller straightedge when scoring the pairs of vertical lines on the main body and border sections in steps 2 and 7. Note that it can be difficult to measure handmade paper precisely because of the deckled edges.

This project involves simply folding the paper as described and cutting it with a paper knife. Crease the folds well, and your knife will cut through the paper like butter.

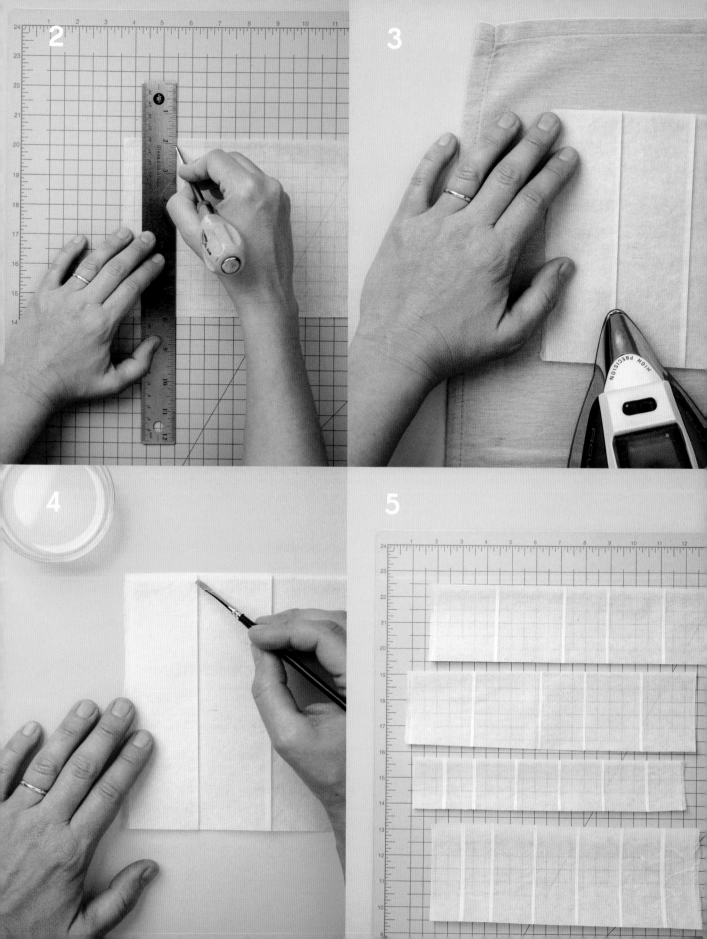

HANJI THROUGH THE AGES

Hanji is soft and durable, delicate and strong. Made from the inner bark of the mulberry tree, hanji is a sustainable and versatile material with a 1,500-year history. Koreans developed their own unique method of forming sheets, producing a strong two-ply paper of incredible luster and durability. For hundreds of years, hanji was an important part of daily Korean life and was used for printing, calligraphy, painting, interior design, lighting, boxes, bookcases, baskets, clothing, shoes, and even armor.

Hanji artisans today struggle to sustain their craft in an age of rapid modernization. It is now rare to find hanji in its purest, most traditional form: handmade from the best materials, formed in the original Korean method, and free of harsh chemicals. Steph Rue, whose ancestors are Korean, hopes to support and sustain the making of this incredibly beautiful and rich material by spreading the word about hanji and promoting its use.

6 **ASSEMBLE THE MAIN BODY OF THE BOJAGI.** Start with two strips from the center of your layout. If necessary, trim each strip lengthwise to create straight edges where they will overlap. Using your awl or bone folder and straightedge, score a line ⅛" from the edge of one of the strips, fold along the score line, and iron it.

Using your tiny brush, apply wheat paste to the edge of the adjacent strip (the one without the folded edge). Take the strip with the folded edge and adhere it to the paste on the adjacent strip, lining up the folded edge with the edge of the other strip. Carefully flip the adhered pieces over to make sure the edges line up, and adjust and add paste, if necessary. Iron this seam.

Repeat this step until all of the pieces in the main body of the bojagi are connected.

TIP: When gluing, you usually apply glue to the piece or area you are gluing, rather than to the piece you are gluing to. This results in the glue landing only where it needs to be. When working with thin Asian papers, however, it is sometimes best to apply glue to the piece or area you are *gluing to* because the moisture from the paste can cause the seams to lose their sharp crease, which can make it difficult to line up the papers accurately. The beauty of wheat paste is that if a little finds its way to a place it shouldn't be, it doesn't leave a mark.

7 **PREPARE THE BORDER.** The border consists of four pieces that will be adhered to the main body of the bojagi and to each other at the corners. Fold each of the four border pieces in half lengthwise. Trim each folded border piece so it is 2¾" wide when folded. Using your bone folder and straightedge, score a line ¼" in from the long edge. Unfold the border and fold each seam inward. Iron the seams to set them. You should now have four border pieces (two short borders and two long borders) with seams on the long open edges.

8 **ASSEMBLE THE BOJAGI.** Starting with a short border, brush paste on one edge of the main body and adhere one of the folded seam edges of the border to it, leaving an overhang of about ¼" on one end and roughly 3" on the other. Note that you will adhere the other edge of the short border after all four border pieces are connected to the main body.

Continued on page 216

9 Trim off the ¼" overhang so that the border is flush with the main body of the bojagi. Apply paste to the long edge of the main body of the bojagi as well as to the part of the short border that now sits flush. Take a long border piece and adhere it to the entire main body of the bojagi plus the short border, leaving an extra margin of about ¼" on the short border. The other end of this long border should extend beyond the opposite edge by about 3". Iron flat.

10 Repeat steps 8 and 9 to attach the other two border pieces, starting with the short one. Open up the unfinished corners and carefully score and fold the seams, lining them up with the outside border. Trim as necessary, fold over, and glue the small corner seam. Iron flat.

At this point all four border pieces should be adhered to the main body of the bojagi only on one side. Work your way around, applying paste to the other side of the main body, then attaching the folded seams. You are sandwiching the main body of the bojagi between the folded flaps of each border piece.

11 **FINISH THE BOJAGI.** Touch up any areas that are not fully pasted down and iron flat. Choose an area to hang your finished bojagi, such as in front of a window or door. (Somewhere with light is ideal.) Use a curtain rod or wire and clips to hang your bojagi curtain. Attach three or four clips to one of the short edges of the bojagi and hook the clips onto the curtain rod or wire.

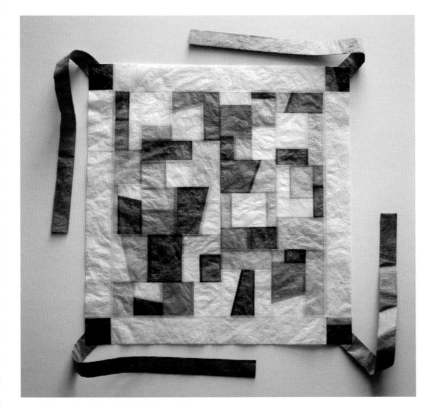

Steph Rue, *Untitled #1*, 2017. Sumi ink and natural dye on artist-made hanji; 14¼" × 14½".

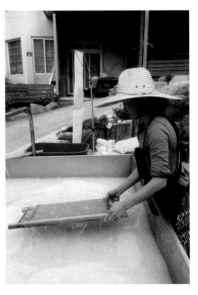

Steph Rue making hanji in Korea

ARTIST

STEPH RUE is an artist who works primarily with handmade paper and books. She first discovered the world of books and paper while working as an editor at San Francisco's Academy of Art University, where she took classes in printmaking and book arts. She then attended the University of Iowa Center for the Book to study papermaking with Timothy Barrett. Rue fell in love with Asian papermaking and continued to study papermaking and book arts in Korea on a Fulbright research grant.

Now based in Sacramento, Rue makes paper bojagi in her home studio and teaches workshops on papermaking and bookmaking, with an emphasis on East Asian techniques and aesthetics. You can read about Rue's research on Korean book and paper arts on her blog (see Contributing and Referenced Artists on page 276).

Quilled
Snowflake
Ornament

DESIGNED BY Ann Martin
PAPER USED Printer paper
LOOK FOR Standard printer paper or quilling strips. It takes very little paper to make one small snowflake ornament. You only need about one-eighth of a sheet of standard printer paper! True quilling strips are slightly thicker and softer than printer paper. You can also use metallic-edge quilling strips for a festive look. Strip length varies by manufacturer, but one package of strips is generally enough to make several snowflakes.

Quilling is an old art form that involves rolling and shaping paper strips and then gluing the shapes together to create decorative designs. Hang this paper snowflake on the holiday tree, in a window, or use it as a present topper . . . a little gift on a gift! If you prefer, you can turn the finished snowflake into a pendant by using jewelry pliers to add a metal jump ring instead of a hanging loop, then simply thread a necklace chain through the jump ring.

Materials

- 8½" × 11" sheet of printer paper
- White glue or clear acrylic gel
- Waxed paper or plastic sheet to protect work surface
- Fine metallic cord

Tools

- Craft knife
- Cutting mat
- Metal ruler
- Plastic lid to use as glue palette
- Ball-head pin
- Small dowel (¼" diameter)
- Large dowel (⅜" diameter)
- Small scissors
- Paper piercing tool or slotted quilling tool
- Tweezers

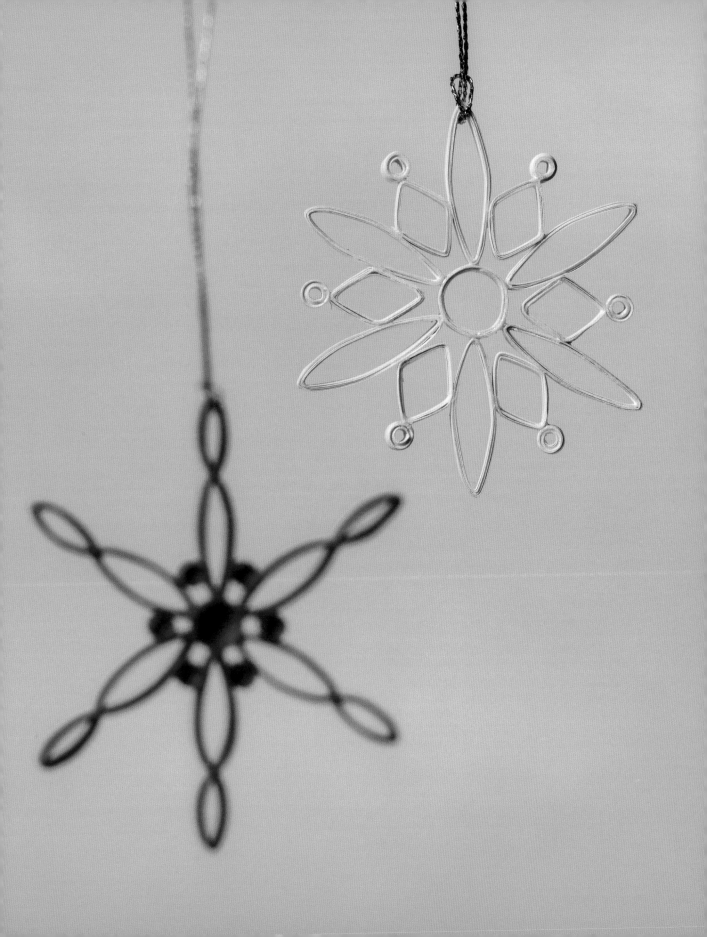

- Instead of purchasing dowels, substitute tools you have on hand to form the ring, marquise, and diamond coils. You might also use a quilling tool handle, pen, pencil, or any implement with a slick surface that will allow the rolled coil to slide off easily.

- Place a dab of craft glue on a plastic lid. When gluing coil ends, dip the tip of a pin into the glue to control the amount you use. Quilling requires less glue than you might expect.

Instructions

1 Use a craft knife, cutting mat, and ruler to cut eight ⅛" × 11" strips from a sheet of your project paper.

2 **MAKE ONE CENTER RING COIL.** Set up the glue on a plastic lid and have a pin handy (see the tip at left). Tear a strip to approximately 4½" long and wrap it around a small dowel five times. Tear off any excess paper and glue the outer end in place. Slide the coil off the dowel and glue the inner end.

3 **MAKE SIX MARQUISE (EYE) COILS.** To make a marquise coil, tear a strip to approximately 6½" long and wrap it around a large dowel five times. Slip the coil off the dowel without allowing it to expand. Pinch the coil at two opposite points, placing one of the pinch points where the initial strip end is located inside the coil; this will help to hide it. Trim any excess strip with small scissors and glue the ends in place.

4 **MAKE SIX DIAMOND COILS.** To make a diamond coil, tear a strip to approximately 4½" long and wrap it around a small dowel five times. Slip the coil off without allowing it to expand. Pinch as for a marquise coil, then turn the marquise 90 degrees and pinch two more opposite points to create a square. Compress the square gently between your thumb and index finger to make a diamond shape. Trim any excess strip and glue the ends in place.

Continued on page 222

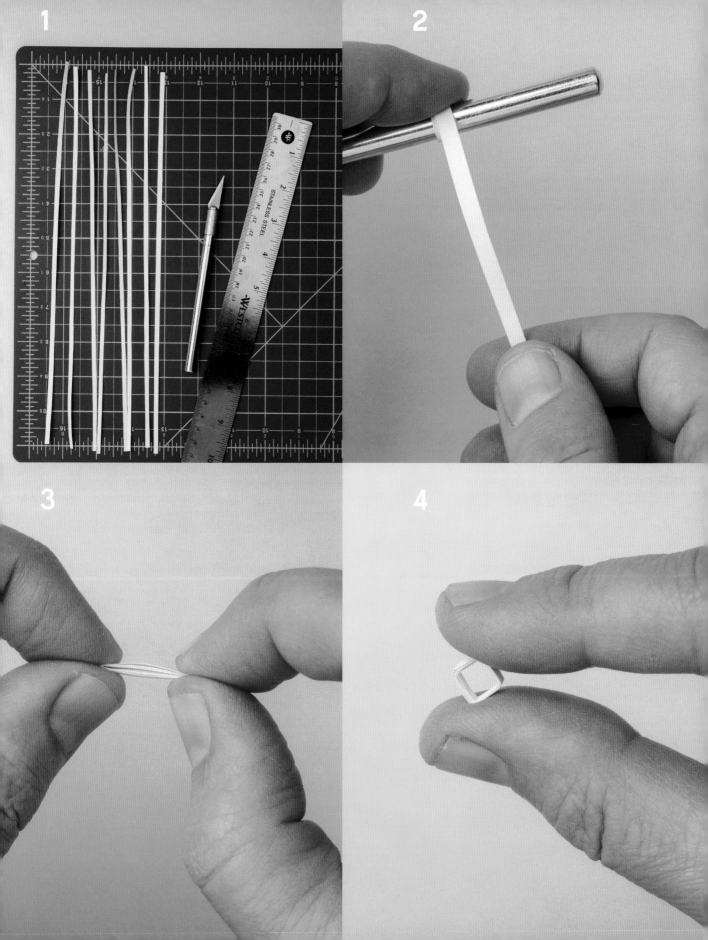

ARTIST

ANN MARTIN became captivated by quilling after seeing a magazine article about the countless design possibilities with coiled strips of paper placed on edge. She enjoys introducing quilling to others by designing modern projects for how-to books and by featuring tutorials on her blog (see Contributing and Referenced Artists on page 276), where she also showcases a variety of paper artisans and their work. Martin is the author of several books about paper quilling and papercrafts.

Ann Martin, *Quilled Chandelier*, 2011.
Metallic paper, metallic-edge quilling
paper; 5" × 5" × ⅛".

5 **MAKE SIX TIGHT COILS.** To make a tight coil, roll a 2"-long strip around the tip of a paper piercing tool or slotted quilling tool (A). Do not allow the coil to relax; glue the end and slide it off the tool.

OPTIONAL: For a dimensional look, make domed tight coils: Press the ball head of a pin against one side of a tight coil to create a dome (B; shown here in purple for greater visibility). Apply a small amount of glue inside the dome to preserve the curve.

6 **ASSEMBLE THE SNOWFLAKE.** Working on a nonstick surface such as waxed paper or a plastic sheet and handling the coils with tweezers, glue each marquise to the ring coil, spacing them evenly around the ring.

- Glue a diamond between each marquise so that the sides of each diamond touch the side midpoints of each marquise.
- Glue a tight coil to the tip of each diamond.
- When the glue is dry, turn the snowflake over and apply tiny dots of glue at each joint as reinforcement.
- Thread 10" of fine metallic cord through one of the marquises and tie it to create a hanging loop.

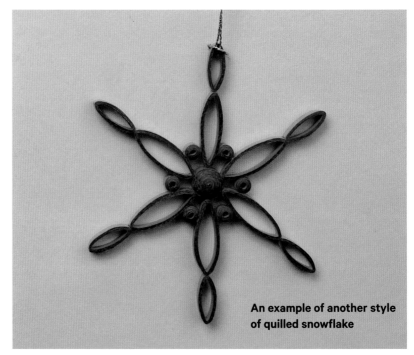

An example of another style of quilled snowflake

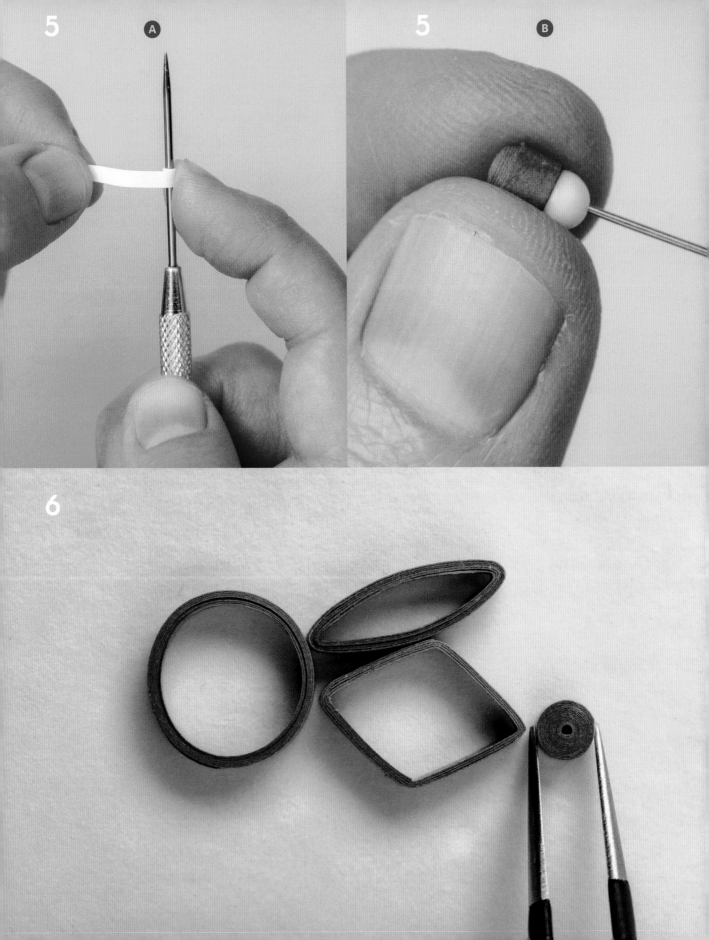

Paper Twist

DESIGNED BY Gina Pisello
PAPER USED 98 lb. (160 gsm)
Canson Mi-Teintes Red Earth
LOOK FOR A sturdy but
not-too-stiff card stock. It
needs to hold its shape and
fold well at the same time.

The amazing thing about this project is the way that a series of scored and folded straight lines can create this spiraling form. There are no curves in the pattern. Be patient; I found this one challenging, but if you follow the instructions step by step, I think you'll be amazed with the way this sheet of paper transforms from a rectangle to a nautilus and finally to a swirling spiral form.

TIP: The instructions are written without using a template, but I highly recommend making a model by printing the Paper Twist windows template onto a sheet of lightweight card stock. You can decide whether you want to cut the windows that are on that template—the Paper Twist looks great with or without windows—and if you choose not to, the printed markings will be hidden on the inside of the piece.

Materials

- Template (see page 300; optional)
- 7½" × 10" sheet of paper
- 24" length of embroidery, silk, or sewing thread (if you plan to hang your Paper Twist, you'll need additional thread)

Tools

- Straightedge
- Bone folder
- Craft knife
- Cutting mat
- Awl or Japanese screw punch with 1.5 mm bit
- Pencil

Instructions

1 Place your sheet of project paper on a firm surface in a landscape orientation, with the X (as shown on the Paper Twist windows template) in the upper left corner. Use a straightedge and bone folder to score and fold on the diagonal from the upper left corner to the lower right corner. Fold the lower left corner up and to the right along the score line. Keep it folded for the next several steps.

2 **(A)** Fold the model in half as shown, then unfold.
(B) Divide the model into four sections by folding the two points into the centerline, keeping the straight edges aligned. (You are folding two layers of paper.) Unfold.

(C) Divide into eight sections: Fold the bottom point up to meet the topmost fold. Unfold. Fold the top point down to meet the bottommost fold. Unfold. Now fold the bottom point up to meet the fold closest to it. Unfold. Fold the top point down to meet the fold closest to it. Unfold. You now have eight sections.

(D) Divide into 16 sections: Make another series of folds as you did in step B to divide each section in half again, ending up with 16 sections. All of the folds should be valleys on one side of the paper and mountains on the other side (do not accordion-fold).

Continued on page 228

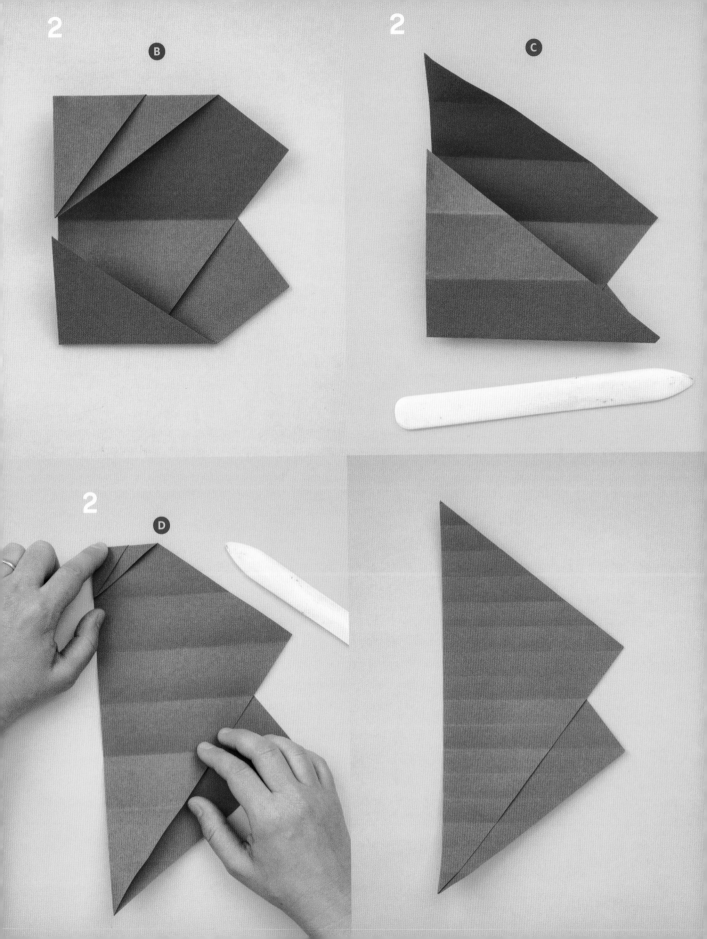

B

C

D

3 Orient the model so the long diagonal fold faces away from you and the open edge faces you, and with the lines you creased in step 2 as all mountain folds. Starting on the top right, score diagonal lines between each pair of vertical lines as shown on the diagram at left (do not score the two ends that are triangle shaped). When scoring the last seven sections of the model, line up your straightedge with the left parallel lines that only show on the lower layer of the folded paper. Make sure that your score lines do not go over the edges of the parallel lines or the model won't collapse correctly.

4 Keeping the paper folded in half (so you work both layers of paper together), start at the end marked with an asterisk on the diagram and fold the diagonal scores as valleys, alternating them with the mountain folds you made in step 2. Gently unfold the opposite end of the paper and use a craft knife and cutting mat to cut off the triangle marked with an X on the diagram; otherwise the model will not collapse fully.

5 Unfold the paper and gently flatten all of the creases, orienting the paper so that the main diagonal line is a valley fold, as shown in the photo at right. Then measure and mark where you will punch five holes on each edge, as indicated:

- One hole approximately ⅛" from the edge at the midpoint of segments 2, 4, 6, 8, and 10, starting from the upper left corner
- One hole approximately ⅛" from the edge at the midpoint of segments 1, 3, 5, 7, and 9, starting from the lower right corner

Use a Japanese screw punch or awl to punch out the 10 holes.

Continued on page 230

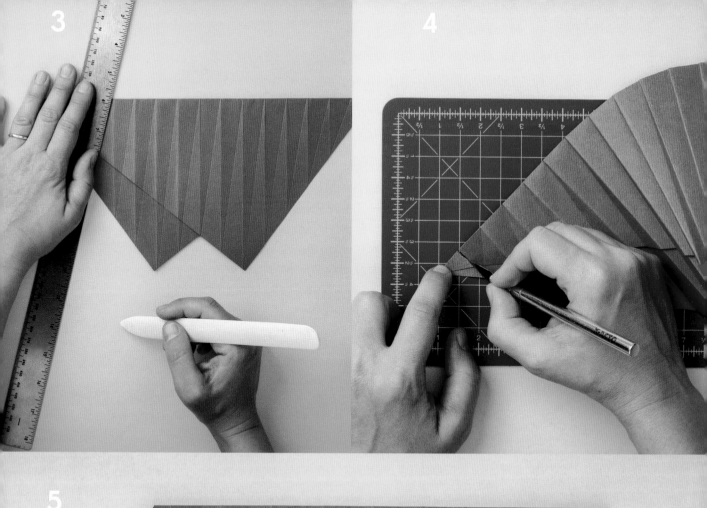

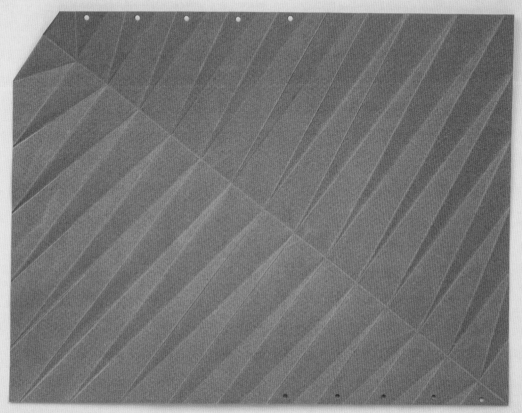

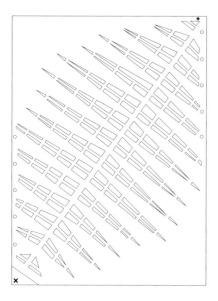

6 **OPTIONAL:** Cut windows using the template on page 300 (and shown at left) or cut your own pattern in the panels to create a lovely shadow effect. If you don't want windows in your model, skip to step 7.

7 Refold the accordion spirals on each side of the diagonal, one at a time. Cradle the paper in your hands and twist to bring the two sides together so the holes created in step 5 are staggered, slightly lower on the right and higher on the left. Weave your thread through the holes as if you were lacing a shoe. Tie with a bow or knot. If you'd like, attach another thread and hang your paper twist, letting it spin and catch the light.

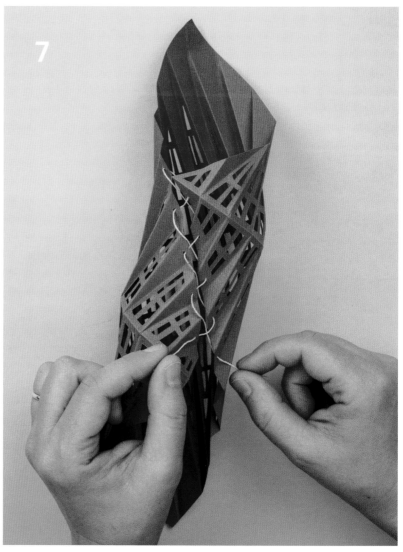

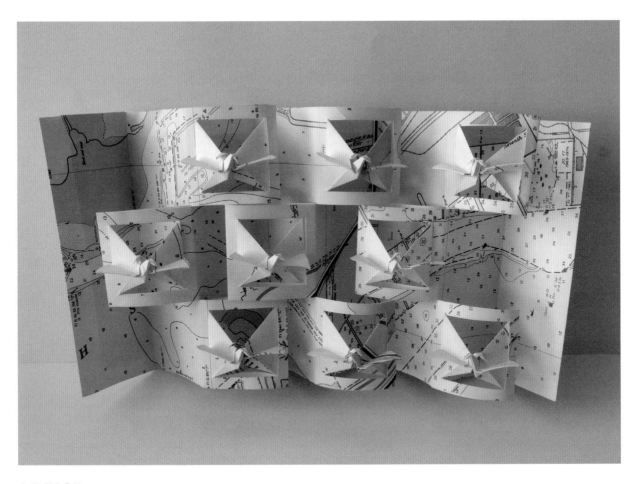

ARTIST

GINA PISELLO, a book artist in Southern California, was experimenting with spiral designs from Tomoko Fuse (see the Reading List on page 277). Instead of always starting with a trapezoid, as Fuse does, Pisello tried starting her spirals with other shapes. She tried a square creased on the diagonal and folded it into a spiral and then wondered what it would look like if she began with a rectangle. Pisello didn't think there would be much of a difference between the square and rectangle, but when she let the rectangle version pop up on her work surface, she discovered that it morphed into an interesting shape. She then devised the lacing method to create this three-dimensional paper twist.

"My approach to paper sculpture is to follow directions and then start asking questions. What happens to the shape or structure when I add this or take away that? The results aren't always pleasing, but sometimes something unexpected and exciting happens." —Gina Pisello

Gina Pisello, *Entanglement 1,* **2012.**
Vintage nautical chart; 6" × 11" × 2".

Paper Thread

DESIGNED BY Susan Byrd
PAPER USED Nishinouchi Shifuyoushi

LOOK FOR Thin, strong Japanese paper. Large sheets of Japanese kozo paper are typically cut into four quarter sheets for making paper thread. This project was created with a quarter sheet.

Shifu is a woven paper cloth (in Japanese, *shi* means "paper" and *fu* means "cloth") that dates back to the Edo period of traditional Japan in the early 1600s. Today, weavers, spinners, basketmakers, book artists, and paper artists are finding innovative ways to create with twisted strips of a variety of papers. Sculptural shifu garments, knitted pages of a book, crocheted large doilies, and a woven teacup are a sampling of items made from twisted paper. A few contemporary Japanese papermakers craft shifu paper to be used in shifu weaving.

Material

- 9" × 24" sheet of strong, thin Japanese paper

Tools

- Ruler (see Metric Measures on page 234)
- Cutting mat (see Metric Measures)
- Heavy stone or other paperweight
- Craft knife
- Two damp tea towels
- Plastic sheeting or garbage bag
- Two concrete blocks (see Tip on page 234)
- Fine-mist spray bottle or damp washcloth
- Low-rimmed bowl or basket
- Handful of small dried beans or other weights
- Bamboo bobbin (¼"-diameter bamboo cut approximately 6" long) or ¼"-diameter stick
- Spinning wheel or drop spindle (optional)
- Skein winder (optional)

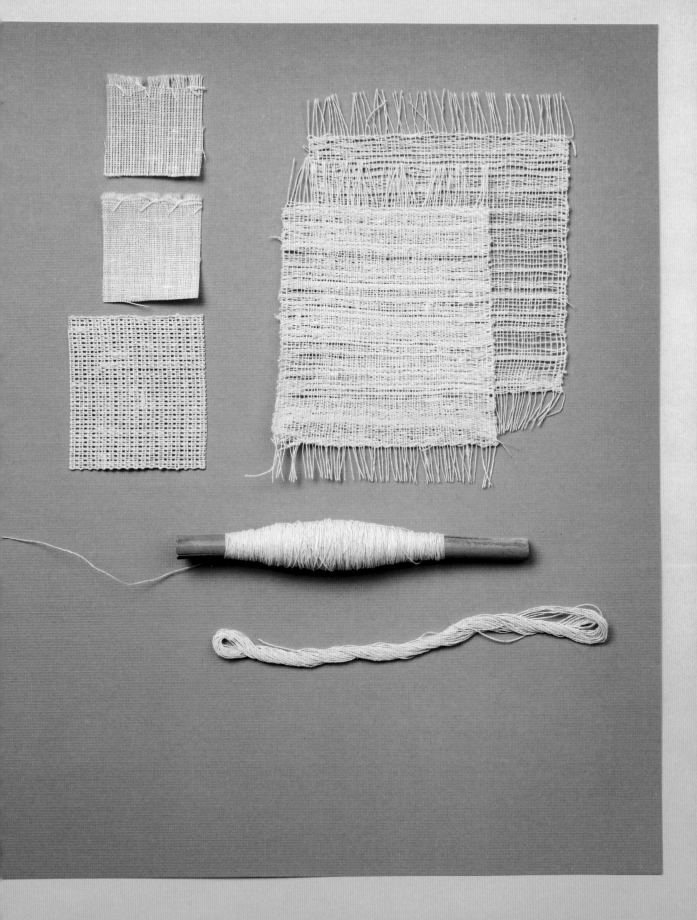

METRIC MEASURES

For this project, the thread sizes in the instructions are in millimeters (mm). This is because shifu makers use millimeters for measuring and identifying the size of the paper thread. For example, after a 2 mm paper thread is cut, rolled and spun, the thread is called a 2 mm paper thread, even though the thread is no longer 2 mm in size. To help you follow along, it is helpful to have a ruler with metric measurements and/or a cutting mat with millimeter measurements on the top and bottom.

TIP

When you roll the paper, a textured surface helps keep the paper from slipping around. If you use concrete blocks for this part, sand any rough edges on the surface of the blocks to prevent the paper strips from breaking. You can also use a low-pile carpet or the underside of a rug as an alternative surface for rolling.

Instructions

1 Fold the sheet of project paper in half lengthwise. Fold each end back in the opposite direction, leaving a 1" overhang on each end.

2 Place the folded sheet on a cutting mat and weigh it down with a heavy stone. Use a sharp craft knife to trim any uneven edges on the right side of your paper to give it a clean, straight edge. Then cut strips 2, 3, or 4 mm wide, starting each cut just above the overhang of the fold. Apply enough pressure to ensure that all four layers are cut and most of the paper's 1" overhang is left uncut.

3 Unfold the paper and place it between two damp (but not wet) tea towels. Cover this with plastic sheeting and let sit for about 15 minutes to allow the dampness to transfer to the paper.

4 Holding the 1" uncut edges of the dampened paper, place the paper on top of the two concrete blocks. Starting at the top of the uncut edges and working your way down to the bottom, carefully gather the uncut ends to form a bundle approximately 1" in diameter on either end of the thinly cut strips. Pinch these uncut ends together. Using the palm of your hands, gently roll the paper in a back-and-forth motion, starting from the two uncut outside edges and rolling toward the center, and then back out to the edges. Repeat this several times.

Take extra care, especially in the beginning, because the paper is more vulnerable to breakage while damp. As the paper dries, you can apply more pressure to help get a good twist in the individual strands. Intermittently lift the sheet, shake it to check for tangles, and separate any strands that are sticking together. If you find the paper dries too quickly, which can cause issues with rolling, dampen either the concrete surface or your hands using a fine-mist spray bottle or a damp washcloth. This step takes about 10 minutes.

Continued on page 236

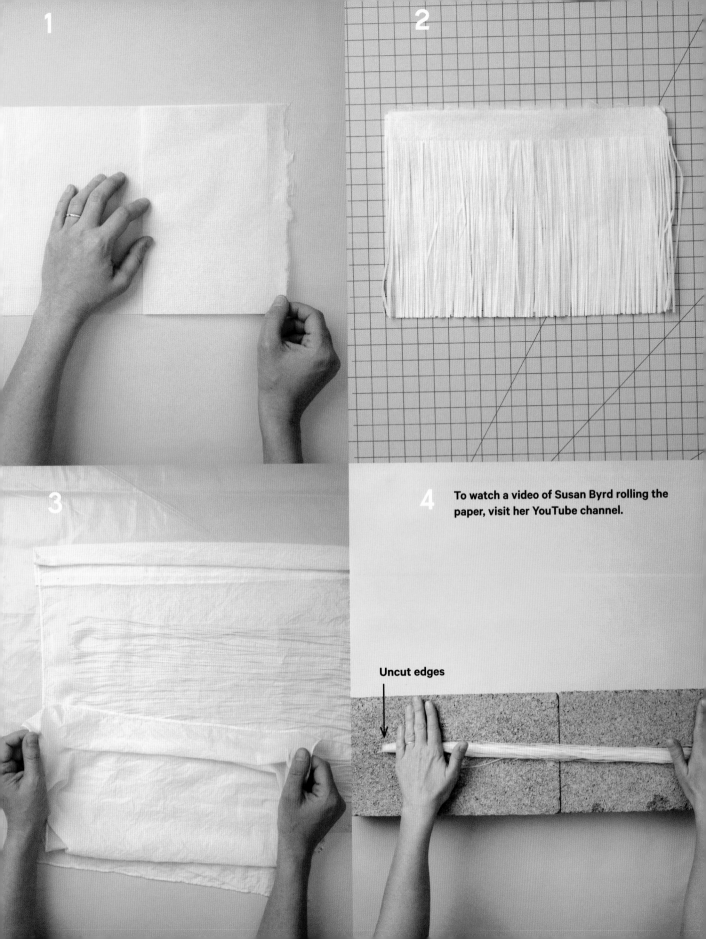

1

2

3

4

To watch a video of Susan Byrd rolling the
paper, visit her YouTube channel.

Uncut edges

Fixing a Broken Thread

If the thread breaks, twist the two ends together in one direction (A), then lay them to the side, parallel to the single strand of thread (B), and twist them together in the opposite direction. The twist should hold when gently pulled (C).

5 The twisted paper strips should now be more threadlike. Now you will separate them to make one long continuous thread. Starting at one end of the 1" strip of paper that is holding the thinly cut strips together, carefully tear off two thread strands, keeping them connected by part of the 1" strip of paper. Roll the paper joint between your thumb and forefinger to create a "seed" or nub, resulting in a loop of paper thread that is still connected to the other 1" strip of paper. Continue along the row until all of the threads form loops.

6 Starting at the other end of the 1" strip of paper that is still intact, tear off one of the strands to form the end of what will become one long continuous paper thread.

Now, as you did in step 5, carefully tear off two thread strands, keeping them connected by part of the 1" strip. Roll the paper joint between your thumb and forefinger to create a "seed" or nub. As you continue tearing off two strands at a time, you will create one long strand of paper thread. As you work, coil your paper thread in a bowl or basket. When you are finished coiling, you may find it helpful to scatter a handful of small beans on top of the thread to prevent it from coming out of the basket during spinning (see the next step).

7 Dampen your hands and further twist the thread as you wind it onto a bamboo bobbin. This will result in a stronger thread with more even twist. If you have a spinning wheel or drop spindle, you can use it to add twist at this point by winding your thread onto its bobbin or spindle. (Shifu weavers use an itoguruma, which is similar to an Indian charkha.)

TIP: If you're winding the thread onto something other than a bamboo spool, make sure it can withstand boiling or steaming. If not, wind your paper thread onto something else, such as a stick, before going on to step 8.

8 Immerse the bamboo spool and thread in boiling water for about 10 seconds to secure the thread's twist. Alternatively, you can steam the thread for 20–30 minutes. While the thread is still damp, carefully unwind it from the spool, then wind it into a skein to dry completely.

TIP: Handspinners use a special tool called a skein winder, but you can also use the backs of two chairs, placed back to back. Simply wind your paper thread around the chair backs to create a large loop of threads.

Continued on page 238

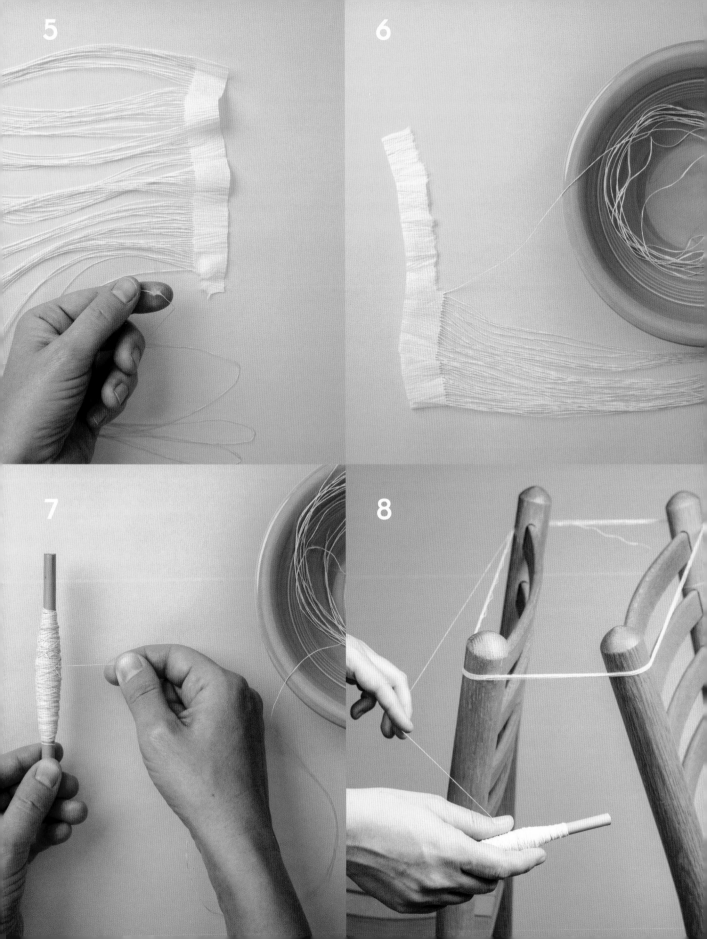

USING SHIFU

Traditionally, shifu weavers used kozo paper (made from paper mulberry fibers) to create paper thread, called kami-ito. Kozo fibers are longer and stronger than the other two traditional Japanese papermaking fibers (mitsumata and gampi), and the plant is readily available in Japan, making it a cost-effective fiber source. The sturdy paper threads also had a variety of traditional uses beyond shifu weaving. For example, under-garments were knotted together using a two-ply paper thread or string, and a paper string or cord was often woven into baskets and other objects.

Variation

You can also do this project with wider strips of paper, between 6 and 10 mm. If your strips are this width, instead of dampening the sheets and rolling on cement blocks, roll with damp hands or spray the paper with a fine mist of water and then roll between your hands.

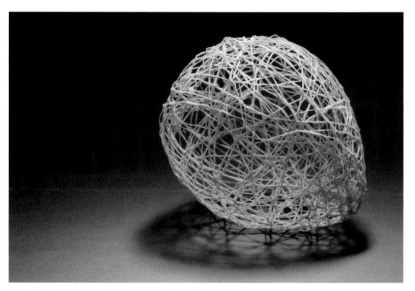

When I lived in Portland, I was a member of a small group of women artists who met monthly to discuss our work, see exhibitions, and support each other's work. One evening the group came to my studio. I had several sheets of handmade abaca paper, and we cut it with a rotary cutter on a cutting mat and spun it into a crude thread. That took us a couple of hours. One member took the pile home (it looked like a huge plate of pasta) and wrapped it around a balloon.

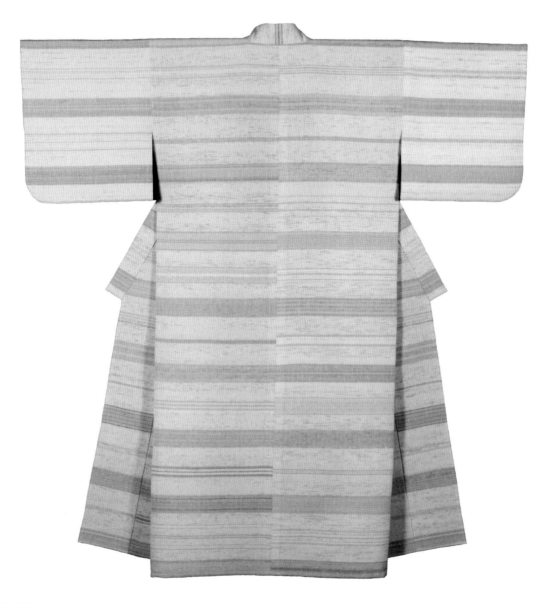

ARTIST

After graduating from college, **SUSAN BYRD** traveled to Japan to study Japanese papermaking and met celebrated shifu weaver Sadako Sakurai. Later she received a Folk & Traditional Arts grant from the National Endowment for the Arts to study shifu with Sakurai. Byrd published *A Song of Praise for Shifu* to help preserve the traditional craft of shifu. She continues to make her own shifu, in addition to mentoring others and running a Facebook group called Paper Threads, Yarns, and Textiles.

Susan Byrd, *Summer Robe (Kimono)*, 1986. 40/2 cotton warp and 3 mm paper weft; sumi ink writing; indigo, walnut, and lac dyes; 55½" × 54".

Pleated
Lantern

DESIGNED BY Helen Hiebert
PAPER USED 50g Tatami paper. Tatami is a Japanese paper machine-made with 30 percent kozo fiber, 70 percent wood pulp, and a light straw inclusion.
LOOK FOR Any strong, thin paper that looks good when held to the light will work.

I have long worked with fabric, sewing, embroidering, and more. One day, I was looking through a book about how to manipulate fabric with tucks, gathers, and pleats and was inspired to try pleating paper. I love sewing paper, so I zipped it through my machine to hold the pleats in place and reinforce a few perpendicular folds. If you stitch a little seam at each corner of this lantern, you can slip in a bamboo skewer for a sturdier structure.

Materials

- 8¼" × 11" sheet of strong lightweight paper
- Thread
- 6" or 12" bamboo skewers, approximately ⅛" diameter

Tools

- Bone folder (optional)
- Sewing machine or hand-sewing needle
- Pencil (optional)
- Heavy-duty garden or kitchen shears

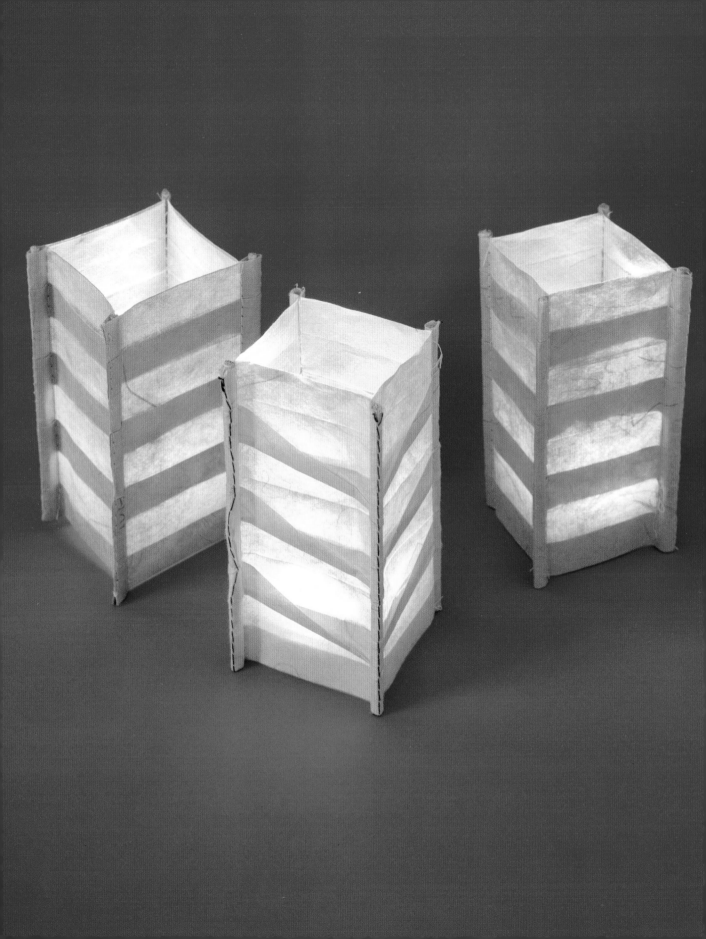

Instructions

1 Accordion-fold the project paper into four sections along the shorter paper dimension (see How to Fold an Accordion on page 26). Unfold, then accordion-fold the sheet into 16 sections along the longer dimension. Unfold again. Use a bone folder to reinforce the folds, if necessary.

2 Starting at the bottom edge, pleat every other accordion as shown: Fold the bottom edge up and over on itself, creating three layers of paper; leave a single section; pleat the next section (three layers); leave a single section; and so on.

3 Stitch along the first and third vertical fold lines. I highly recommend using a sewing machine for this, but you can hand-sew if necessary. Knot the ends and trim any loose thread.

4 Push up the center set of the pleats, forcing them into diagonal folds as shown. Do the same to each half section on the ends of the sheet.

5 Stitch along the second vertical fold line to lock the diagonal pleats in place. Fold the entire paper in half and carefully stitch the two loose ends together to bind the edge and create a box-shaped lantern.

6 To make seams for skewers, stitch another line parallel to each of the four seams, making sure the seams are wide enough (approximately ¼") to accommodate the skewers. Slip in the skewers and trim the ends with heavy-duty shears.

1

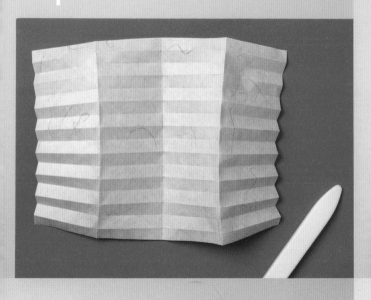

2

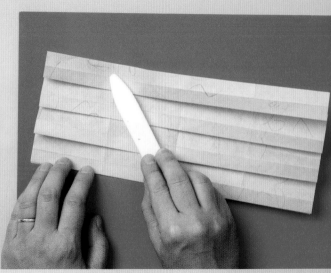

3 You might want to draw a guideline in pencil to help you stitch a straight line.

4

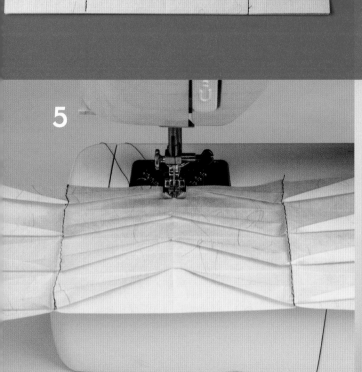

5

6

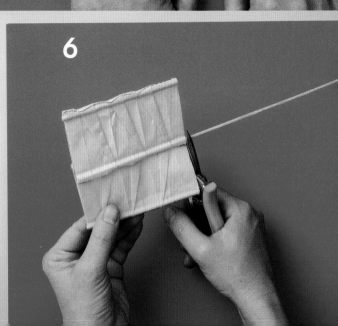

Paper- making & Surface Treatments

THERE IS A WIDE VARIETY OF TECHNIQUES—both traditional and contemporary—for making your own papers. Get your hands wet and make your own unique handmade sheets or apply one of many surface design techniques to embellish your papers.

From back to front: *faux batik by Melanie Terasaki; painted paper by Marcello Araldi; cyanotype by Beatrix Mapalagama; painted paper by Andrew Borloz; chalk-marbled paper by Paula Beardell Krieg; itajame dyed paper by Susan Kristoferson; and Slip-On Sleeve, Large Brass Fastener, and Shoelace Wrap-Around with Bone Attachment by Susan Joy Share*

Papermaking Techniques

Most projects in this book call for commercially made papers, although you can use handmade papers for many of them, if you'd like. The following pages offer a visual overview of some of today's common papermaking practices. These general categories can produce a wide range of variations depending on the exact technique and equipment you use. And there is still much to be explored in the fascinating world of handmade paper. For in-depth information on how to practice these papermaking techniques, refer to my book *The Papermaker's Companion*, as well as other books on the subject (see the Reading List on page 277).

Pulp Painting

Wet paper pulp can be pigmented and used as a medium to paint on the surface of a wet sheet of paper, similar to painting a canvas. Layers of pulp can be applied and built up on the freshly made sheet of paper. When pressed, the layers flatten and bond, becoming one uniform surface.

Examples of pulp-painted papers by Michelle Scarlett (top) and Ilze Dilane (right)

Lynn Sures, *Frasassi*, 2016. Cotton base sheets painted with pigmented flax pulp, with beeswax and thread; dimensions variable: each element is approximately 12" × 18". (Installation at Southwest School of Art.)

TRANSFORMING AGRICULTURAL "WASTE" INTO SUSTAINABLE JOBS

Matt Simpson founded Green Banana Paper in Kosrae, Micronesia, one of the most remote islands in the world. Simpson had learned that the island's younger generations were being forced to trade their homes and families for minimum-wage jobs in the United States, and he started his paper company as a social enterprise to help address the scarcity of job opportunities on the island. Today, Green Banana Paper combines the traditional art of hand papermaking with printing and stitching techniques using modern manufacturing technology. The company provides jobs, skill development, and sustainable exports for the community of 6,000.

The island of Kosrae is covered with banana trees that provide local families with sweet bananas. After local farmers complete the banana harvest, the trees are chopped down so that new fruit-bearing offshoots can grow. Green Banana Paper buys the leftover agricultural "waste," and its team of artisans transforms the natural fibers into beautiful wallets. These handmade vegan wallets are naturally resistant to water, fire, and rips.

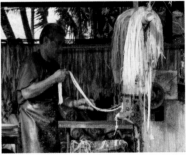

Pulp Stenciling/Pulp Printing

You can push wet paper pulp through a stencil to create drawings with a feathered edge, or spray layers of colored pulps into shaped stencils to build up imagery.

Laminating

Laminating is a way to adhere wet sheets of paper or collage onto the surface of a wet sheet.

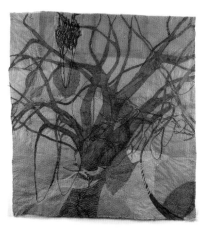

Examples of pulp stenciling and pulp printing by Susan Mackin Dolan

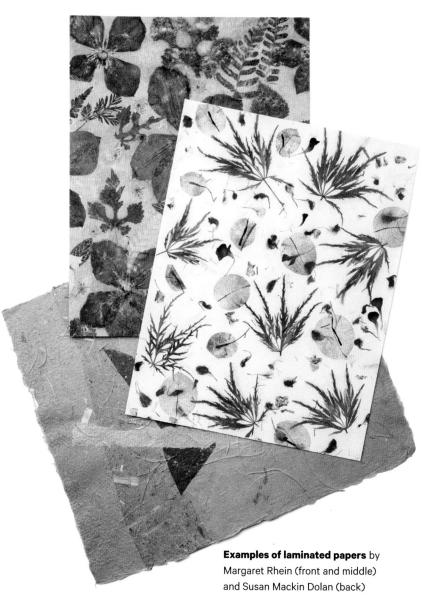

Nancy Cohen, *Settling In*, 2019.
Abaca, cotton, and linen paper pulp and handmade abaca paper; 77" × 73".

Examples of laminated papers by Margaret Rhein (front and middle) and Susan Mackin Dolan (back)

HEALING THROUGH PAPERMAKING

Peace Paper Project uses papermaking as art therapy and social engagement, and for making fine art around the world. Those involved with the project work with healing communities, such as survivors of war and terrorism, to take discarded fibers (including old military uniforms), cut them up, and transform them into sheets of paper and works of art. The organization relies heavily on pulp printing because it is an approachable technique that allows participants to create personalized compositions through the papermaking process.

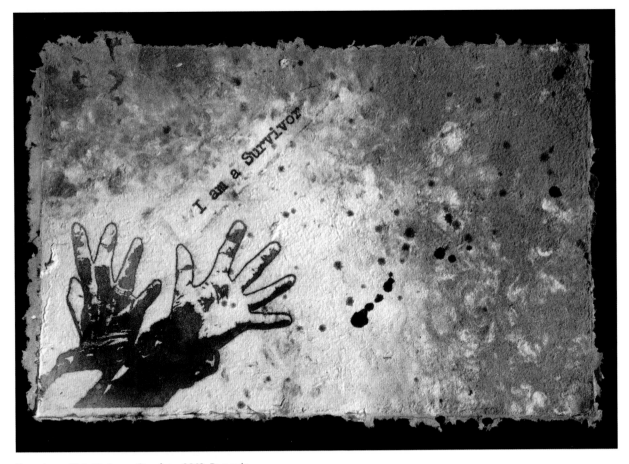

Drew Luan Matott, *I am a Survivor*, 2013. Rag pulp and pigmented overbeaten spray pulp; 20" × 26".

Embedding and Embossing

Items can be sandwiched between two sheets of wet paper during the papermaking process to create drawings or interesting textures, or to add structure to the sheet. You can use a translucent fiber on one side (or both) to embed an object such as a leaf or string to make the object visible or slightly hidden. You can create sculptural paper by sandwiching pieces of wire or string between sheets. Wet, freshly formed sheets of handmade paper can be placed onto textured surfaces and left to dry, resulting in embossed sheets.

Helen Hiebert, *Spine*, 2010.
Abaca and embedded string;
18" × 12".

Examples of embossed papers by (back to front) Linda Scarborough; Margaret Rhein; and Michele Emerson-Roberts

Inclusions

Adding items to the papermaking vat is one of the simplest ways to make paper unique and intriguing. Some interesting inclusions I've seen in papers include seeds, coffee grounds, flower petals, and shredded money.

Examples of papers with inclusions by (back to front) Susan Mackin Dolan; Susan Mackin Dolan; Ilze Dilane; and Gillian Spires

LIVING QUILT FOR SANTA ROSA

This public art installation spearheaded by artist Jane Ingram Allen started as a handmade paper "quilt" with seeds in the pulp. Over time, wildflowers bloomed in the same colors and patterns as the quilt. *Living Quilt for Santa Rosa* brought new life and beauty to an area of northern California that was severely damaged by wildfires.

Jane Ingram Allen, *Living Quilt for Santa Rosa*, 2018. Handmade paper from abaca pulp and blue jean sheet pulp, fiber reactive dyes, cotton string, seeds for wildflowers, and soil; total quilt measures 96" × 120", each sheet is 8½" × 17".

Susan Mackin Dolan, *Egg Woman,* **1991.**
Monotype on shaped handmade cotton
rag paper; 20" × 9".

Shaped Sheets

Cutting stencils or shaped deckles that control where pulp flows onto the mould can vary the shape of a sheet of handmade paper. This is an easy way to create envelopes, circles, and other shapes.

Watermarking

A watermark is a translucent design incorporated into a sheet of paper when it is made; it becomes visible when the dry sheet is held up to the light. Traditionally, watermarks were made by creating an image in wire that was stitched onto the papermaker's mould. Since the wire is raised above the mould's surface, the resulting paper is thinner where the wire is and a regular thickness everywhere else. This variation in thickness makes the watermark more translucent than the rest of the sheet. Once a sheet is pressed and dried, the variation in thickness is not apparent, but when the paper is held up to the light, the image becomes visible. Artists today create watermarks using a variety of materials, including adhesive-backed vinyl and fabric paint.

Helen Hiebert, *Equality,* **2017.** Pigmented and
watermarked cotton handmade paper; 18" × 12".

Sculptural Paper

There are many ways to work sculpturally with paper. In addition to altering the surface of the sheet by embossing, you can use paper pulp or wet, formed sheets for casting; attach wet sheets to armatures; or, as shown here, embed an armature in the paper. In this process, the pulp shrinks around the embedded armature as it dries and creates sculptural forms.

Peter Gentenaar, *Eternal Flame*, 2011.
Linen pulp, pigment, and bamboo; 75" × 59".

Examples of dyed papers (clockwise from top left): rust print by Jill McDowell; itajame dyed paper by Susan Kristoferson; dyed and stitched paper by Jill McDowell; and pounded flower paper by Gina Pisello

Decorating Techniques

We have all doodled, painted, and written on the surface of paper. These are all basic forms of surface design. You can apply a variety of media to the surface of a sheet, crumple it to add texture, or treat it to make it more translucent. The following pages offer a visual overview of the ways artists today are employing a range of techniques, some adhering to tradition and others applying contemporary adaptations. There are books that go into detail about many of the techniques described here (see the Reading List on page 277).

Dyeing

Who doesn't love saturated colors? Artists and papermakers have been adapting fabric-dyeing techniques for centuries. From shibori (a Japanese term for manipulated dye techniques) and staining with rust to applying dyes made from plants (such as black walnut or indigo), the range of colors and patterns you can get is limitless.

Printmaking/Photography/Stenciling

Printing was developed for spreading the word (literally printing type on a paper substrate to record history and spread news), but it was also an early form of surface design. Traditional printmaking techniques include woodcuts, etching, engraving, and lithography. Originally, letterpress printing was used to print books and news, but digital developments led to polymer plates and new artistic methods of this form of printing, which have helped prevent it from dying out.

Other printmaking technologies and artistic offshoots include serigraphy or screen printing (a modern version of an ancient stencil printing technique used in Japan), linoleum block printing, rubber stamping, Styrofoam printing, monoprinting, encaustic, and nature printing. Early photographs were printed on handmade papers, and today artists are using old methods as well as new alternative and digital techniques to print photographic images on paper. Rubbings and stencils are two other decorative techniques that lead to a wide variety of unique surface designs.

Examples of printmaking, photo, and stenciling techniques on paper (back to front): stenciling by Michele Emerson-Roberts; cyanotype by H. Lisa Solon; Van Dyke print by Alyssa Salomon; and stamped paper by Michele Emerson-Roberts

FROM FIBER ARTS TO PAPER ARTS

Susan Kristoferson, an artist in rural Alberta, Canada, hand-paints and hand-dyes papers to create an extensive palette for her unique collages and fine craft objects. When she was 6 years old, Kristoferson's father gave her a tiny hand-crank sewing machine and paper upon which he had drawn lines in spirals and labyrinths. She was given the task of sewing holes into the lines, and when she mastered that, her father gave her thread.

Kristoferson holds a master of fine arts degree in fiber arts, with a specialty in surface design and shibori techniques. She eventually shifted from working with fabric to dyeing paper and sewing paper collages. Her itajime (folded and dip-dyed) papers can be as small as 9 × 12 inches and as large as 40 inches × 15 feet. To create these itajime papers, Kristoferson must perfectly balance the qualities of the paper, colorants, folding techniques, and time.

Her research also includes historic paste papers, and she has developed a specialty in reproducing historic paste paper designs for antique book repair. Kristoferson uses her hand-painted paste papers and other decorative papers to create collages of the mountain vistas she sees daily and develops abstract collages based on the unique qualities of the shibori papers she creates.

Susan Kristoferson, *Many Alternatives*, 2019. Cotton vellum dyed with fiber reactive dye in the Katano shibori technique, collaged elements added; 22¼" × 41¾". Japanese artist Motohiko Katano developed this technique for fabric dyeing.

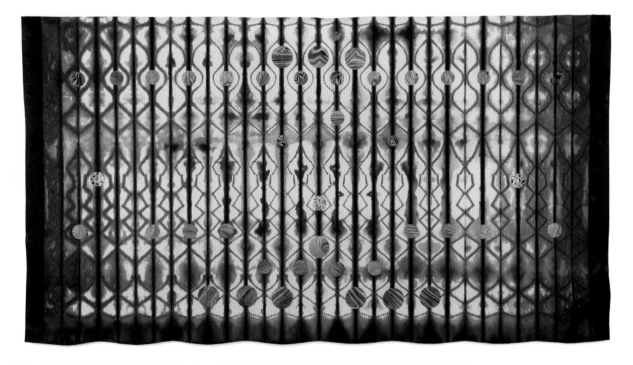

REDISCOVERING FORGOTTEN PATTERNS

Madeleine and Vernon Wiering are the daughter-and-father design team behind Papillon Papers, based in Grand Rapids, Michigan. They are design archaeologists, looking to the past for lost and forgotten patterns on paper and objects, then giving those patterns new life. The Wierings produce printed patterns in the way they were originally created, using hand-inked wooden blocks or magnesium plates, handmade papers, and an old letterpress.

Flora is an original hand-carved pattern inspired by an eighteenth-century French paper.

The French Pinwheel block print design originated in eighteenth-century France, where these patterned papers, called papier dominate, were created. These papers were used as endsheets in books, coverings for books, and wallpaper. This design is printed on Khadi paper, made by hand in India from T-shirt cuttings.

Marbling

Marbling is an age-old technique, and you can find gorgeous marbled endpapers inside the covers of old books. Suminagashi (in Japanese, *sumi* means "floating" and *nagashi* means "ink") is the oldest marbling method developed in Asia. As with papermaking, the craft moved west, and as artisans sought to replicate the patterns they saw from the East, they developed new techniques using local materials. Both involve floating color on the surface of a liquid, disturbing the design, and then picking up that design on the surface of a sheet of paper.

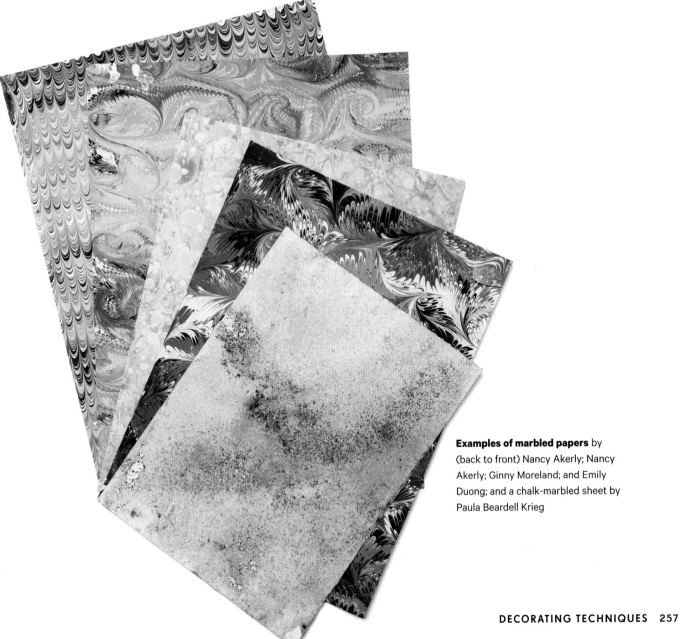

Examples of marbled papers by (back to front) Nancy Akerly; Nancy Akerly; Ginny Moreland; and Emily Duong; and a chalk-marbled sheet by Paula Beardell Krieg

Paste Paper

Remember finger painting? Paste paper brings finger painting to another level. You'll find historic paste papers on old book covers and endpapers, and today artists mix color into various types of paste, which can be applied to paper and scraped with implements such as combs, rubber stamps, sponges, and patterned rollers to create unique decorative patterns.

Examples of paste papers by (back to front) Kris Nevius; Marie Kelzer; Hélène Francoeur; and Karen Krieger

Madeleine Durham, *Journey of a Thousand Horizons 2*, 2019. Paste paper on Arches Text Wove, mounted on cradleboard; 24" × 12".

MAGIC BRUSHSTROKES

Madeleine Durham came to the world of paste paper after her husband's death and the closing of her bead store in Santa Fe, New Mexico. At that time, she became fully engaged in the thriving book arts program at Santa Fe Community College, where she discovered the wondrously curious and relatively unknown world of paste paper.

For a few years she made traditional paste papers by using combs to scrape through the paste applied to the paper, resulting in various patterns created by the teeth of the combs. But one day, when she was applying the paste to her paper with a large brush, she saw a type of line created by the edge of the brush that she had never noticed before. It was like magic. She literally gasped when she saw the line the edge of her brush created as her hand swept from left to right across the paper. Then she gasped again when she turned her brushstroke in the opposite direction, working with the line the edge of the brush created while blending the colors on her paper. Her new papers were received with stunning success at a book arts fair that year. Durham hasn't created another paper with the combed technique since then, unless she needs something for a particular project.

She now teaches paste paper techniques and creates paste papers that book artists and paper artists around the world enjoy. She also mounts her papers on wooden cradleboards to create wall art.

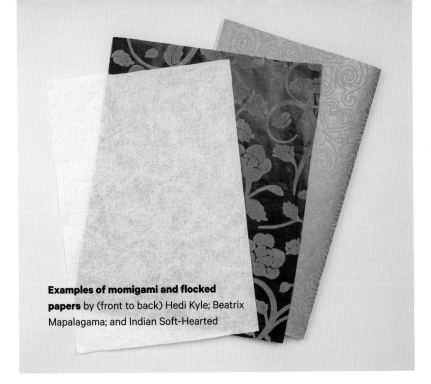

Examples of momigami and flocked papers by (front to back) Hedi Kyle; Beatrix Mapalagama; and Indian Soft-Hearted

Texture and Other Wild Ideas

Several kinds of textured papers are available for sale today. Some are made by simply pressing the sheet onto a surface during the manufacturing process, giving the paper an embossed finish that is prominent on one side. Flocked wallpaper was first developed in the seventeenth century by applying an adhesive pattern to colored paper, then adding wool scraps to the adhesive. This gives the paper a rich, velvety texture that is fun to touch. A textured Japanese paper called momigami is created by repeatedly crumpling or kneading the paper until it becomes so soft it resembles cloth. Long ago, momigami was used to make clothing in Japan. Another way to add texture to paper is to cut and/or fold in patterns.

Translucency

Translucent paper has captivated me since I first saw light filtering through Japanese shoji screens 30 years ago. There are many types of ready-made translucent papers, including vellum, machine- and handmade watermarks, and thin, Japanese handmade papers. In addition, there are ways you can make paper translucent, including waxing, batiking (which uses dyes and removable wax resists), and applying gel medium.

Examples of translucent papers: (top) handmade Lokta paper with Nepalese batik design, artist unknown, courtesy of Maureen Maki; (bottom) faux batik paper by Melanie Terasaki

Fasteners and Connections

Susan Joy Share's creative methods and samples on the following pages for fastening, attaching, and connecting pieces of paper will help you experiment beyond the projects in this book. I consider Share a major influence on my own work, since she sparked my interest in finding innovative ways to attach and connect pieces of paper and pages of books. You got a taste of this in Gatefold with Paper Washers on page 146.

The following samples are mostly trifold paper variations made with 100–184 lb. card stock resulting in 4½ × 6-inch rectangles or 6-inch squares. They are created from 4½-inch and 6-inch strips of paper (grain short) in most instances. Share painted or printed some details and trimmed ¹⁄₁₆ inch off most corners to create a slight round to prevent dog-earring.

TIPS FOR SUCCESS

WHEN ATTACHING MECHANICAL ELEMENTS to paper for closures, it is best to double the paper in areas that receive these elements. Doing so creates a sturdy section and minimizes potential stress, weakness, or tears.

AS LAYERS ARE FOLDED OVER ONE ANOTHER, allow space for the increasing thickness by making incrementally wider double scores. This is especially important when you're using card stock. It creates a nice square edge and allows the paper to lie flat. It's a little tricky to make scores so close together, so work on a cardboard surface with a very pointy bone folder, scoring bone, or thin metal knitting needle. Score tightly against a metal triangle. After scoring, keep the triangle in place and fold the paper up to set the score.

Similarly, when enclosing separate flat components within a folded construction, double scores allow space for the increased thickness. For example, if the components are ¼" thick, the double scores should be a hair wider than ¼" apart to accommodate the thickness.

Elastic Wrap with Eyelet

An elastic closure is a quick, unfussy way to secure papers.

1 Use a Japanese screw punch (see page 35) to make a hole slightly smaller than the eyelet shank into a doubled paper flap.

2 Punch two smaller holes on either side of the eyelet hole to make space for the elastic. This is especially important if you are using round elastic. Be sure the elastic holes are placed in the same direction that the elastic will wrap.

3 Cut a piece of elastic several inches longer than the contents it will wrap around.

4 Insert the two ends of the elastic into the two smaller holes, then insert the eyelet into the main hole, over the elastic. Stretch the elastic over your bundle of papers and pull the ends of the elastic until the loop fits snugly to the size of the bundle but doesn't bend it. Double-check that you have the correct length of elastic. Set the eyelet. Trim the ends of the elastic, leaving ½" tails.

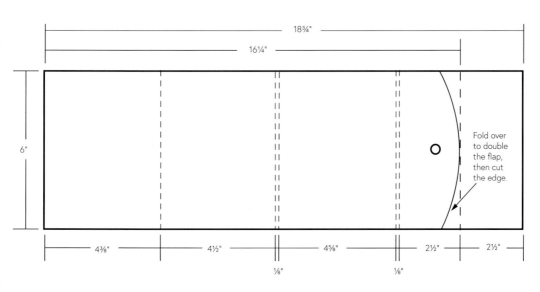

18¾"

16¼"

6"

4⅜" 4½" 4⅝" 2½" 2½"

⅛" ⅛"

Fold over to double the flap, then cut the edge.

Large Brass Fastener

(Modeled after a Hedi Kyle box closure)

A brass fastener provides a quick way to connect a flap and has an elegant look.

1 Make a trifold with a smaller single-layer paper flap on top. Mark a light line where the top flap ends on the larger side flap. Unfold the flap and then, centered on that line, punch a hole slightly smaller than the shank of your brass fastener.

2 Punch the same size hole in a small paper reinforcement, match it to the main hole, and glue the paper reinforcement in place on the back (inside) of the larger side flap.

3 Trim the fastener shank with a metal shear, if desired (the shank is likely to be quite long otherwise), and sand any sharp edge or burr until smooth.

4 Insert the fastener into the hole you made in step 1, making sure the shank is parallel to the top and bottom edges of the paper. Splay the fastener open, and slide the top paper flap under half of the fastener head.

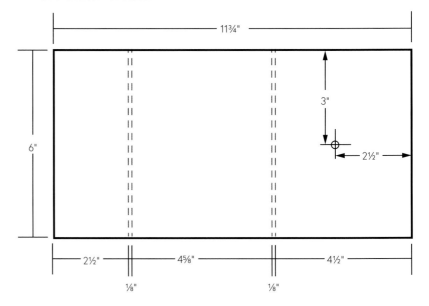

Velcro

We are used to seeing Velcro on backpacks, wallets, clothing, and other functional objects. It works just as well as a paper closure— especially the self-adhesive Velcro that sticks in place.

1 Make a trifold with a smaller double-layer paper flap on top.

2 Attach one side of a Velcro piece to the inside of the flap. (Most Velcro you will use for papercrafting comes with a self-stick surface, but you can add a dot of full-strength PVA to the self-stick surface to make sure the adhesion is strong.) Press and let dry.

3 Place the corresponding Velcro half onto the first one. Add a dot of PVA on the exposed back of the Velcro. Close the flap onto the body of the paper. Press and let dry.

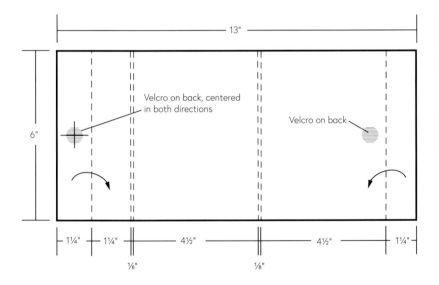

13"

6"

Velcro on back, centered in both directions

Velcro on back

1¼" 1¼" 4½" 4½" 1¼"

⅛" ⅛"

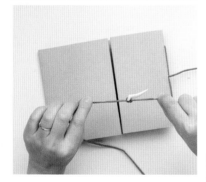

Shoelace Wrap-Around with Bone Attachment

Old books and pouches were wrapped with a long piece of leather cord; a piece of bone affixed to one end of the cord was tucked into the wound cord to secure the bundle. Create a similar closure using a shoelace and a bone clasp or stick.

1 Make a trifold with a shorter double-layer flap for the cover.

2 Glue a reinforcement layer, such as a strip of book cloth or heavy text-weight paper, over the inside of this fold. Along the fold, evenly measure out and mark three holes, then use an awl or Japanese screw punch to make holes that are large enough to slip the shoelace through.

3 Using a 45" shoelace, insert one end, leaving a 1"–2" tail. Sew a pamphlet stitch (see page 27) into the three holes and tie a knot on the inside.

4 Bring the long end of the shoelace out through the middle hole (you will have about 2' of cord left) and attach a tapered bone or stick by slipping the shoelace through the hole in the bone and tying a knot.

5 To close, wrap the shoelace around the paper bundle and slip the bone under the lace.

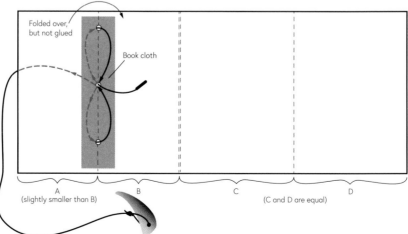

Cord Cinch

Cinching a cord around a folio creates an adjustable closure that is easy to slip on and off and expands or contracts when you need to add or remove contents. You can slide the bead to cinch the cord tighter or make it looser.

1 Fold the project paper in half (short side to short side) and then fold the two outer edges to meet just shy of the center fold, creating an extra flap on each side.

2 Slip two ends of a cord onto a pony bead. The diameter of the cord corresponds to the bead opening and should create a fairly tight cinch. Slip the open loop over a paper bundle. Cinch in the pony bead. Knot the cord ends. Be sure the loop is large enough to slip on easily.

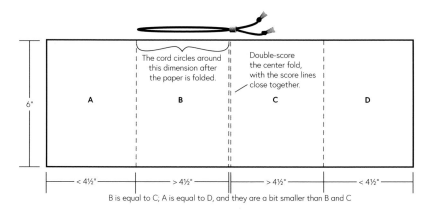

6"

| A | The cord circles around this dimension after the paper is folded. | B | Double-score the center fold, with the score lines close together. | C | D |

|— < 4½" —|— > 4½" —|— > 4½" —|— < 4½" —|

B is equal to C; A is equal to D, and they are a bit smaller than B and C

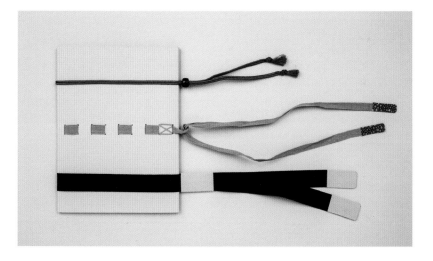

Experiment with a ribbon or paper cinch or weave a ribbon through paper slits to create other adjustable closures.

Rubber Magnet Strips

Strip and sheet magnets have an adhesive backing that can be attached to paper, making them a fun closure that can be shaped and cut to size.

This paper features a crayon rubbing with acrylic paste paper overpainting.

1. Make a rectangular-flapped envelope with a double-layer paper flap on top. Glue the two layers of the top flap together as shown below.

2. Cut two self-adhering rubber magnet strips ½" wide and just shorter than the size of the paper.

3. Remove the adhesive backing and adhere one magnet on the underside of the double flap and press to secure. Place the second magnet strip on top of the first and test to make sure it has the correct magnetic pull. (If you have it oriented in the wrong direction, the magnets will repel each other. In that case, simply flip the second magnet strip vertically.)

4. Remove the adhesive backing from the second strip. Close the flap onto the body of the paper and press to adhere the second half of the magnet strip.

5. Open the flap and press each again to make sure the magnets have adhered.

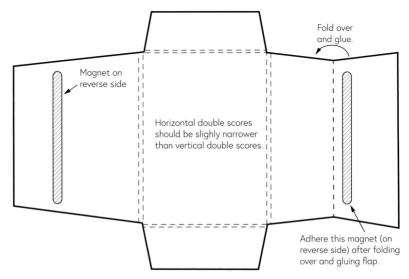

Magnet on reverse side

Fold over and glue.

Horizontal double scores should be slightly narrower than vertical double scores.

Adhere this magnet (on reverse side) after folding over and gluing flap.

Rare Earth Magnet

Rare earth magnets are incredibly strong for their size and work well when you want to connect two spots, such as the points on an envelope flap. Choose the magnet size according to the weight of paper. (In the photo at right, the magnets are 6 × 1 mm and the paper is 80 lb. Via card stock.)

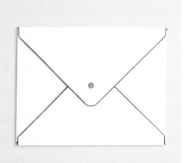

1 Make an envelope with four overlapping triangular flaps.

2 Align two magnets of the same size. Lightly sand the outer surfaces of the magnets for better adhesion. With PVA, glue one magnet to the top side of the top paper flap, then gently press in place to secure.

3 Experiment with the remaining flaps of your envelope until you find where to position the second magnet to hold everything closed. Mark the spot on that flap.

4 Make sure you have the second magnet oriented in the right direction for its magnetic pull, and then apply glue and press to adhere it. You can cover the magnets with thin paper or leave them exposed.

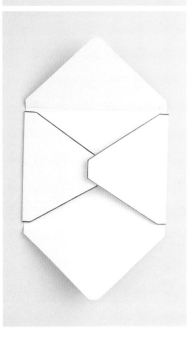

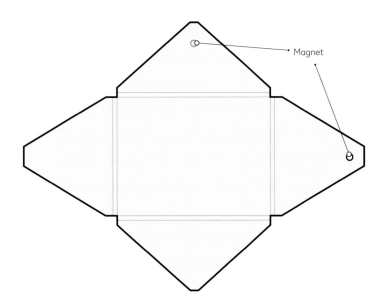

Magnet

Box-Top Interweave

This way of interweaving paper is similar to folding a packing box (one panel over the other and tucking the last panel under the first). This closure requires accurate measurements and marks. Use a square piece of paper twice the size of your desired finished square—for instance, a 12" square produces a 6" finished piece.

1 Photocopy, print, or trace the template (see page 302) onto the project paper (see Working with Templates on page 28 and the Template Key on page 280).

2 Cut along all of the solid lines.

3 Score along all of the dashed lines.

4 Fold down one semicircle at a time, along its edge of the inner square. Tuck the edge of the fourth semicircle under the first to create an interwoven box-top closure.

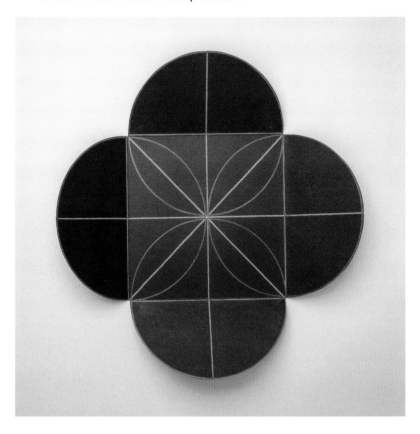

Inch Overlap Weave

(Modeled after a unique artist's book by Paul Johnson)

This is a simple, practical, and pleasing way of interlocking two flaps of paper.

1 Make a trifold with single-layer flaps.

2 Trim back the flaps so that the edges overlap by 2" on each side.

3 Make a mark 1" from the edge at the center of each flap.

4 Starting with the mark as the peak, draw and cut out the sides of a triangle on both flaps. Interweave the halves.

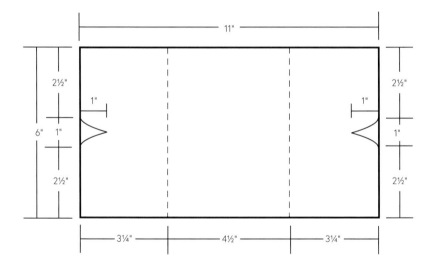

Slip-On Sleeve

A slip-on sleeve is a great way to contain a small folded piece or a stack of cards. It only covers part of the piece that it wraps around, allowing for fun paper combinations or visual elements to be hidden underneath the sleeve and revealed when it slides off.

1 Cut a strip of paper about one-third the height of your paper bundle and long enough to wrap around it with an extra 1".

2 Mark and double-score the strip (see Tips for Success on page 260) at key points based on the size of your bundle.

3 Overlap and glue the ends together to create a sleeve. Be sure to make the sleeve slightly larger than your object for easy slip-on and slip-off. This sleeve is a good spot for a title and/or image.

Tuxedo Flap

This closure simply requires cutting a slit and sliding a flap into it. Variations on the tuxedo closure are used widely in commercial boxes and folders. In this version, Susan Joy Share made her own rubber stamps to print the flap.

1 Make a trifold with single-layer flaps.

2 Taper the top flap by cutting it on an angle from the top and bottom edges, and shorten it to be about 1" from the folded edge. On the bottom flap, mark a light line parallel to and about 2" from the fold.

3 Close the tapered flap and mark the two points where its edges intersect with the light line.

4 Use an awl or Japanese screw punch to make a small hole at each intersection, just clear of the tapered flap's edges. Cut a slit between the holes. Cut a second parallel slit ¹⁄₃₂" away from the first and remove the very narrow paper strip. (The width of the slit depends on the paper thickness.) This allows you to easily insert the paper flap.

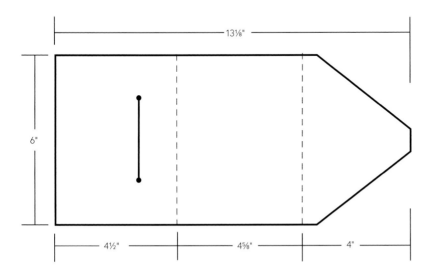

TERMS TO KNOW

DECKLE. The frame that sits on top of the papermaking mould to contain the pulp. It controls the shape, size, and thickness of the sheet of paper formed on the mould. The feathered edge of a handmade sheet of paper is called the deckled edge.

FOLIO. A sheet of paper folded in half once to form two leaves (four pages) of a book. Also known as a bifold.

HOLLANDER BEATER. A machine used to refine pulp for hand papermaking, developed in Holland in the 1680s and still man-ufactured on a small scale today.

LANDSCAPE. The orientation of a sheet of paper that is wider than it is tall.

LARK'S HEAD KNOT. A lark's head knot is used to attach a cord or thread to another object. In this book, we use it to attach to the flying line in the Capucheta (Paper Kite) on page 94. This knot is secure and will not untie or slip.

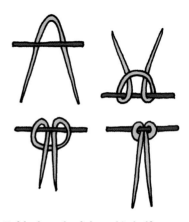

Fold a length of thread in half so you have a loop on one end and two loose ends on the other. Slip the two loose ends through the loop. Pull the cord tight around the object.

MOULD. The tool used to form sheets of handmade paper, made up of a screen surface stretched across a frame.

MOUNTAIN FOLD. When a sheet of paper is folded and then unfolded, and the crease sits at the top like the peak of a mountain.

OVERHAND KNOT. An overhand knot is commonly used to knot the end of a thread. It is also the first part of the knot used to tie a shoe.

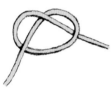

Form a loop at the end of the thread by crossing one end over the other end. Tuck the working end of the thread through the loop. Pull the overhand knot tight.

PORTRAIT. The orientation of a sheet of paper that is taller than it is wide.

SCORE. To make a crease on a sheet of paper so that it will fold more easily, using a bone folder or other scoring tool.

SIGNATURE. In bookbinding, a group of sheets folded in half and stitched into a book. Sometimes this is a single section, but most often there are multiple signatures in a book.

SQUARE KNOT. A square knot is commonly used to knot two ends of a piece of thread, as in the pamphlet stitch (see page 27).

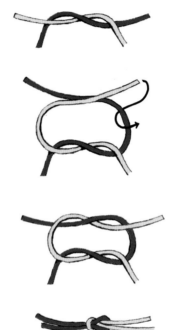

Hold the two ends of thread, one in each hand. Cross the right end over the left end and twist it around the left thread, as if you were tying an overhand knot. Now cross the left end over the right end and twist it around the right end. Pull the threads tight to secure the square knot.

SUBSTRATE. The base material or surface, such as a sheet of paper, onto which images will be applied (printed, painted, handwritten, etc.).

TRIFOLD. A three-panel structure.

VALLEY FOLD. When a sheet of paper is folded and then unfolded, and the crease sits at the bottom, forming a *V*.

ACKNOWLEDGMENTS

I am grateful to my parents, who instilled in me a sense of wonder and a passion to seek meaning in the world (my father was a nuclear physicist, exploring how the world began, and my mother a psychotherapist, pondering human behavior).

I sometimes wonder where I would be today if I hadn't taken a course about paper at the art school in Mainz, Germany, where I spent my junior year of college. My professor there opened my eyes to the potential of paper.

I am grateful to my papermaking and paper art colleagues for being generous with their knowledge and encouraging me along the way. You will see a variety of unique paper projects designed by some of them within these pages. I'm especially thankful to Susan Joy Share, who shares a multitude of unique fasteners and connections that can be integrated into paper and book works (see pages 260–271), and to Michael G. LaFosse, who came to the rescue when I realized we needed some technical help with the illustrations.

I am also appreciative of my students—I learn as much from you as you do from me. You inspire me to keep designing with paper and sharing my love for this amazing material.

What a delight to be working with Storey Publishing again, where this journey began more than 20 years ago. I never dreamt I would write how-to books, but Deborah Balmuth (now the publisher) sent me a letter (typed on paper) asking me to submit a proposal to write a book about making paper with plants. She came up with the idea after seeing a one-paragraph description of a workshop called Compost Papermaking that I taught at the Horticultural Society of New York and thought it might make a good book.

That was an offer I could not refuse, so I stumbled my way through that first manuscript. And now I am up to book number six. I am so impressed by the team at Storey, and my project editor—Mia Lumsden—deserves a toast. She probably learned more than she wanted to about paper (I was pleased that she tried her hand at most of the projects while editing the text) and provided fresh and astute attention to the overall concept and fine details in this book. Thank you!

RESOURCES

CONNECT WITH HELEN

https://helenhiebertstudio.com
On my website, you can access my art, online classes, and workshops—plus my blog, *The Sunday Paper*, and my *Paper Talk* podcast. You can also access my Facebook group and Instagram page through my website.

PAPER SUPPLIERS

Many local art supply stores carry a selection of decorative papers, and there are specialty paper stores in larger cities and online. The following suppliers are the sources for the projects in this book.

www.cartefini.com
Italian crepe paper

www.cutcardstock.com
Discount card stocks and other papers

www.frenchpaper.com
Commercial papers in popular sizes, weights, and finishes

www.gpcpapers.com
Distributor of decorative papers from around the world; they sell retail online

https://hollanders.com
Decorative papers and bookbinding supplies

www.mohawkconnects.com
Commercial mill willing to sell small quantities of their papers

www.mulberrypaperandmore.com
Hand-crafted decorative papers from around the world

www.origami-shop.com
Origami shop in Europe

www.origamishop.us
Origami shop in the United States

https://origamiusa.org
US origami organization that also sells origami papers

www.paperconnection.com
Asian papers

www.paperpapers.com
Commercial papers in popular sizes, weights, and finishes

https://store.hiromipaper.com
Japanese papers

www.thepapermillstore.com
Commercial papers in popular sizes, weights, and finishes

www.washiarts.com
Japanese papers and tools

PAPER ORGANIZATIONS & OTHER USEFUL WEBSITES

www.bestpopupbooks.com
All about pop-ups

https://carriagehousepaper.com/museum
International Paper Museum

https://drachen.org
Kite-making foundation

https://foldfactory.com
Weekly YouTube videos highlighting uniquely designed printed materials often made from one sheet of paper

https://handpapermaking.org
Quarterly papermaking journal

https://iapma.info
International Association of Hand Papermakers and Paper Artists

www.ifides.com
Website about hanji (Korean paper)

https://movablebooksociety.org
Paper engineering, pop-ups, and movable books

www.nahandpapermakers.org
North American hand papermaking organization

https://onpaperwingsthemovie.com
Documentary about Japanese balloon bombs

https://paperforwater.org
Kids folding origami to raise money for clean water

https://paper.gatech.edu/robert-c-williams-museum-papermaking
Robert C. Williams Museum of Papermaking

www.pbs.org/independentlens/between-the-folds
Documentary about contemporary origami artists

https://shibori.org
World Shibori Network

https://templatemaker.nl/en/
Templates for boxes with customizable dimensions and angles

www.youngminlee.com
Artist website with information about bojagi

SPECIALTY SUPPLIERS

www.adamsmagnetic.com
Magnetic strips and rare earth magnets

https://chibitronics.myshopify.com
Paper electronics and kits

www.craftparts.com
Wooden thread spools

https://hollanders.com
Paper, paper knife, tools, and bookbinding supplies

https://intothewind.com
Kite-making supplies

www.leathersmithdesigns.com
Leatherworking tools and snaps

https://littlecircles.co/collections/tools
Quilling tools

www.talasonline.com
Bookbinding supplies and specialty papers

CONTRIBUTING AND REFERENCED ARTISTS

Artists are listed in alphabetical order by last name.

Trinity Adams
www.paperforwater.org

Susan Byrd
www.byrdsnest.net

Béatrice Coron
www.beatricecoron.com

Peter Dahmen
www.peterdahmen.de/en

Erik Demaine
https://erikdemaine.org/

Martin Demaine
http://martindemaine.org/

Madeleine Durham
www.madeleinedurham.com

Eric Gjerde
www.ericgjerde.com

Debra Glanz
www.thepaperassembly.com

Arnold Grummer
www.arnoldgrummer.com

Paul Jackson
www.origami-artist.com

Paul Johnson
www.bookart.co.uk

Paula Beardell Krieg
https://bookzoompa.wordpress.com

Susan Kristoferson
www.kristoferson-studio.ca

Hedi Kyle
www.artofthefold.com

Michael G. LaFosse
www.origamido.com

Robert J. Lang
https://langorigami.com

Jean-Paul Leconte
www.paperpaul.com

Ann Martin
www.allthingspaper.net

Bhavna Mehta
www.bhavnamehta.com

Cathryn Miller
https://byopiapress.wordpress.com

Marianne R. Petit
www.mariannerpetit.com

Gina Pisello
www.ginapisello.com

Jill Powers
https://jillpowers.com

Jie Qi
www.technolojie.com

Steph Rue
www.stephrue.com

Laura Russell
www.laurarussell.com

Susan Joy Share
www.susanjoyshare.com

Shawn Sheehy
www.shawnsheehy.com

Scott Skinner
www.drachen.org

Ioana Stoian
www.ioanastoian.com

Peter Thomas
https://wanderingbookartists
.blogspot.com

Janna Willoughby-Lohr
www.papercraftmiracles.com

READING LIST

I love how-to books and have amassed my own paper library over the years. The following selection relates to the projects in this book. To keep this list concise, I included only one book on most topics or by a particular author (an asterisk * next to an author's name indicates they have written more books about paper). A few of these books are out of print, but you can usually find used copies.

Ainsworth, J. H. *Paper, the Fifth Wonder.* Thomas Printing and Publishing Co., 1959.

Anderson, Kelli. *This Book Is A Planetarium: And Other Extraordinary Pop-Up Contraptions.* Chronicle Books, 2017.

Baker, Cathleen* *By His Own Labor: The Biography of Dard Hunter.* Oak Knoll Press, 2000.

Barrett, Timothy.* *Japanese Papermaking: Traditions, Tools, and Techniques.* Weatherhill, 1984.

Basbanes, Nicholas A. *On Paper: The Everything of Its Two-Thousand-Year History.* Alfred A. Knopf, 2013.

Bell, Lilian A.* *Papyrus, Tapa, Amate and Rice Paper: Papermaking in Africa, the Pacific, Latin America and Southeast Asia.* Liliaceae Press, 1993.

Birmingham, Duncan. *Pop-Up Design and Paper Mechanics: How to Make Folding Paper Sculpture,* 2nd ed. Guild of Master Craftsman Publications, 2011.

Bodger, Lorraine. *Paper Dreams.* Universe Books, 1977.

Brosterman, Norman. *Inventing Kindergarten.* Harry N. Abrams, 1997.

Byrd, Susan J. *A Song of Praise for Shifu: Shifu Sanka.* Legacy Press, 2013.

Chatani, Masahiro.* *Pop-Up Origamic Architecture.* Ondorisha Publications, 1984.

Chung, Jiyoung. *Joomchi & Beyond.* Beyond & Above, 2011.

Farnsworth, Donald.* *Momigami: Japanese Kneaded Paper.* Magnolia Editions, 1997.

Fuse, Tomoko.* *Spiral: Origami, Art, Design.* Viereck Verlag, 2012.

Gildersleeve, Owen. *Paper Cut: An Exploration into the Contemporary World of Papercraft Art and Illustration.* Rockport Publishers, 2014.

Ginsberg, Tatiana, ed. *Papermaker's Tears: Essays on the Art and Craft of Paper, Volume 1.* Legacy Press, 2019.

Gjerde, Eric.* *Origami Tessellations: Awe-Inspiring Geometric Designs.* AK Peters/CRC Press, 2008.

Greenfield, Jane, and Jenny Hille. *Headbands: How to Work Them,* 2nd ed. Oak Knoll Press, 2008.

Griffith, Lia. *Crepe Paper Flowers: The Beginner's Guide to Making and Arranging Beautiful Blooms.* Clarkson Potter, 2018.

Grummer, Arnold E.* *Tin Can Papermaking: Recycle for Earth and Art.* Greg Markim, 1992.

Hazell, Rachel. *Bound: 15 Beautiful Bookbinding Projects.* Kyle Books, 2018.

Hiebert, Helen. *Playing with Paper: Illuminating, Engineering, and Reimagining Paper Art.* Quarry Books, 2013.

———. *Playing with Pop-Ups: The Art of Dimensional, Moving Paper Designs.* Quarry Books, 2014.

Holländer, Friederike, and Nina Wiedemeyer, eds. *Original Bauhaus Workbook.* For the Bauhaus-Archiv/Museum für Gestaltung. Prestel, 2019.

Holt, Neil, Nicola von Velsen, and Stephanie Jacobs, eds. *Paper: Material, Medium and Magic.* Prestel, 2018.

Hughes, Sukey. *Washi: The World of Japanese Paper.* Kodansha International, 1978.

Hunter, Dard. *Papermaking: The History and Technique of an Ancient Craft.* Dover Publications, 1947.

Jackson, Paul.* *Folding Techniques for Designers: From Sheet to Form.* Laurence King Publishing, 2011.

Johnson, Paul. *Pop-Up Paper Engineering: Cross-Curricular Activities in Design Technology, English and Art.* Routledge, 2013.

Johnson, Pauline. *Creating with Paper.* University of Washington Press, 1958.

Kenneway, Eric. *Complete Origami: An A–Z of Facts and Folds, with Step-by-Step Instructions for Over 100 Projects.* St. Martin's Press, 1987.

Kurlansky, Mark. *Paper: Paging Through History.* W. W. Norton & Company, 2017.

Kyle, Hedi, and Ulla Warchol. *The Art of the Fold: How to Make Innovative Books and Paper Structures.* Laurence King Publishing, 2018.

LaFosse, Michael G., and Richard L. Alexander.* *LaFosse and Alexander's Essential Book of Origami: The Complete Guide for Everyone.* Tuttle Publishing, 2016.

Lang, Robert J.* *Origami Design Secrets: Mathematical Methods for an Ancient Art,* 2nd ed. AK Peters/ CRC Press, 2011.

Lee, Aimee. *Hanji Unfurled: One Journey into Korean Papermaking.* Legacy Press, 2012.

Lee, Chunghie. *Bojagi and Beyond.* Bargain Smart Plug, 2010.

Lukasheva, Ekaternia. *Kusudama Origami.* Dover Publications, 2014.

Martin, Ann.* *All Things Paper: 20 Unique Projects from Leading Crafters, Artists, and Designers.* Tuttle Publishing, 2013.

Matsui, Keizo, ed. *Three-Dimensional Graphics.* Rikuyosha, 1988.

Maurer-Mathison, Diane,* with Jennifer Philippoff. *Paper Art: The Complete Guide to Papercraft Techniques.* Watson-Guptill Crafts, 1997.

Mikesh, Robert C., *Japan's World War II Balloon Bomb Attacks on North America,* 2nd ed. Smithsonian Institution Scholarly Press, 1973.

Millington, Jon. *Curve Stitching: The Art of Sewing Beautiful Mathematical Patterns.* Tarquin, 1999.

Mollerup, Per. *Collapsible: The Genius of Space-Saving Design.* Chronicle Books, 2001.

Müller, Lothar. *White Magic: The Age of Paper.* Polity, 2015.

Munson, Don, and Allianora Rosse. *Big Book of Papercraft Projects.* Dover Publications, 2001.

Ody, Kenneth. *Paper Folding & Paper Sculpture.* Emerson Books, 1965.

Pelham, David. *The Penguin Book of Kites.* Penguin Books, 1976.

Reeve, Catherine, and Marilyn Sward. *The New Photography: A Guide to New Images, Processes, and Display Techniques for Photographers.* Prentice-Hall, 1984.

Röttger, Ernst. *Creative Paper Design.* Van Nostrand Reinhold, 1959.

Schepper, Anna, and Lene Schepper. *The Art of Paper Weaving.* Quarry Books, 2015.

Shannon, Faith. *Paper Pleasures.* Grove Press, 2018. Mitchell Beazley Publishers, 1987.

Sloman, Paul, ed. *Paper: Tear, Fold, Rip, Crease, Cut.* Black Dog Publishing, 2009.

Smith, Esther K. *How to Make Books.* Potter Craft, 2007.

Smith, Keith A.* *Structure of the Visual Book.* Keith A Smith Books, 1995.

Stoian, Ioana.* *Origami for All: Elegant Designs from Simple Folds.* Busy Hands Books, 2013.

Thomas, Peter, and Donna Thomas.* *More Making Books by Hand: Exploring Miniature Books, Alternative Structures, and Found Objects.* Quarry Books, 2004.

Wada, Yoshiko Iwamoto, Mary Kellogg Rice, and Jane Barton. *Shibori: The Inventive Art of Japanese Shaped Resist Dyeing.* Kodansha International, 2012.

Witkowski, Trish. *Paper Folding Templates for Print Design.* HOW Books, 2011.

Wolff, Colette. *The Art of Manipulating Fabric.* Chilton Book Company, 1996.

Yabuka, Narelle, ed. *Cardboard Book.* Gingko Press, 2010.

METRIC CONVERSION CHARTS

WEIGHT

TO CONVERT	TO	MULTIPLY
ounces	grams	ounces by 28.35
pounds	grams	pounds by 453.5

VOLUME

TO CONVERT	TO	MULTIPLY
teaspoons	milliliters	teaspoons by 4.93
tablespoons	milliliters	tablespoons by 14.79
cups	liters	cups by 0.24
quarts	liters	quarts by 0.946

LENGTH

TO CONVERT	TO	MULTIPLY
inches	centimeters	inches by 2.54
feet	meters	feet by 0.3048
yards	meters	yards by 0.9144

TEMPLATES

The following templates should be reproduced at 100 percent unless otherwise indicated. You can do this on many home and office printers, or take the templates to your local copy shop and have them enlarged there. I recommend printing templates on white card stock or on the back side of your project paper (see Working with Templates on page 28).

Feel free to copy these templates at various sizes to create larger or smaller versions of the projects.

Visit www.storey.com/papercraft-projects to download the template(s) and print at 100 percent. Many of the templates can be printed on 8½" × 11" paper, but you will need larger sheets for some of them.

TEMPLATE KEY

The symbols below relate to the templates on the next several pages. Note that mountain and valley folds are relative to the way your paper is oriented. This is especially important when using the templates that indicate which side of the paper should be faceup when you fold. In some situations, you might choose to orient your project paper differently from how I suggest.

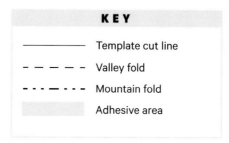

KEY	
——————	Template cut line
– – – – –	Valley fold
– · – — · – ·	Mountain fold
▓▓▓▓	Adhesive area

ONE-SHEET TREE (PAGE 112)

Enlarge to 125% and photocopy, print, or trace on the back side of your paper.

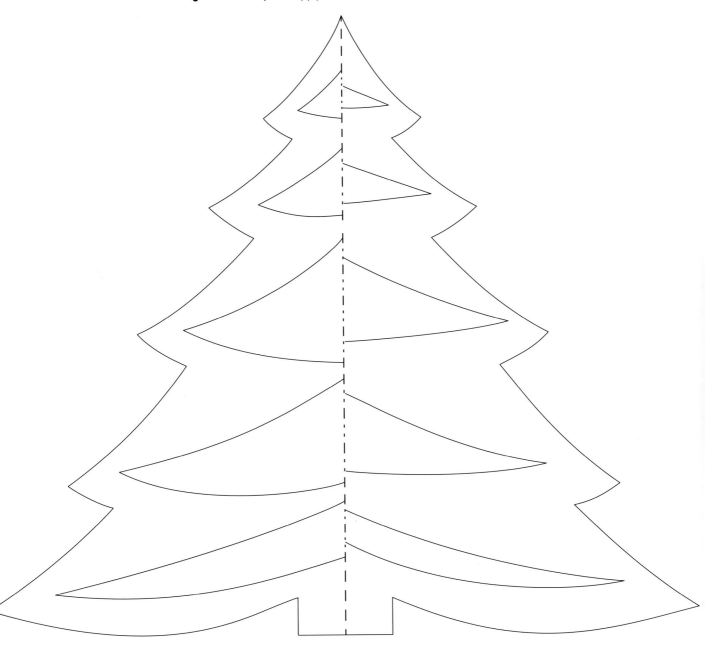

TYVEK LANTERN (PAGE 62)

Photocopy, print, or trace onto card stock.

SPRING SHAMROCK (PAGE 104)

Photocopy, print, or trace onto card stock.

POP-UP DRAGONFLY (PAGE 178)

Photocopy, print, or trace on the back side of your paper.

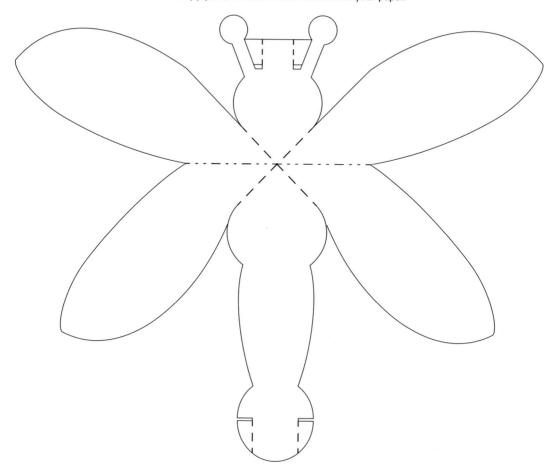

POP-UP DRAGONFLY CARD (PAGE 178)

Photocopy, print, or trace on the back side of your paper.

PEACE TREE CARD (PAGE 100)

Enlarge to 139% and photocopy or print on the display side of your paper.

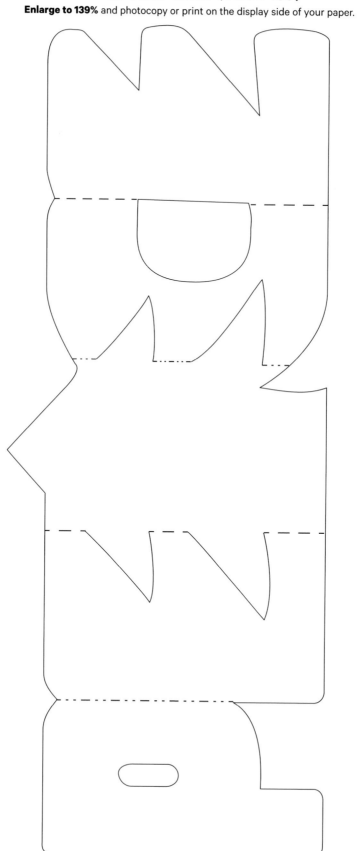

VALENTINE LOVE NOTE (PAGE 48)

Photocopy or print on the display side of your paper.

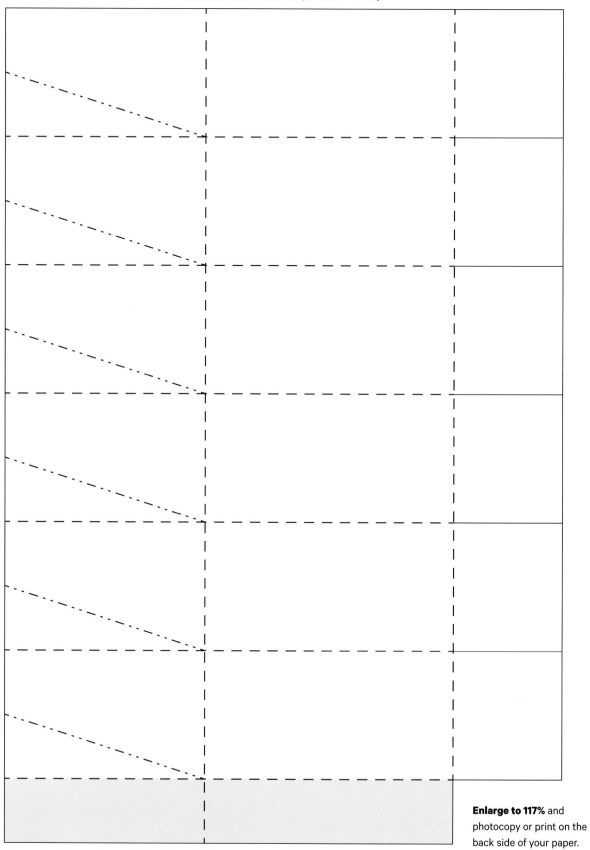

Enlarge to 117% and photocopy or print on the back side of your paper.

If you print this template on the back side of the project paper, as indicated here, you will need to apply double-sided tape (or other adhesive) on the opposite/front side of this tab.

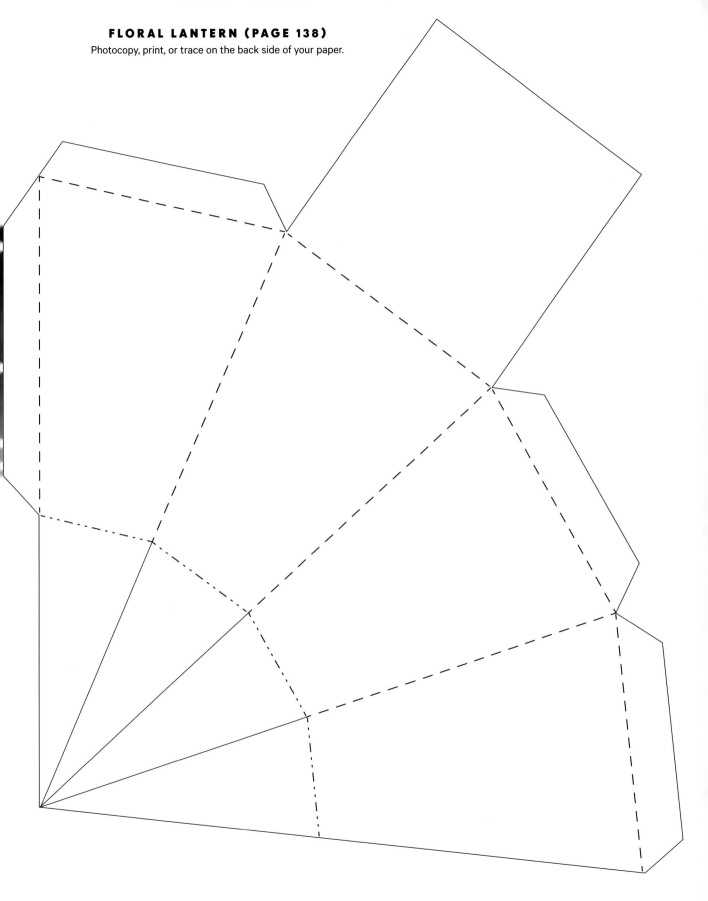

SLICE-FORM HEART (PAGE 120)
Photocopy, print, or trace on the back side of your paper.
Cut two of each template.

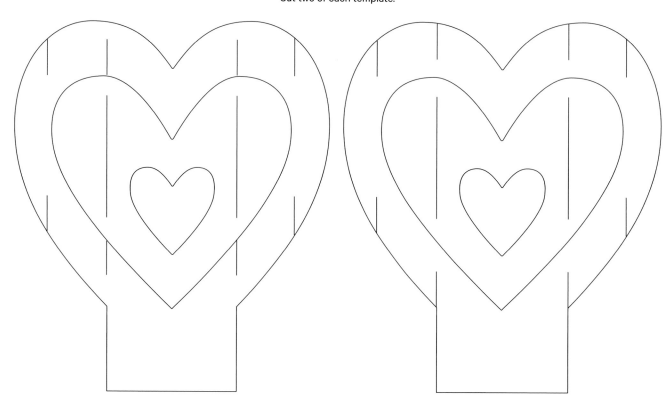

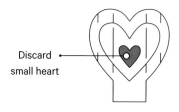

Discard
small heart

INFLATABLE PAPER VOTIVE (PAGE 58)

Enlarge to 125% and photocopy or print on the display side of your paper.

Photocopy or print all of the letter templates on the display side of your paper.

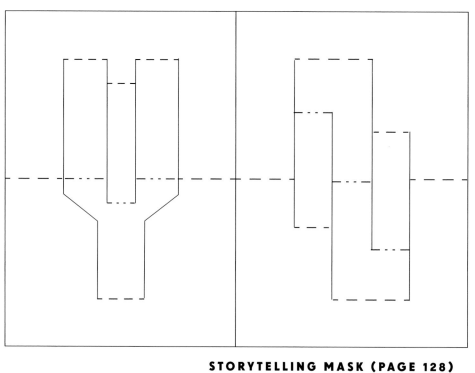

STORYTELLING MASK (PAGE 128)

Photocopy, print, or trace on a sheet of printer paper.

Place this edge on center fold.

CURVED FLIP MECHANISM (PAGE 200)

Enlarge to 123% and photocopy or print on the back side of your paper.

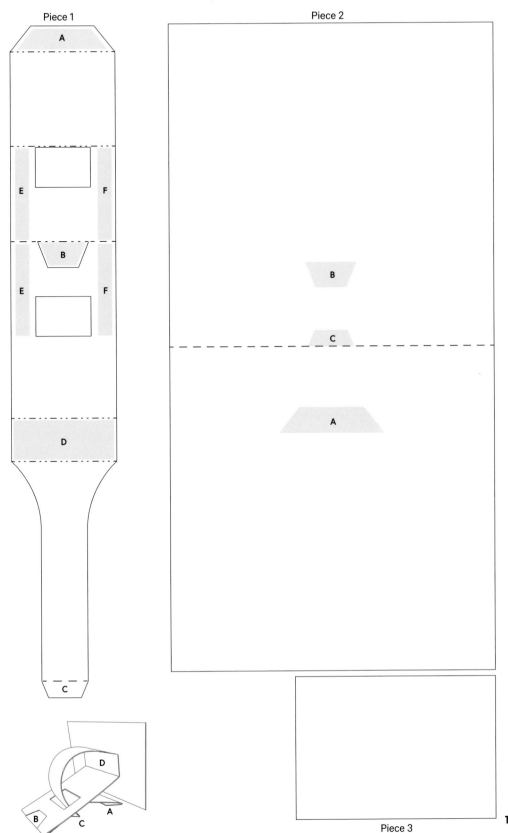

Piece 1

Piece 2

Piece 3

Photocopy or print on the back side of your paper.

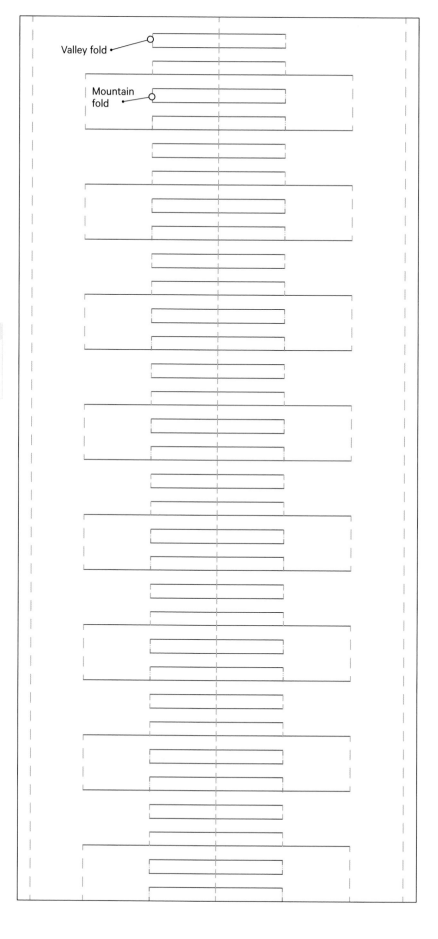

Valley fold

Mountain fold

KEY

– – Valley fold

–·– Mountain fold

BLUSHING TIGER CARD (PAGE 182)

Photocopy or print on the display side of your paper.

FRONT PIECE

CIRCUIT PIECE

TINY HOUSE (PAGE 186)

Photocopy, print, or trace all three template pieces on the back side of your paper.

House piece

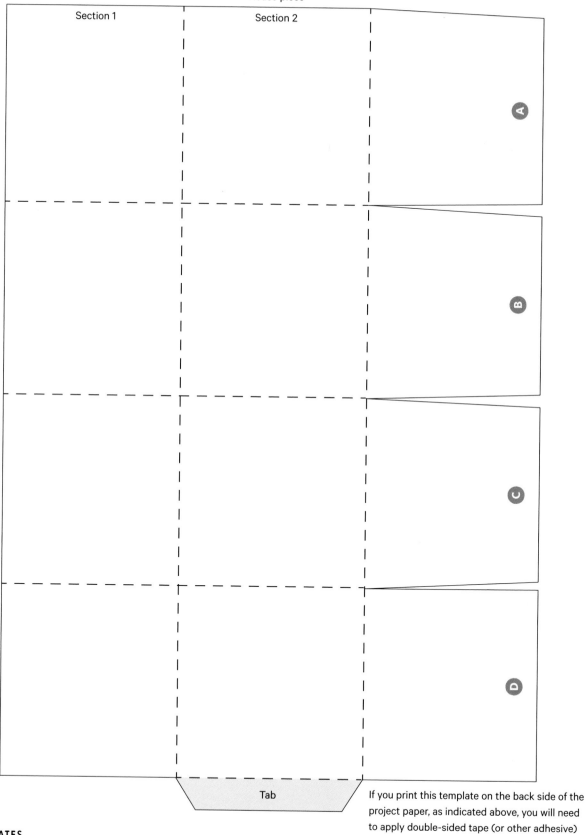

Section 1

Section 2

A

B

C

D

Tab

If you print this template on the back side of the project paper, as indicated above, you will need to apply double-sided tape (or other adhesive) on the opposite/front side of this tab.

TINY HOUSE
Roof reinforcement piece

TINY HOUSE
Roof piece

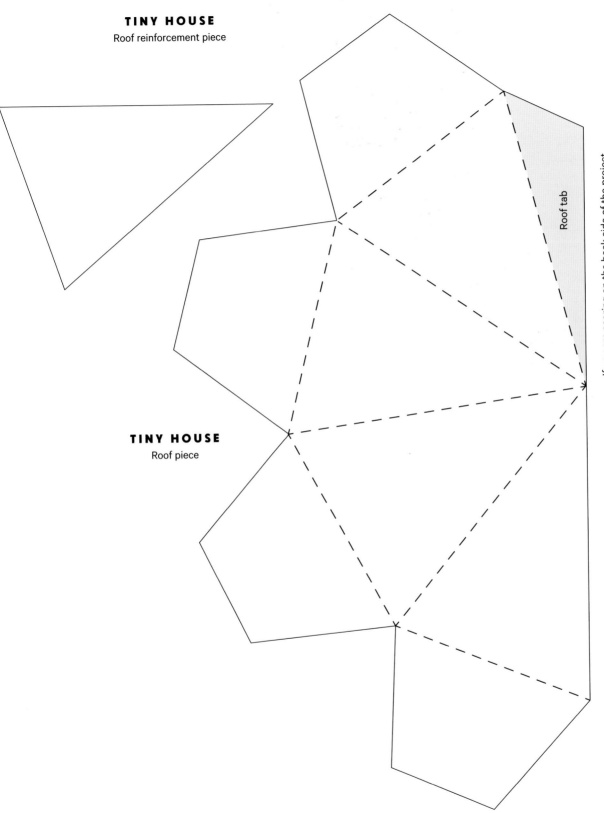

Roof tab

If you are scoring on the back side of the project paper, as indicated, you will need to apply double-sided tape (or other adhesive) on the opposite/front side of this tab.

PAPER TWIST

Enlarge to 112% and photocopy or print on the front side of your project paper. Or, simply use it as a guide for cutting windows.

Windows template

✳

✕

MINI TUNNEL BOOK (PAGE 174)

Photocopy or print on the display side of your paper.

BACK OF CENTER PAGE
Cut out.

FRONT OF CENTER PAGE
Cut out.

BACK OF FRONT COVER
Cut out.

FRONT COVER
Cut out.

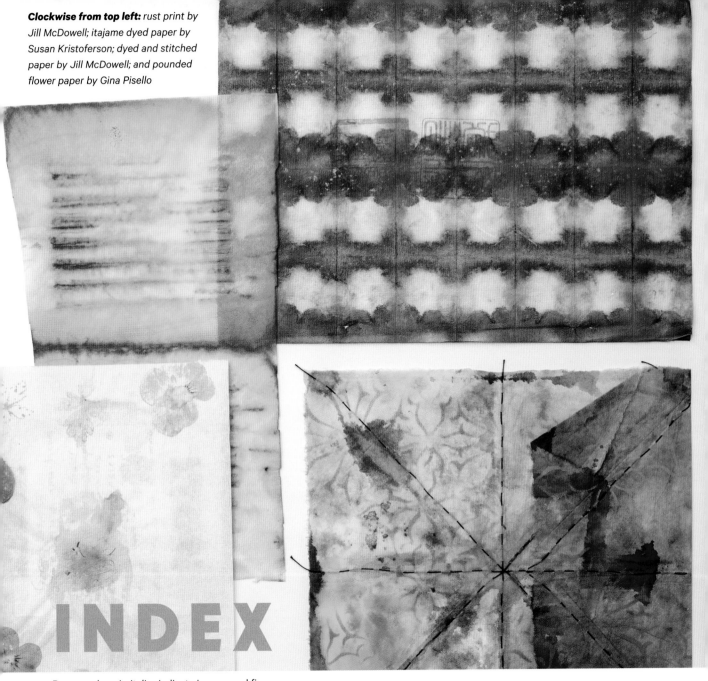

Clockwise from top left: *rust print by Jill McDowell; itajame dyed paper by Susan Kristoferson; dyed and stitched paper by Jill McDowell; and pounded flower paper by Gina Pisello*

INDEX

Page numbers in *italics* indicate images and figures.

A

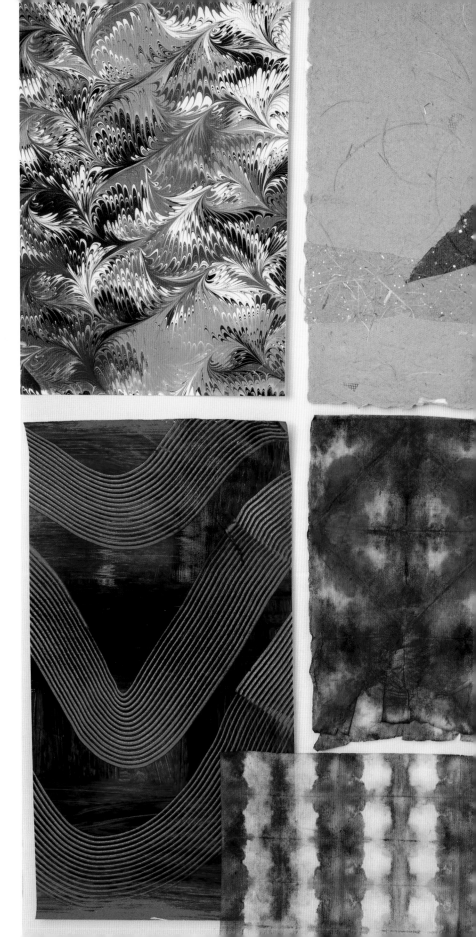

Clockwise from top left: *marbled paper by Emily Duong; handmade paper collage by Susan Mackin Dolan; itajame dyed paper by Susan Kristoferson; itajame dyed paper by Susan Kristoferson; and paste paper by Melanie Terasaki*

Jumpstart Your Creativity
with More Books from Storey

The Papermaker's Companion
by Helen Hiebert

This is the ultimate guide to making your own paper! And once you've made it, Hiebert shows you how to creatively craft it into lanterns, decorative boxes, and much more.

Papermaking with Garden Plants & Common Weeds by Helen Hiebert

Illustrated, step-by-step instructions show you how to make exquisite decorative papers using the fibers from backyard plants, such as daffodil and milkweed, and then use your papers to create envelopes, lampshades, and other unique items.

Hand Printing from Nature
by Laura Bethmann

Use natural and found materials to create unique prints on fabric, paper, and other surfaces. Fifty step-by-step projects show you how to create works of art from plain pillows, curtains, dishes, and more.

Journal Sparks
by Emily K. Neuburger

Make a visual day-in-your-life map, turn random splotches into quirky characters for a story, and list the things that make you you! Sixty interactive writing and art prompts will inspire your imagination and self-expression.

ABOUT THE COVER

The cover of this book was designed by award-winning artist Owen Gildersleeve, who is based in London and specializes in handcrafted illustration, set design, and art direction.

Gildersleeve began this cover design by creating a range of rough pencil sketches. He then scanned in the chosen drawing and refined the forms digitally, finalizing the composition and working out the color palette. These digital drawings were then printed onto sheets of colored paper backwards, so that when cut out (by hand), they could be flipped over to hide the printed lines.

Next, Gildersleeve hand-assembled the dimensional design, using pieces of foam core to create depth between the layers. The final step was photographing the artwork under natural light. This helped to convey additional depth as well as soft shadows, while also highlighting the texture of the paper. Gildersleeve did a final retouch of the image in Photoshop, and then the photo was printed as the cover of this book.